AT THE OCEAN

INSPIRING COASTAL HOUSES AND REFUGES

MIRJAM BLEEKER & FRANK VISSER

SENEGAL 8
LAMU 34
URUGUAY 42
TENERIFE 122
ITALY 146
COSTA RICA 158
JAPAN 232
CURAÇAO 248

INDIA 68 COLOMBIA 80 SPAIN 94 BALI 112

SWEDEN 174 PORTUGAL 200 CHILI 214

THE STORY

MIRJAM BLEEKER & FRANK VISSER

Mirjam and Frank's story began in Curaçao, about 18 years ago. They had already met a little earlier and closer to home, at a photo shoot in Frank's home in Amsterdam. They hit it off right away, finding that they shared the same sense of style - they both feel inspired by beautiful chance findings and like things that are a bit rough around the edges - and a longing for adventure and travel. They decided to 'do something together' - a vague plan that did not take tangible form until Mirjam followed Frank to Curaçao with no real information about the journey. Since then, they have travelled together numerous times, to destinations all over the world. Their habits haven't changed over the years: every couple of months they still feel the urge to just pick a place that interests or intrigues them, pack their bags and leave, without making a plan. So that is what they do, and they will keep doing it for as long as they can.

This book is an ode to the beautiful places on the coasts of seas and oceans around the world, and to the inspiring and hospitable people who live there. It is a record of Mirjam and Frank's travels together over the years, combined with photos of beautiful natural sights and fantastic houses and cabins: from a modernist villa in sunny Tenerife to a small hut in Goa, and from a holiday home on a still undiscovered beach in Uruguay to a traditional living-room restaurant on a Japanese island. It is an introduction to people of different nationalities who have transformed their homes or holiday retreats into authentic places of refuge, and to the wonderful world of stylist Frank Visser and photographer Mirjam Bleeker. Their images always evoke dreams and desires; perhaps they will even inspire you to discover some of these magical coasts around the world for yourself.

Most of all, it is an ode to freedom, to the unique collaboration and to the wonderful friendship of two people who share their sense of adventure and their appreciation of a beauty that does not need many words.

SENEGAL

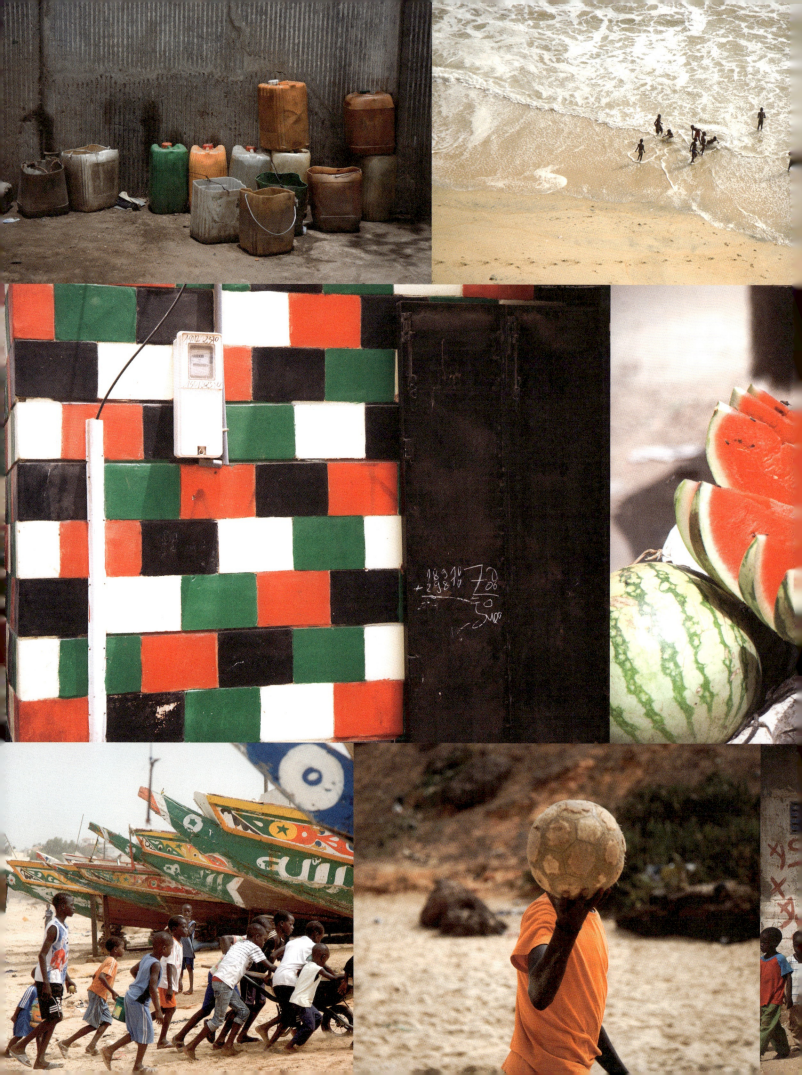

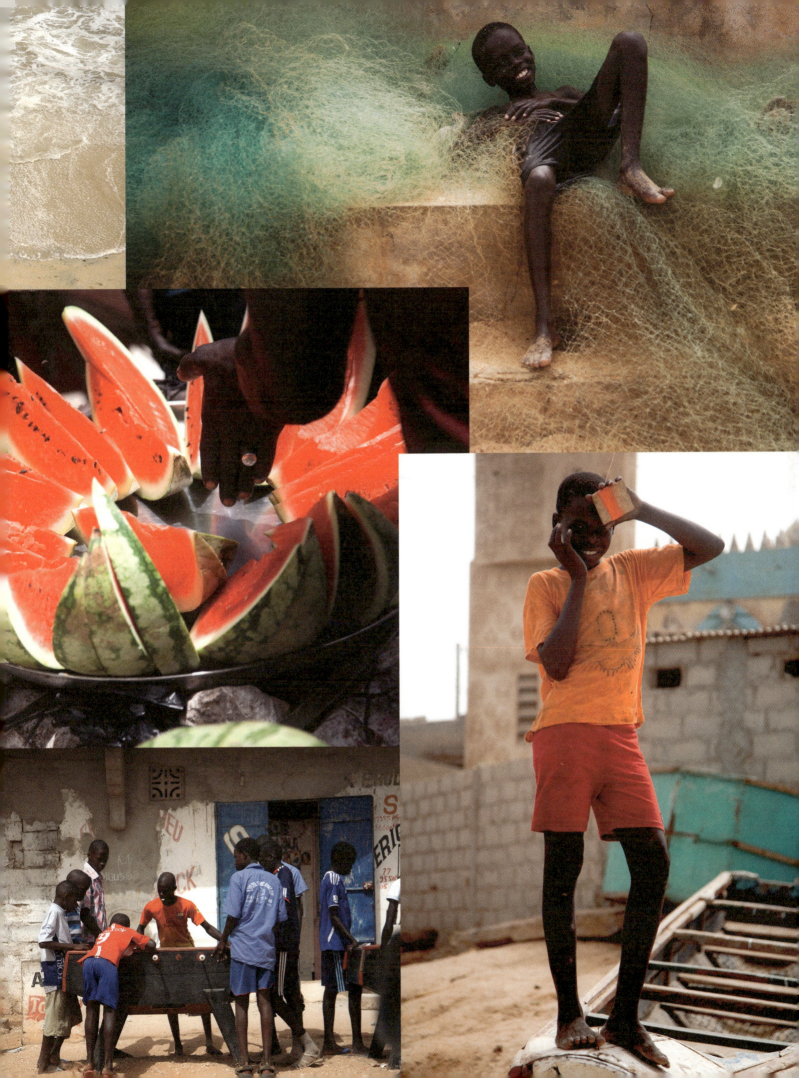

WHO?

Dutchman Erik Pol is joint owner of earthenware and interior design label Pols Potten.

WHERE?

Yène, Senegal. A small village consisting of 15 kilometres of artificial beach along the Atlantic Ocean, about 45 kilometres south of Dakar and close to the larger town of Rufisque. The village is almost exclusively inhabited by fishermen.

Erik ended up in Senegal through his company: the furniture they had ordered from Senegal never arrived, so he decided on a whim to start a workshop of his own: "It may not have been a very smart move – out of 195 countries, Senegal comes 178th on the World Bank's 'Ease of Doing Business' list – but it turned out to be the right decision. Africa is an attractive market for Pols Potten when it comes to articles that cannot be produced anywhere else in the world. For our line of interior design products, that mainly means wooden stools."

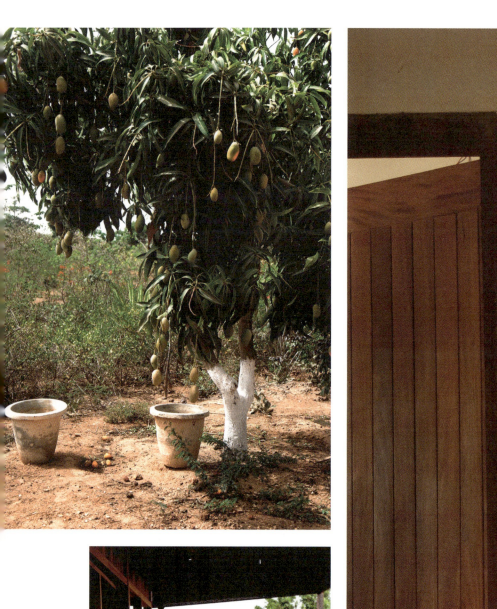

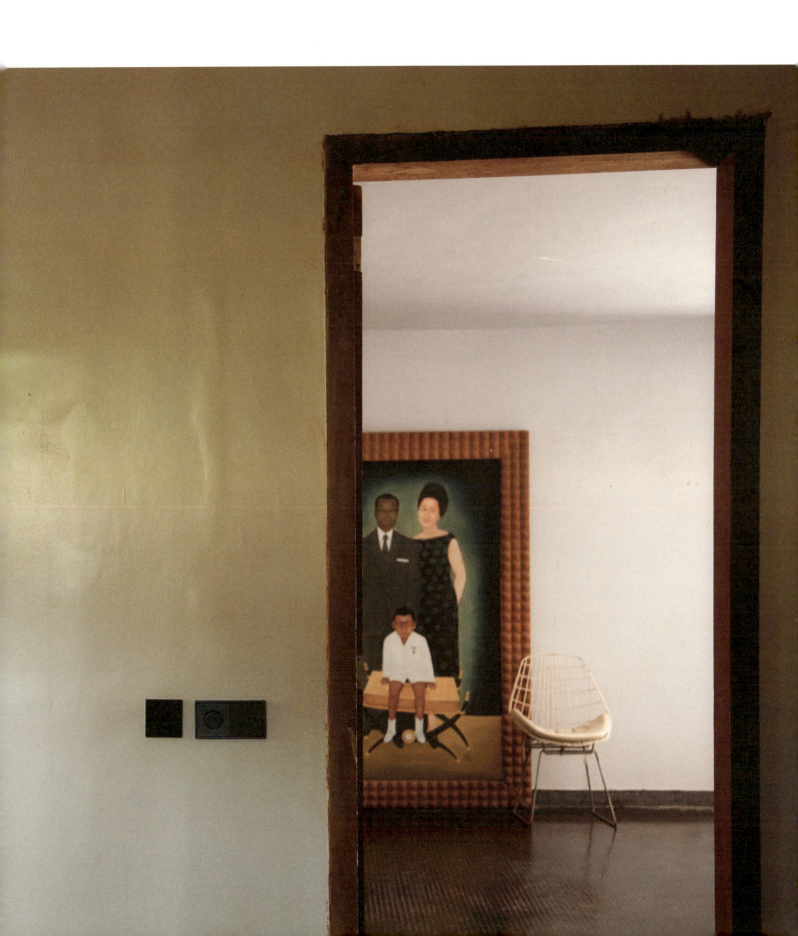

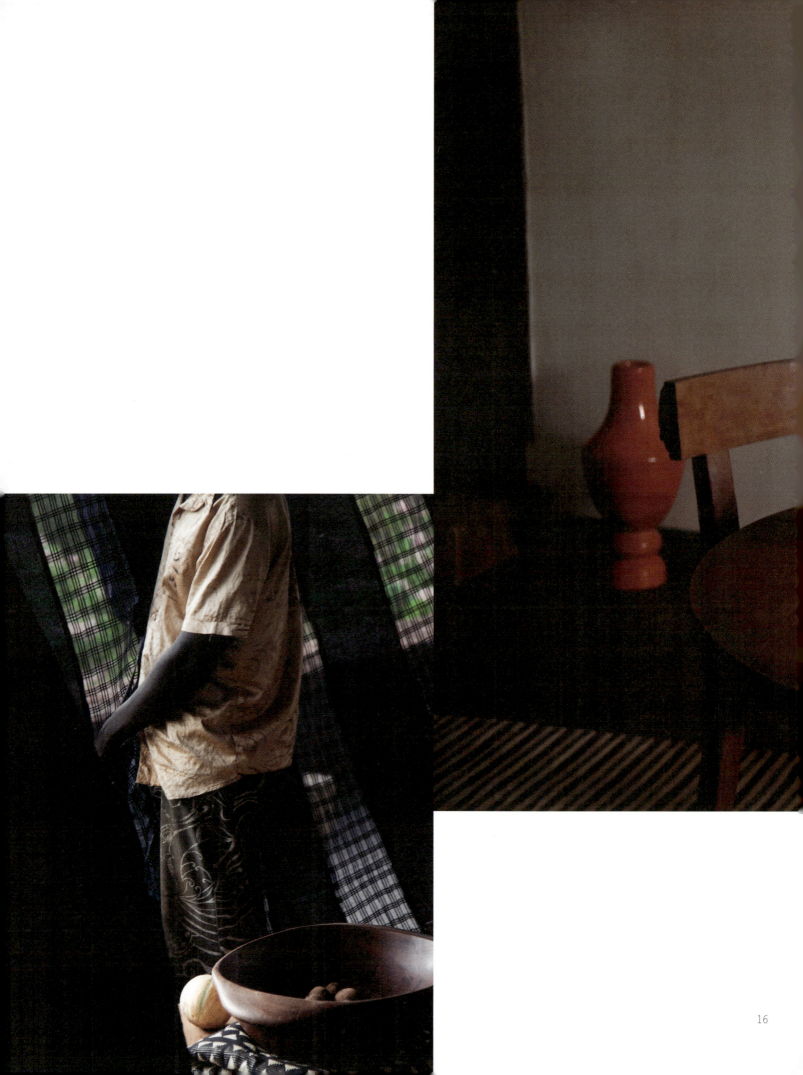

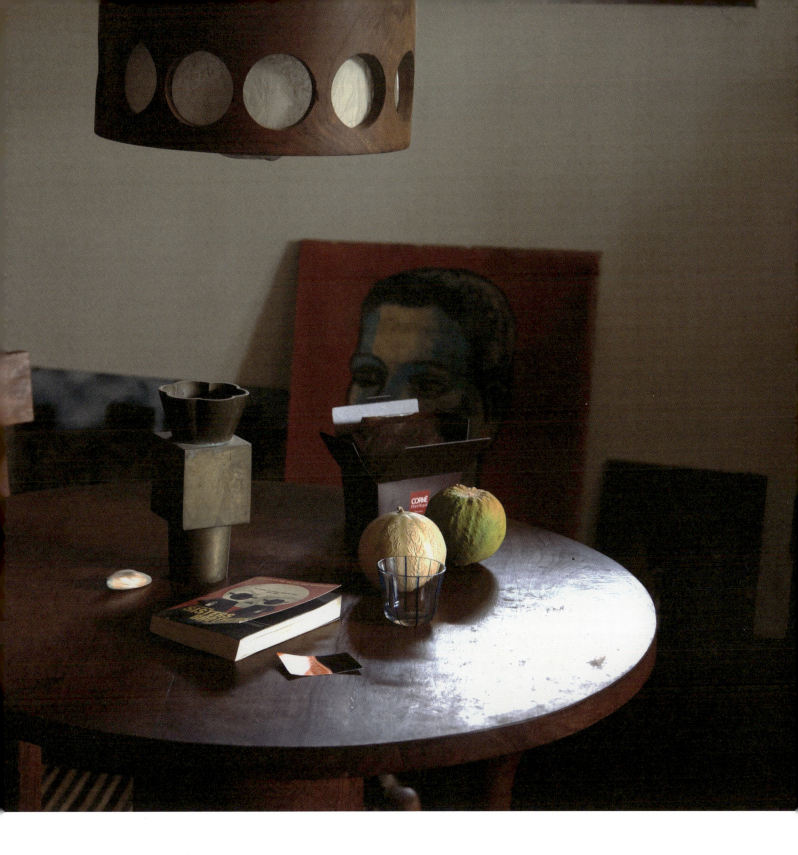

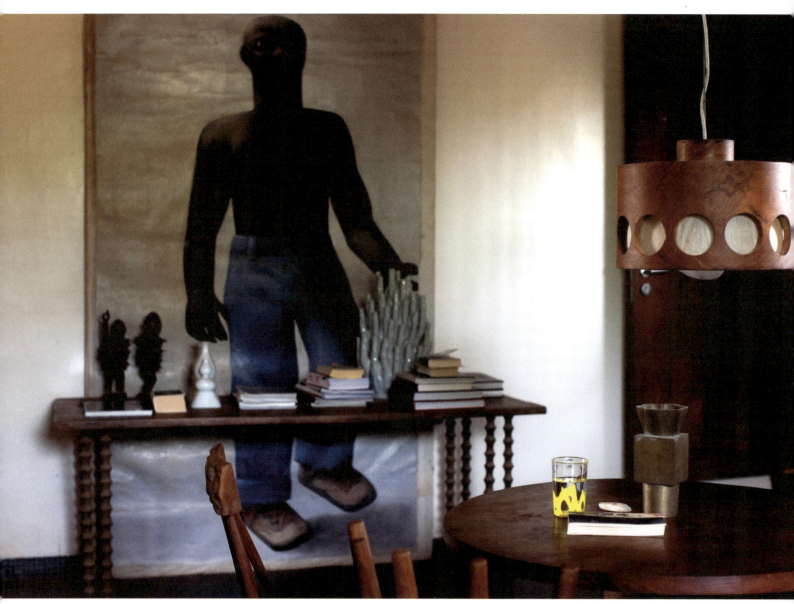

When he first came to Senegal about 16 years ago, Erik ran the African arm of his business from a modern-style rented villa in Dakar. There were several practical reasons for his decision to move to Yène, 45 kilometres to the south, but he also wanted to get away from the crowded city. He bought 3,000 m² of land, and added more soon afterwards: "I wanted to avoid eventually ending up in some kind of noisy medina again, with a mosque, army barracks or a Qur'an school on every corner. Now, I live among the trees, with the birds and the iguanas. There are five gardeners who make sure everything is properly tended. The beach is beautiful and completely empty, with some abandoned houses slowly being reclaimed by the sea. Every now and then, you see a pirogue (small fishing boat, Ed.) sailing by, or a plume of smoke rising where people are wood-smoking fish. The whole effect is quite surreal. To me, it just doesn't get any better than this."

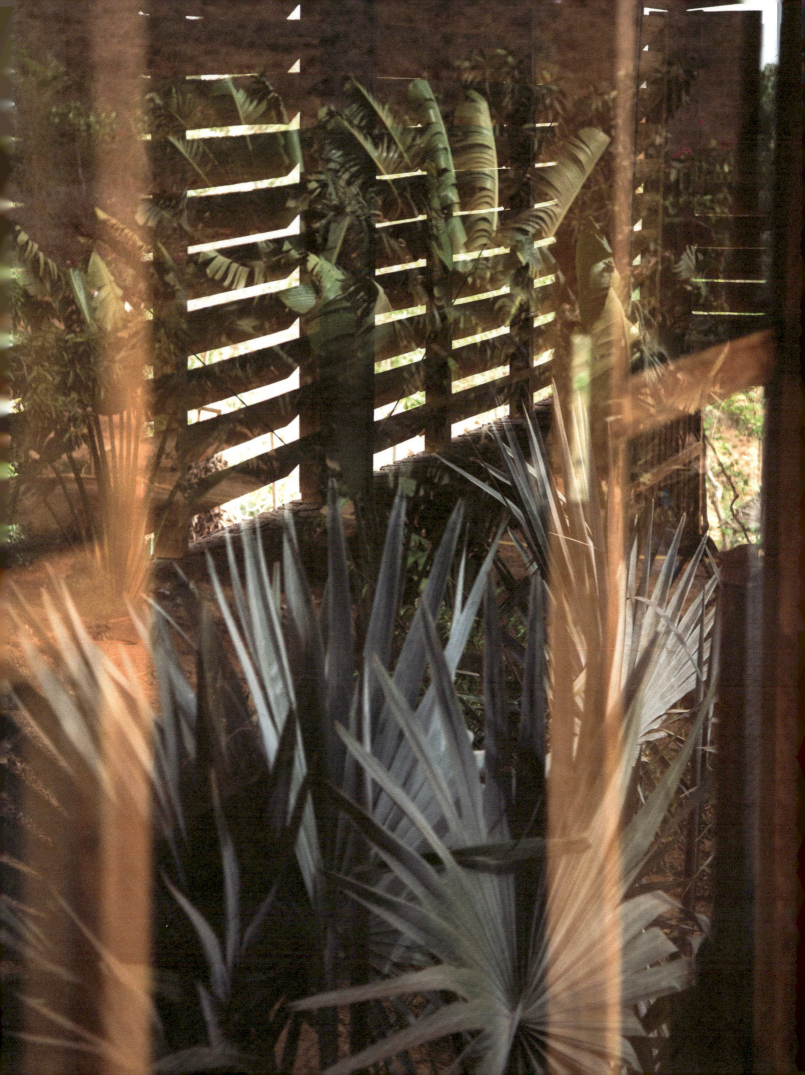

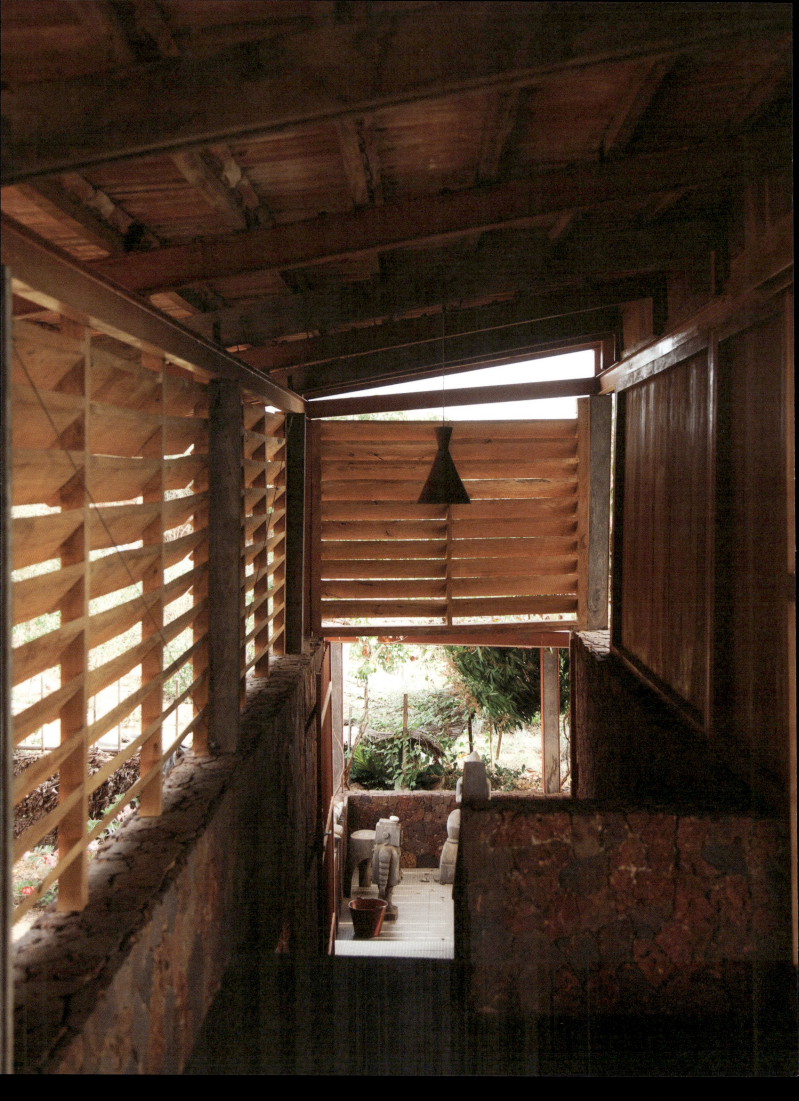

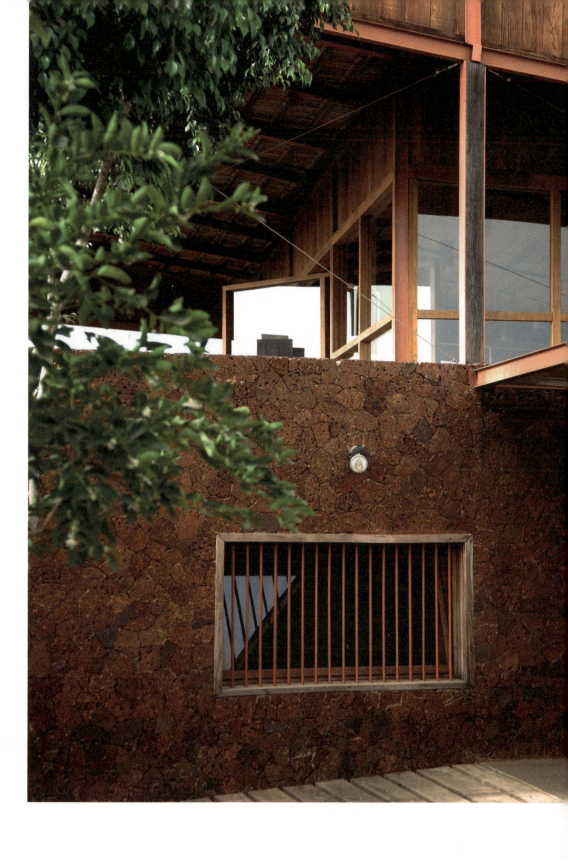

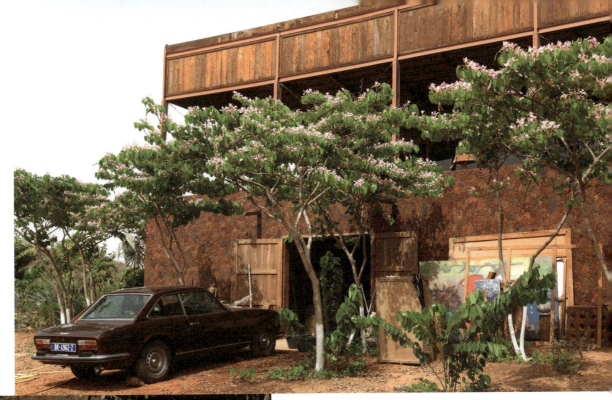

For people travelling through the arid landscape around Yène, Erik's lush gardens seem almost like an oasis. The minimalist house in the middle of the plot reflects European building traditions but also has a distinctive African feel. The large, reddish-brown bricks were brought from another part of Senegal and hand-cut into useable but still rough pieces of different shapes and sizes. They seem to be placed at random, almost as if they had landed in the walls of a perfectly planned architectural project simply by chance. The generous use of wood further adds to the earthy look and feel of this house. Erik built it in collaboration with architect Wim de Vos. "Wim had previously designed my home in Amsterdam, and he received an award for that design. He is a good architect. I do have to walk down a few steps to get from the kitchen to the most important space – the outside terrace – but other than that, it's a great house: spacious and sheltered, airy and transparent."

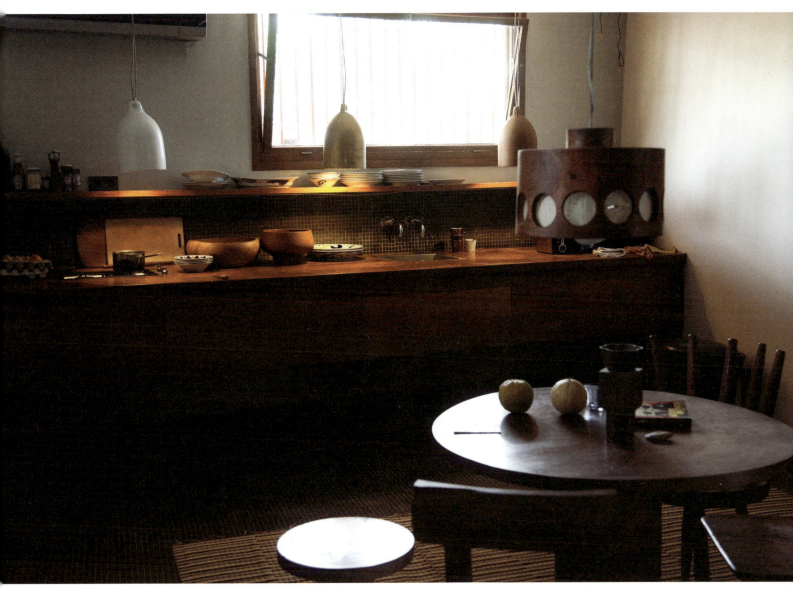

Erik is currently working on building a second house in a 3-hectare orchard across the road, next to the workshop he built there years ago. About forty local skilled workers are employed on the site: choppers, woodworkers and masons, as well as craftsmen making baskets and stools from the heaps of refuse and old shoes that wash ashore. The stools and other polished wood objects are made by boys from the Diourbel area, who grow up creating all kinds of objects from wood. "They are true artists who would amaze European artists if they saw them. At our workshop, we also create sculptures for Dutch artist Hans van Benthem (who is well-known for his magnificent chandelier); these have been exhibited at places like the Gemeentemuseum in The Hague. We have partnered with Hans in the past to take part in the Dakar biennial art fair together. You might not expect it, but there are a lot of cultural activities in Dakar – mostly organised by and for white expats, but still."

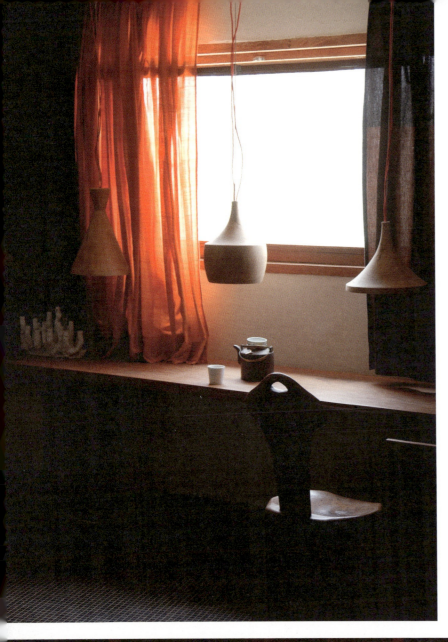
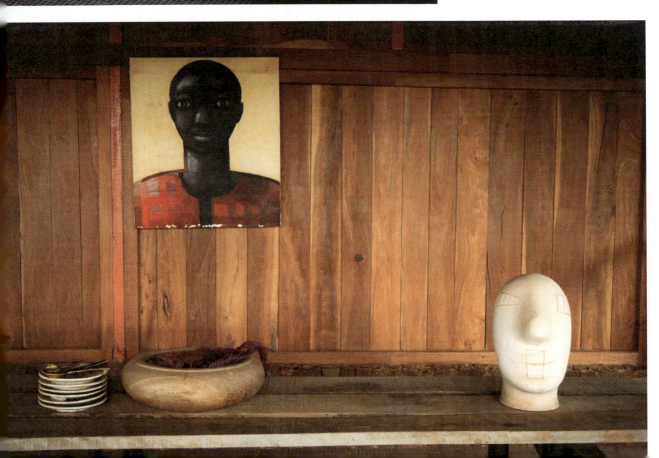

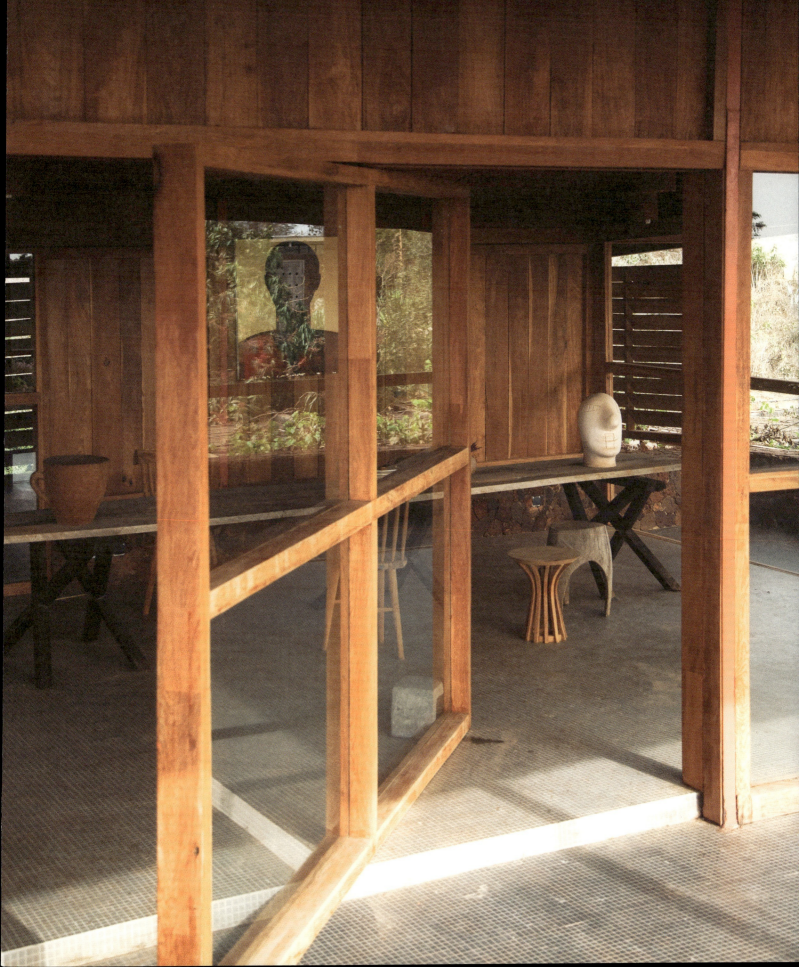

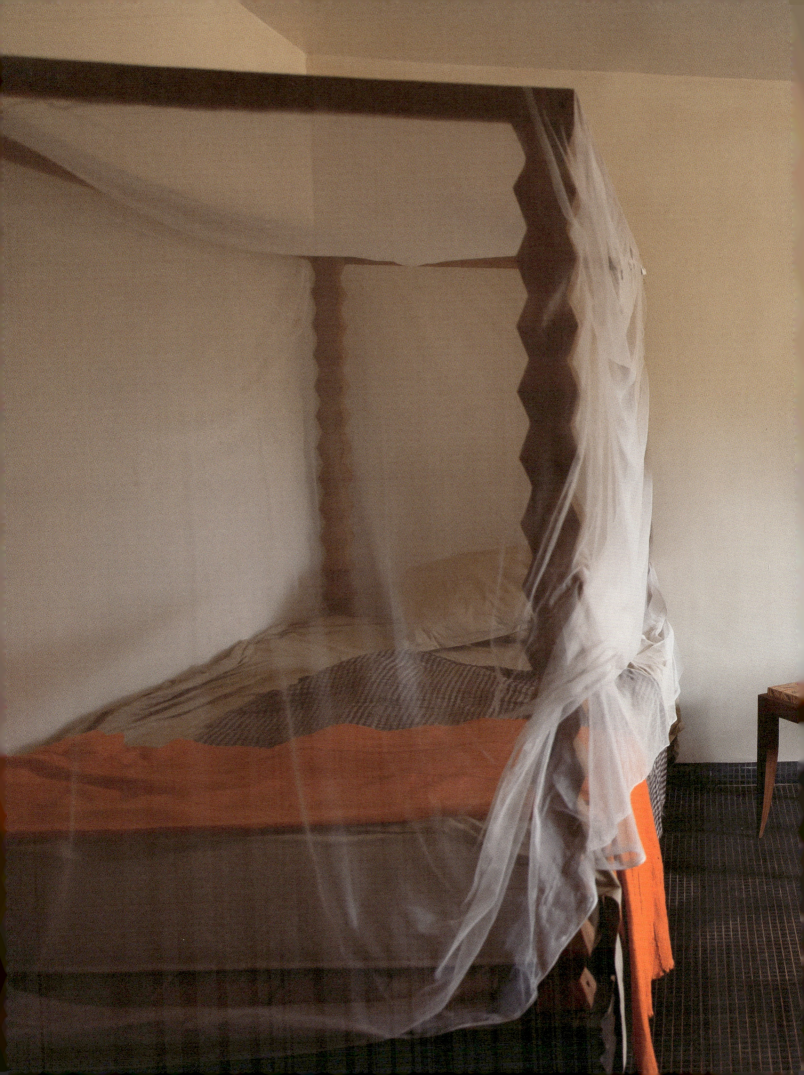

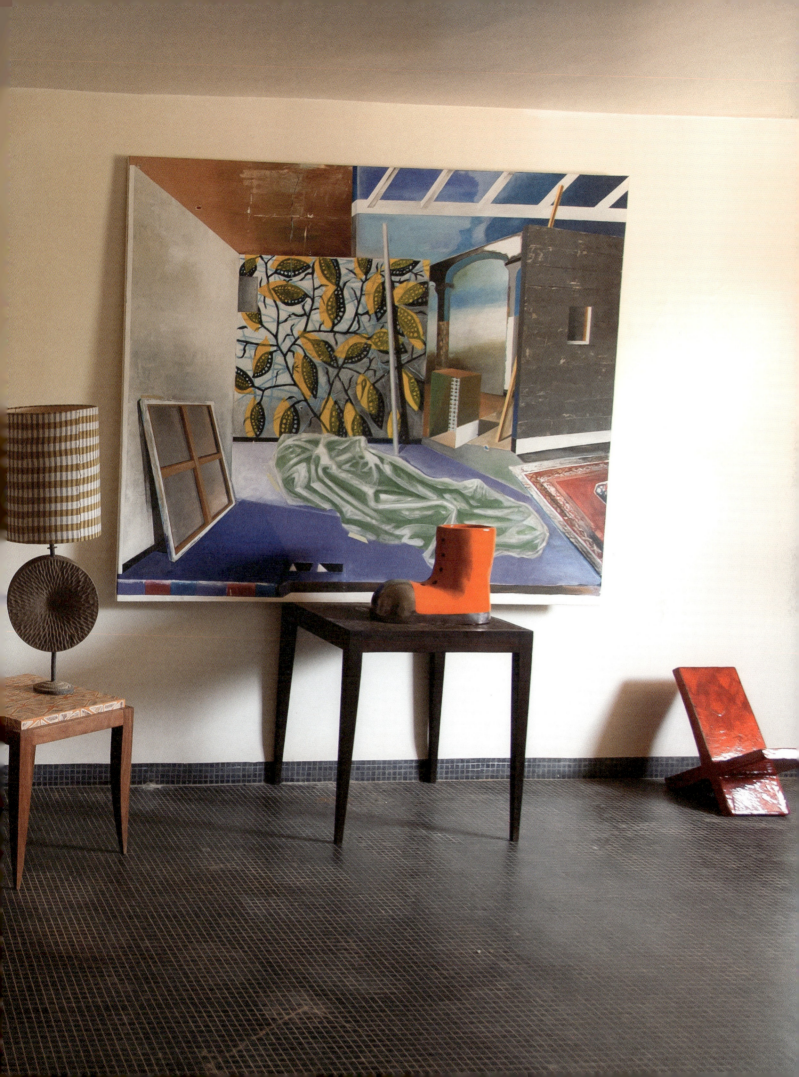

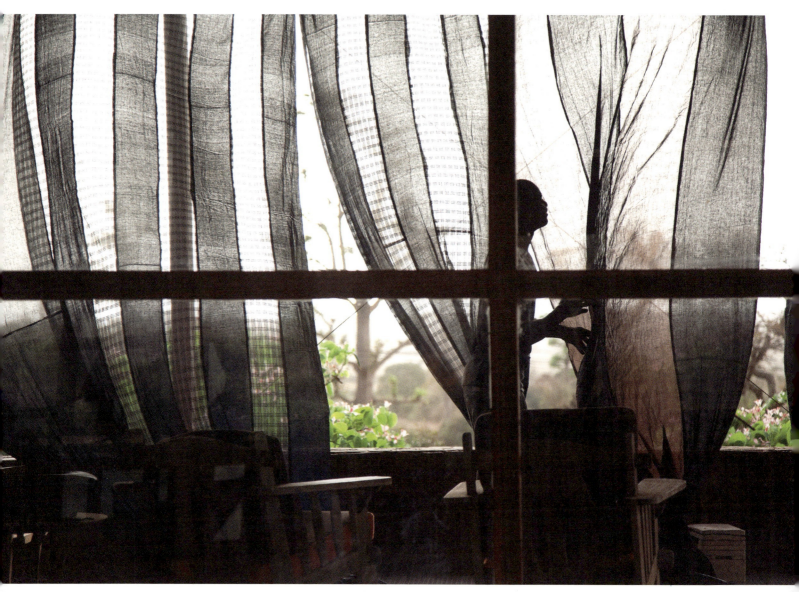

There's no need to feel lonely in Yène: it's an easy car ride to vibrant Dakar, where Erik still owns an apartment. He emphasises that Yène is anything but remote. Even when he is at home, Erik is almost never alone: "I wish! Most days, I have talked to a dozen people before 10 am: about the building work on my new house, about the garden, about the workshop, about my car that needs to be repaired again and so it goes on. The downside is that sometimes everybody seems to be wanting something from you. On the other hand, you learn to deal with time differently here. In Africa, the concept of time is much more fluid, not measured so strictly. That is a welcome change; after 45 years of living in Europe, I was done with it."

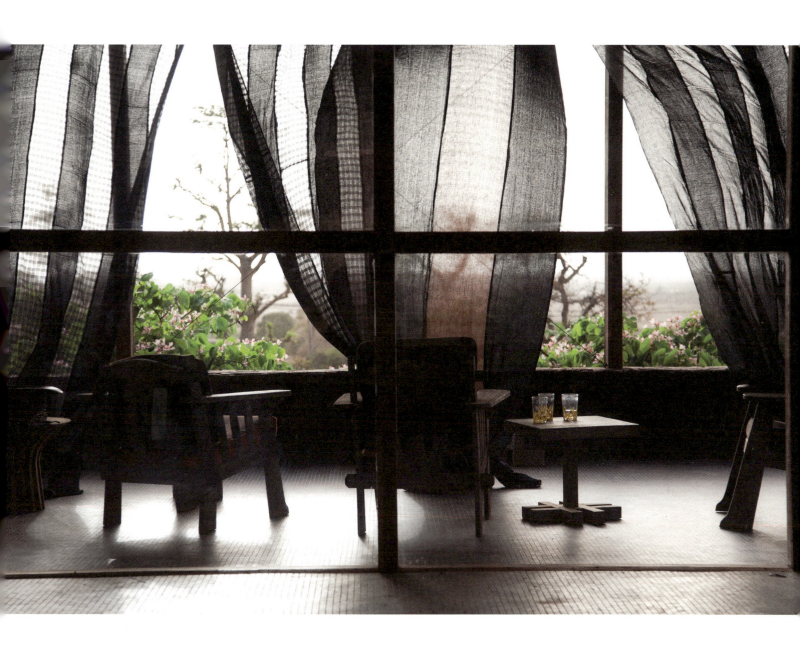

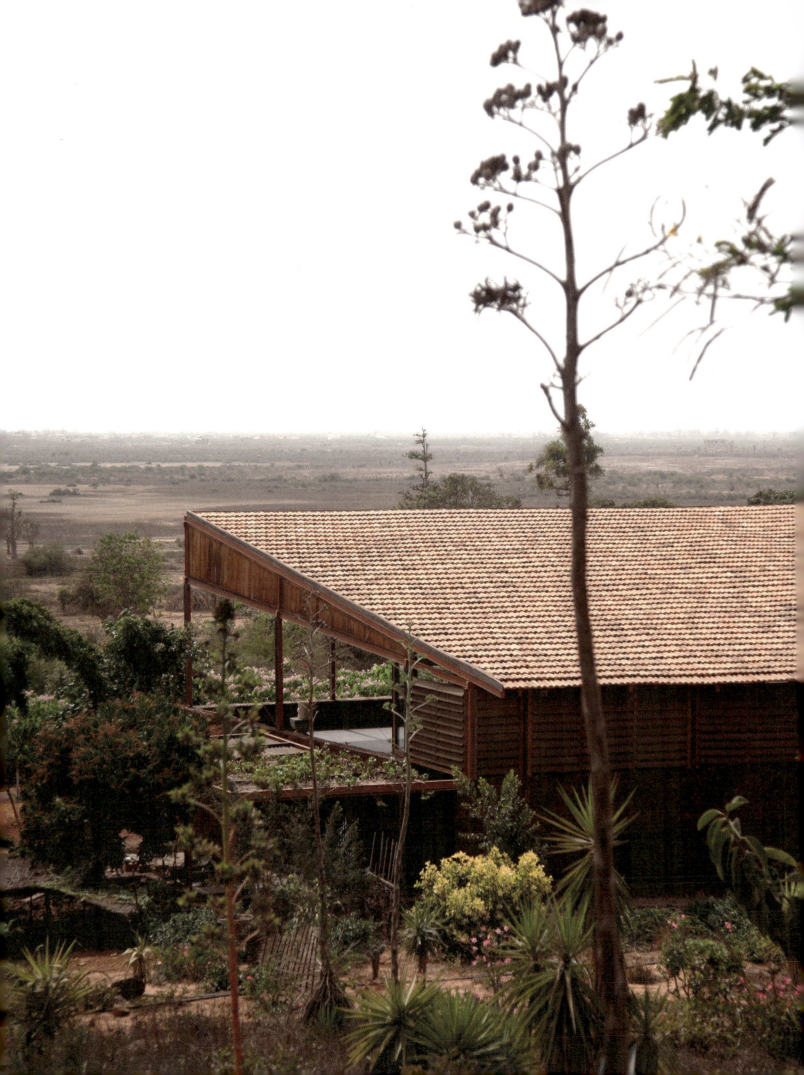

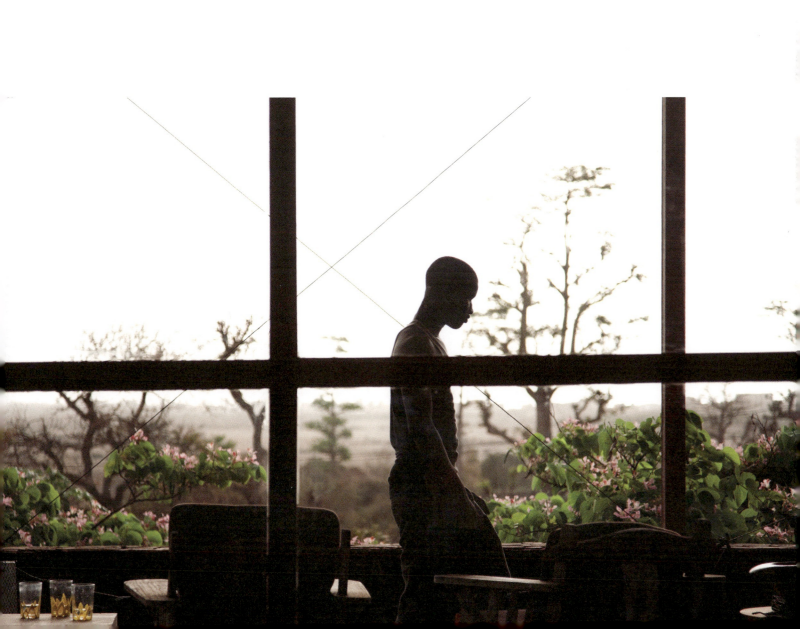

LAMU

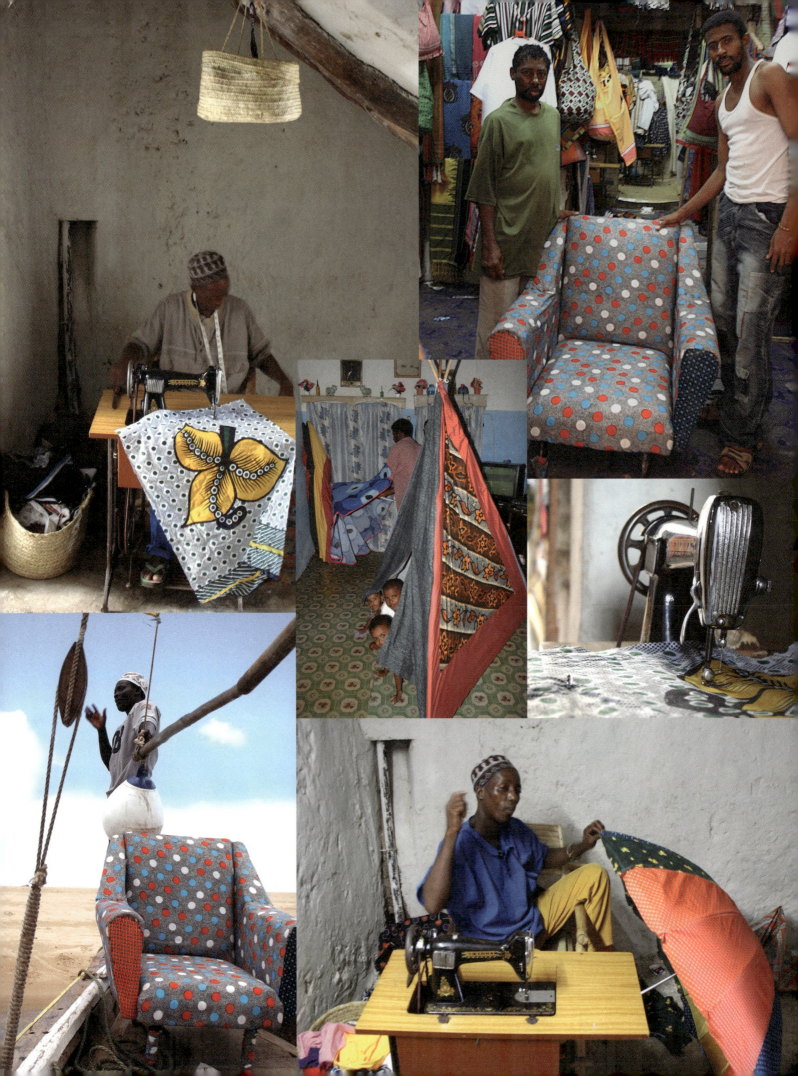

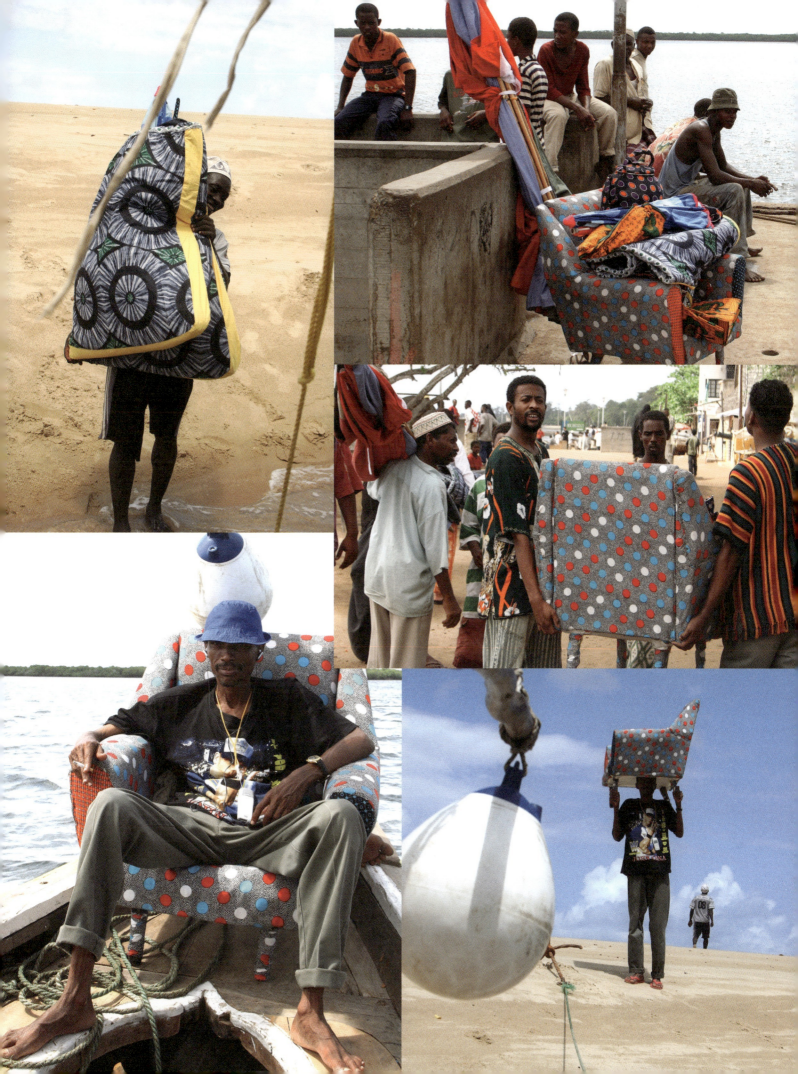

WHERE?

Lamu, an authentic Swahili town on the archipelago of the same name in the Indian Ocean, just off the north coast of Kenya. The islands look like paradise, with the azure ocean and mangrove swamps. The town itself has been designated a World Heritage Site by UNESCO. Lamu's culture is unique, a one-of-a-kind mix of African and Arabian that is particularly reflected in its poetry, architecture and woodwork.

"Like almost all our trips, our journey to Lamu was the result of a chance meeting - in this case, with a Dutch woman married to a Kenyan - and a spontaneous decision to get on a plane. We left with just a suitcase full of fabrics and the idea to use them for a shoot. Once we arrived in Lamu, we were inspired by its unique atmosphere. Frank set to work with the fabric that he brought in his luggage and especially some colourful fabrics we found in the small stores on the island. We asked a few local tailors to help us to make our 'designs'. We had a few bags made, a tent, two umbrellas and we even had an old chair upholstered. It's in moments like these - when you start talking, negotiating, describing things - that an interaction takes place between the ideas we have and the place where we are. We enjoy just letting things happen: guides who happen to sit on a chair while we are on our way to a shoot, donkeys passing through... In the end, those are the situations that result in the most beautiful photos."

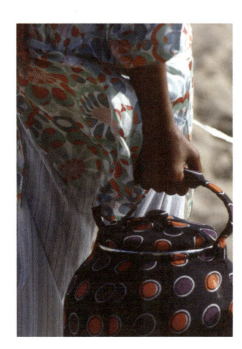

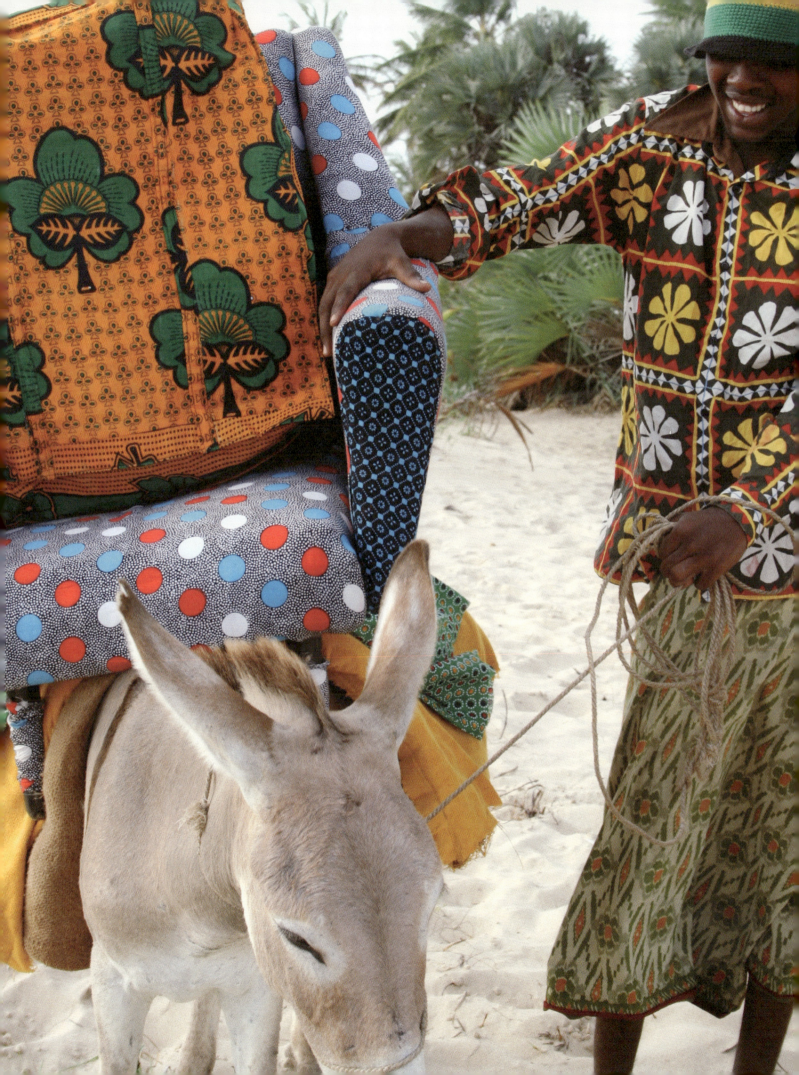

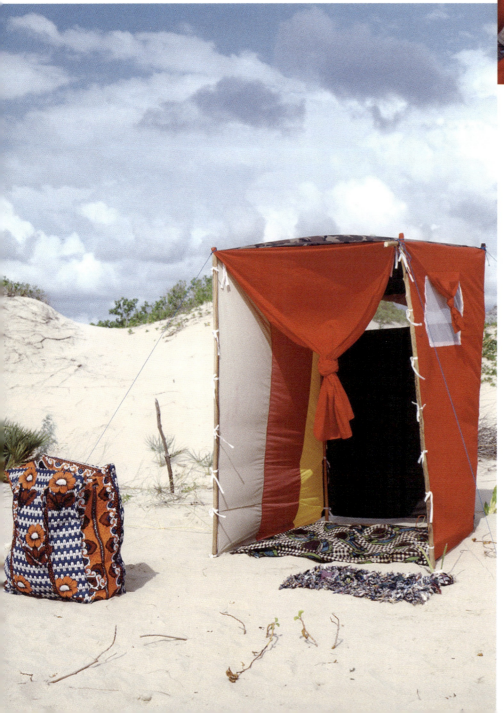

40

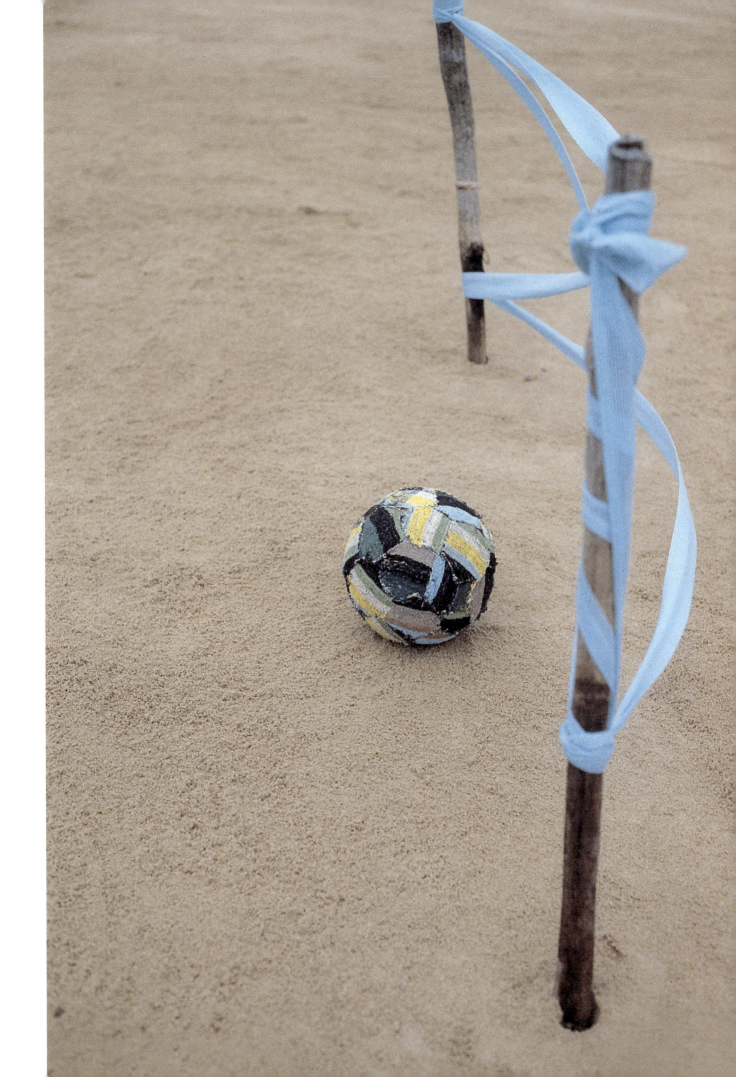

URUGUAY

WHO?

Andres Ferreyra is an architect from Buenos Aires.

WHERE?

Cabo Polonio, a tiny settlement on the Atlantic coast in Uruguay, not far from the Brazilian border.

Everyone who has been there agrees that Cabo Polonio is a magical place. It used to be a fishing village, with a few small buildings scattered around a small rock and amongst the sand dunes nearby. Life can be quite hard here, especially during the winter when Antarctic winds sweep along the coast. The locals are tough fishermen and they are the only ones who know how to survive here then. In summertime Cabo Polonio is a little bit of paradise, but the sea is still untameable.
This is the reason why not many tourists ever come there. There is no electricity - although you'll see the occasional solar panel or generator here and there - and no running water. The only way to get to the beach houses is by horse and cart or by four-wheel-drive truck. That's how Anders Ferreyra reached the place, some 20 years ago. People told him he was crazy, but he didn't care; he immediately fell in love with the impressive beaches, the unspoilt landscape and the special atmosphere that reminds visitors of a Garcia Marquez story. "The simplicity of it all is almost surreal. The fishermen make their own boats and nets, and they need very little to survive - a piece of driftwood, a nail... it all has value."

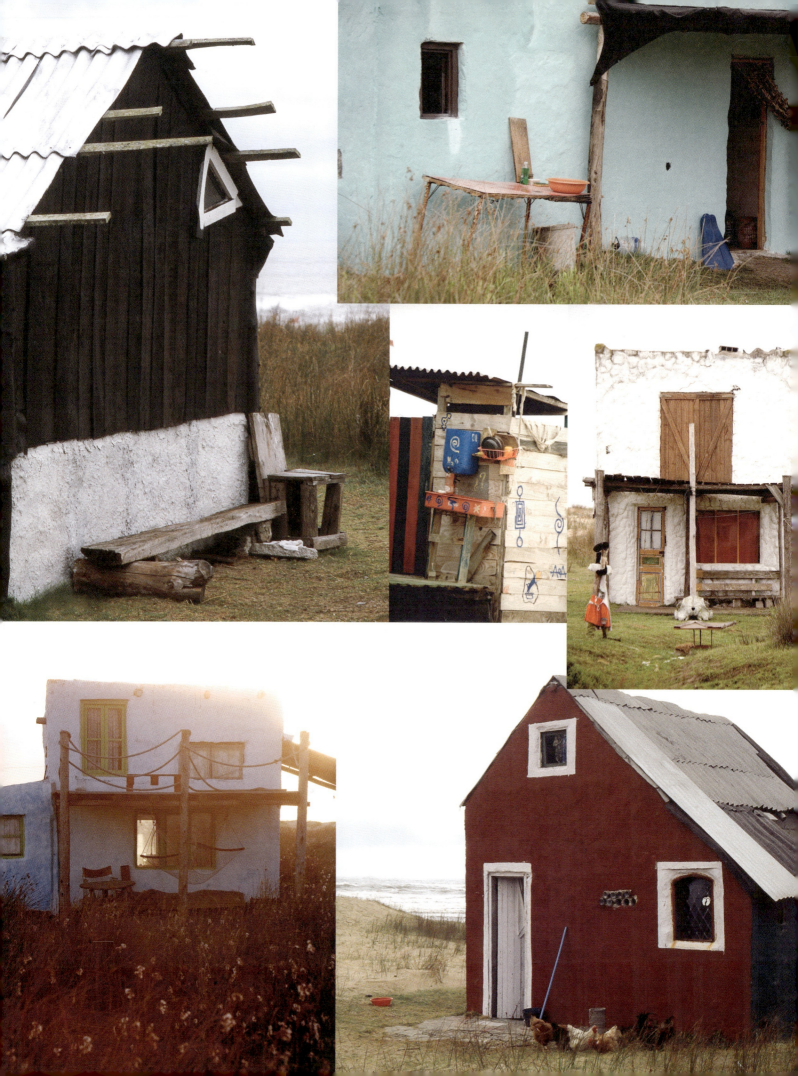

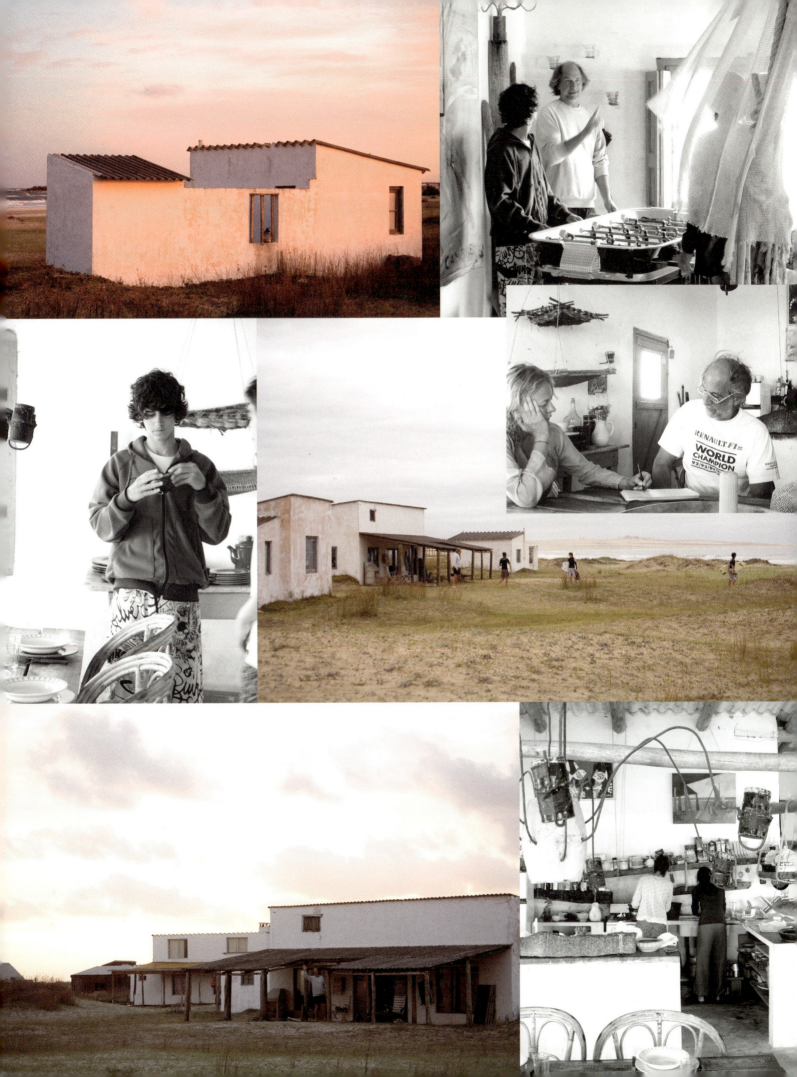

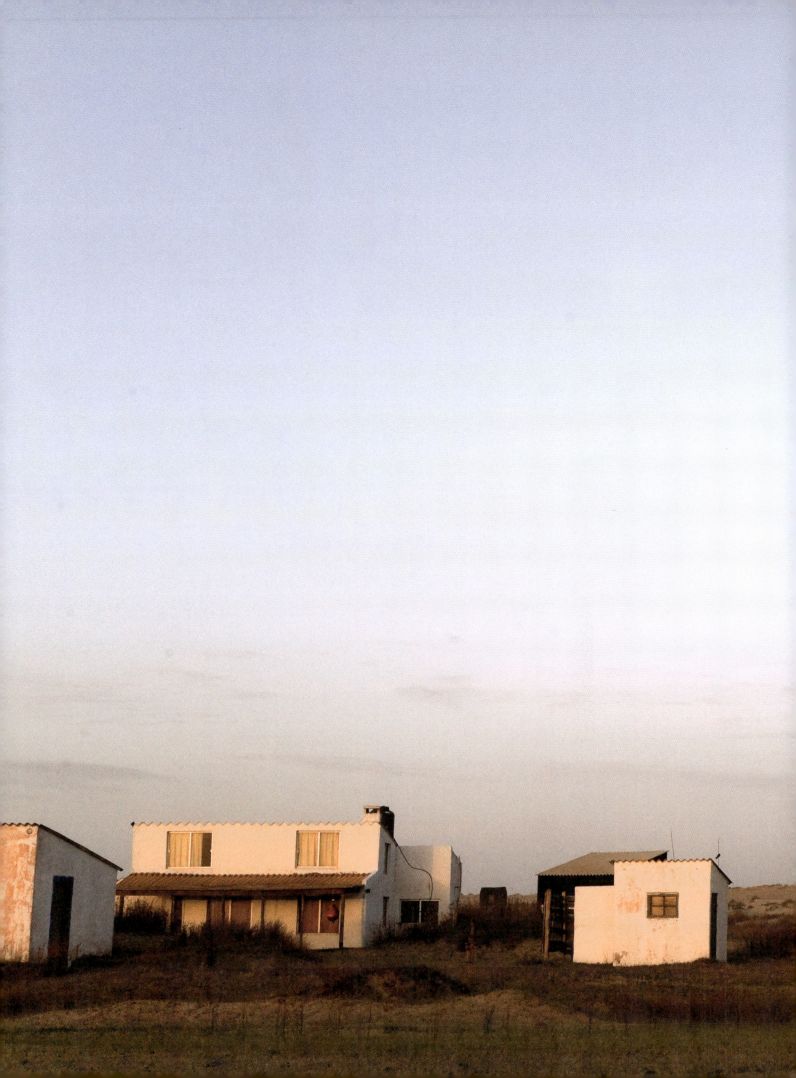

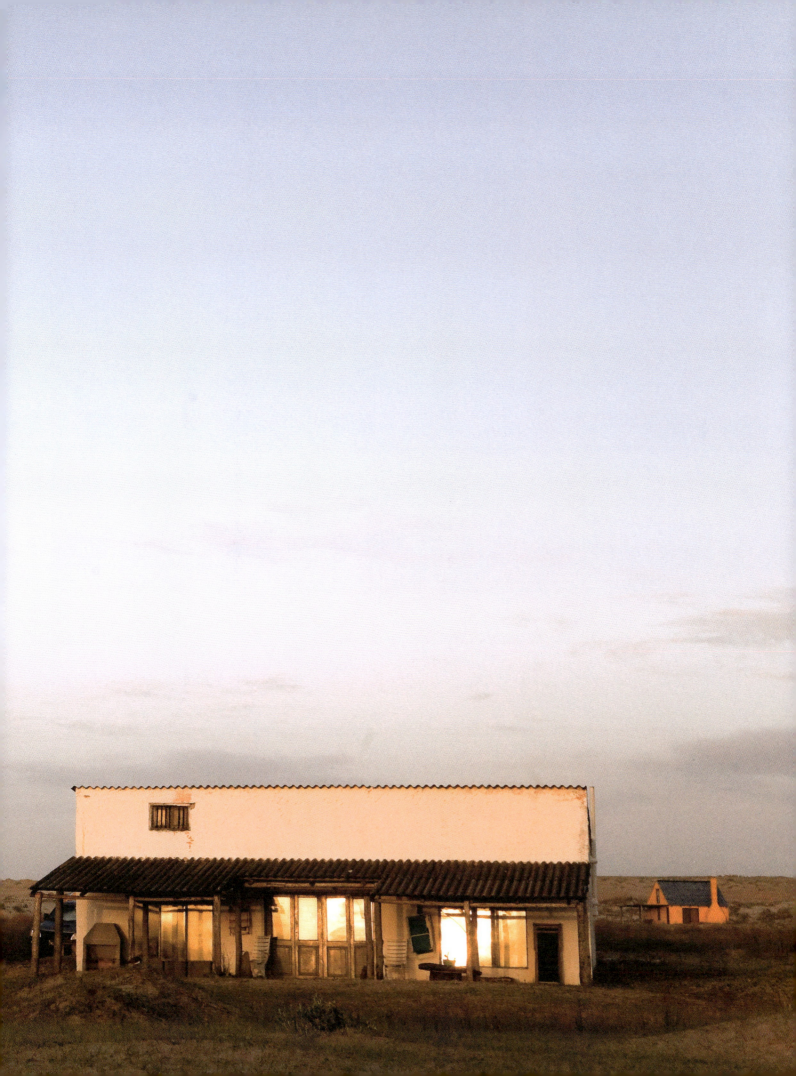

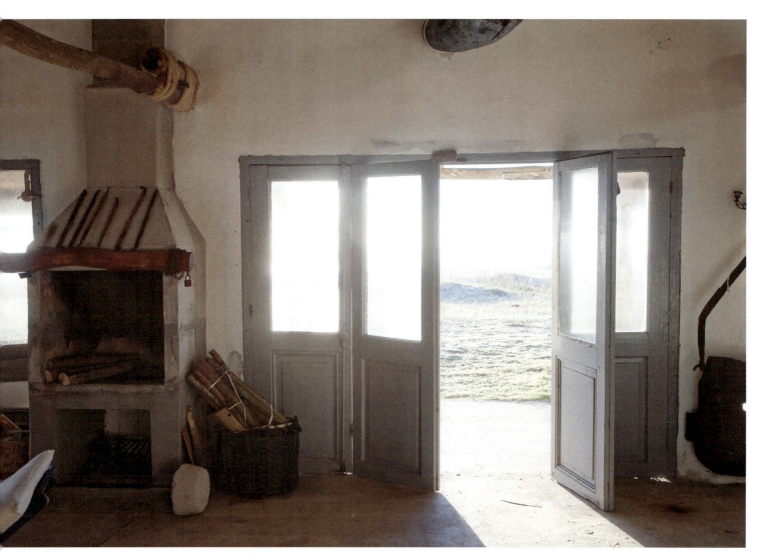

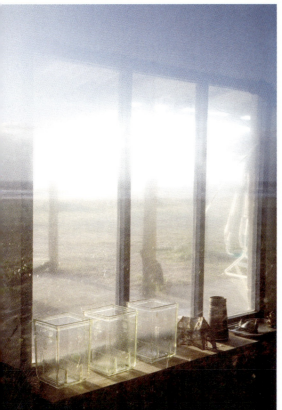

Their philosophy - honour the simple bare necessities - had a strong appeal for Andres. The beach was so special that he decided to build a house there, using just his hands and materials from the immediate environment. "I worked for a year until the house was complete. While construction was still under way, I combed the beach for things that I could use. The table is made of driftwood and the bench is an old leaking boat I bought for next to nothing from a fisherman." All over the house there are objects that Andres found on the beach, used as racks in the kitchen, for example, or serving as occasional tables or decorative sculptures. Another special feature in the house are the paintings, made by Andres' artist friends; they are very precious to him. Nevertheless, the view is what matters most: Andres intentionally positioned the front of the house in such a way that he could see the moonlight on the water.

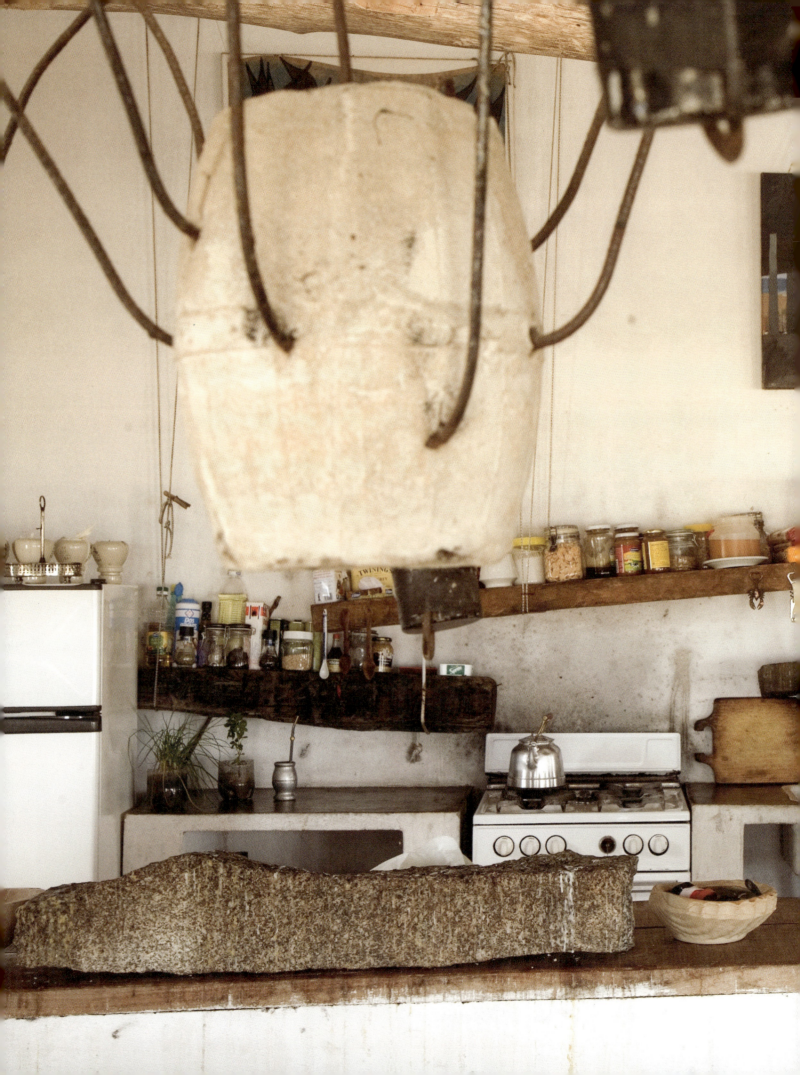

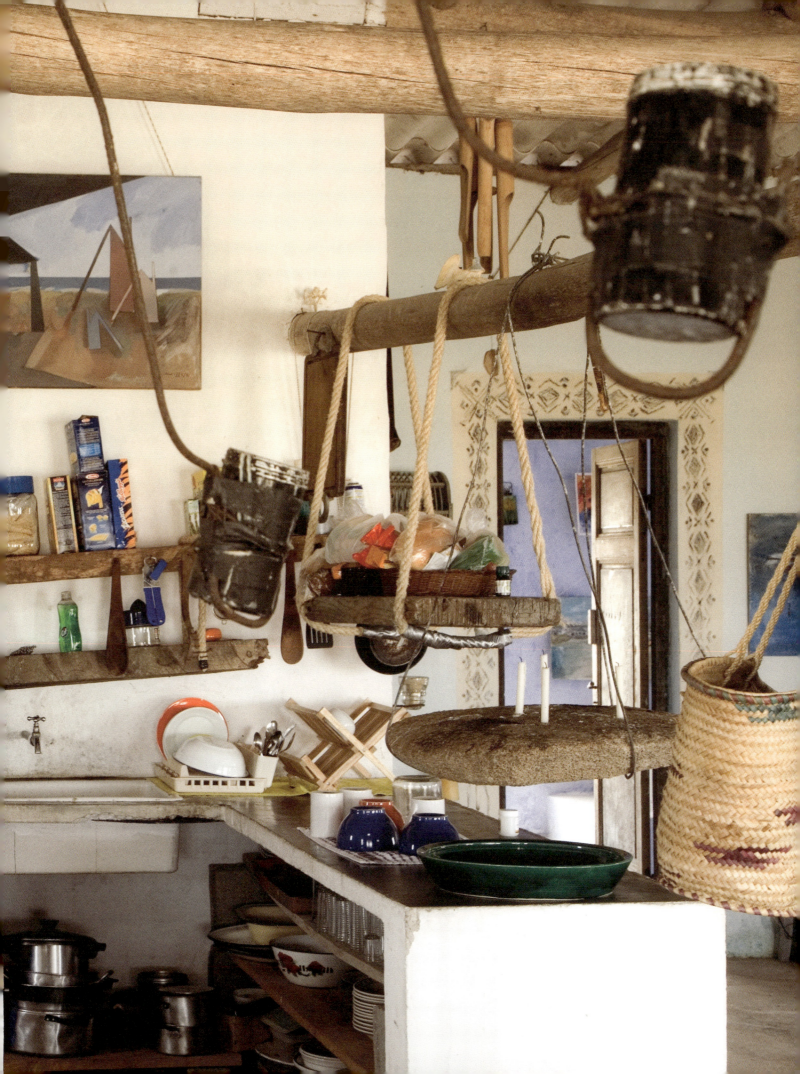

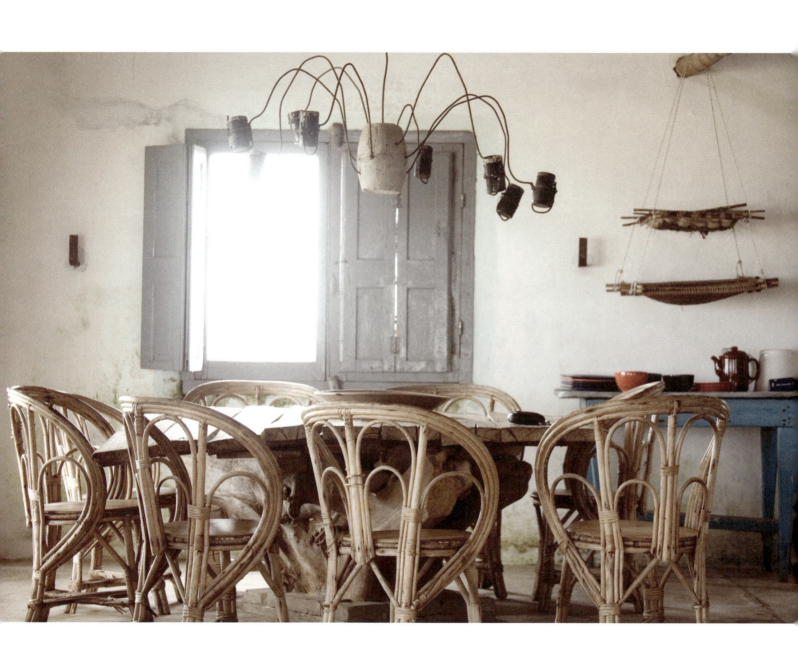

The enchanting view over the ocean looks like a painting in itself. It is one of the reasons why Cabo Polonio is such an inspiring place. Also, the wildness of nature here and the sense of being far away from civilisation are unique - this is what makes Cabo Polonio a sanctuary that sparks the imagination. Having a house there has been an enriching experience for Andres. He goes there every summer to rest and recuperate, enjoy the peace and quiet, relax and eat fish with like-minded friends and most of all to simply spend time alone, in harmony with the environment.

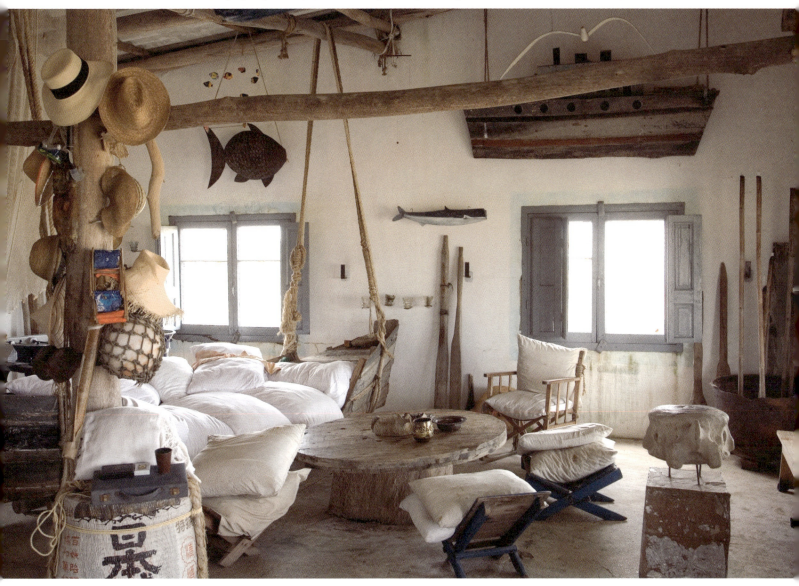

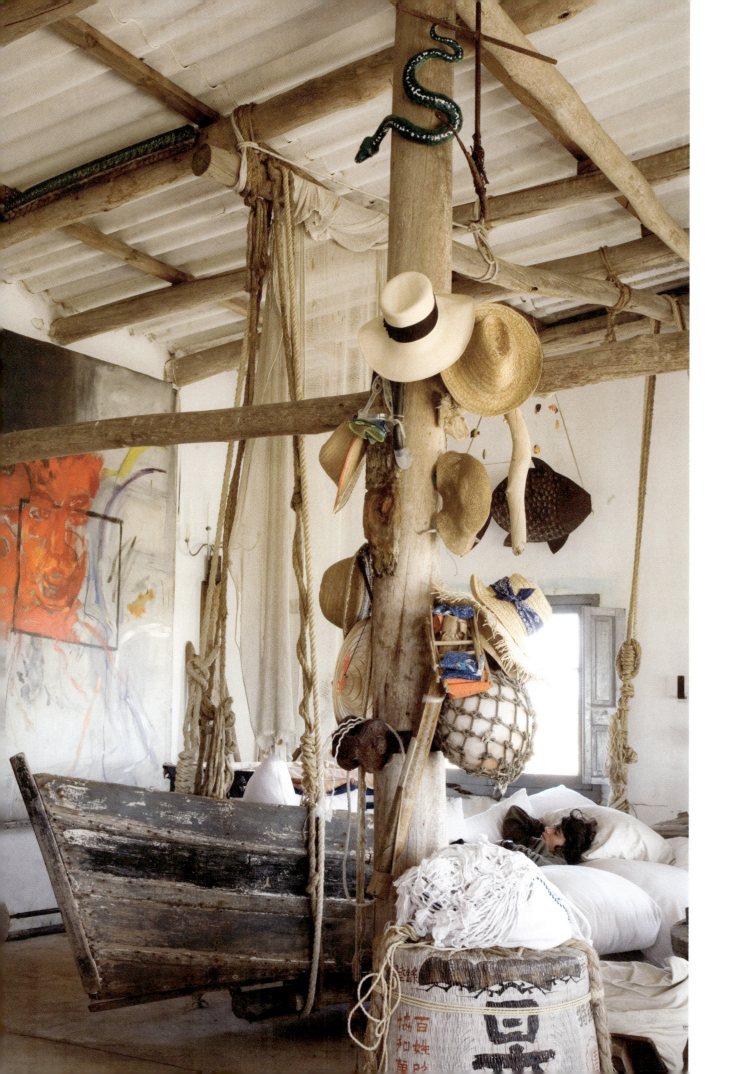

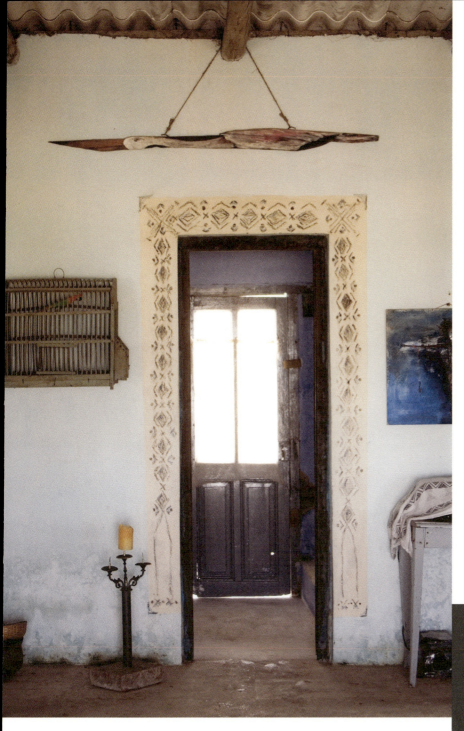
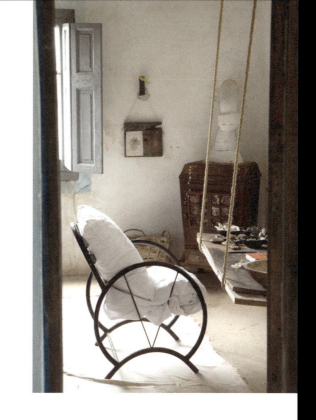

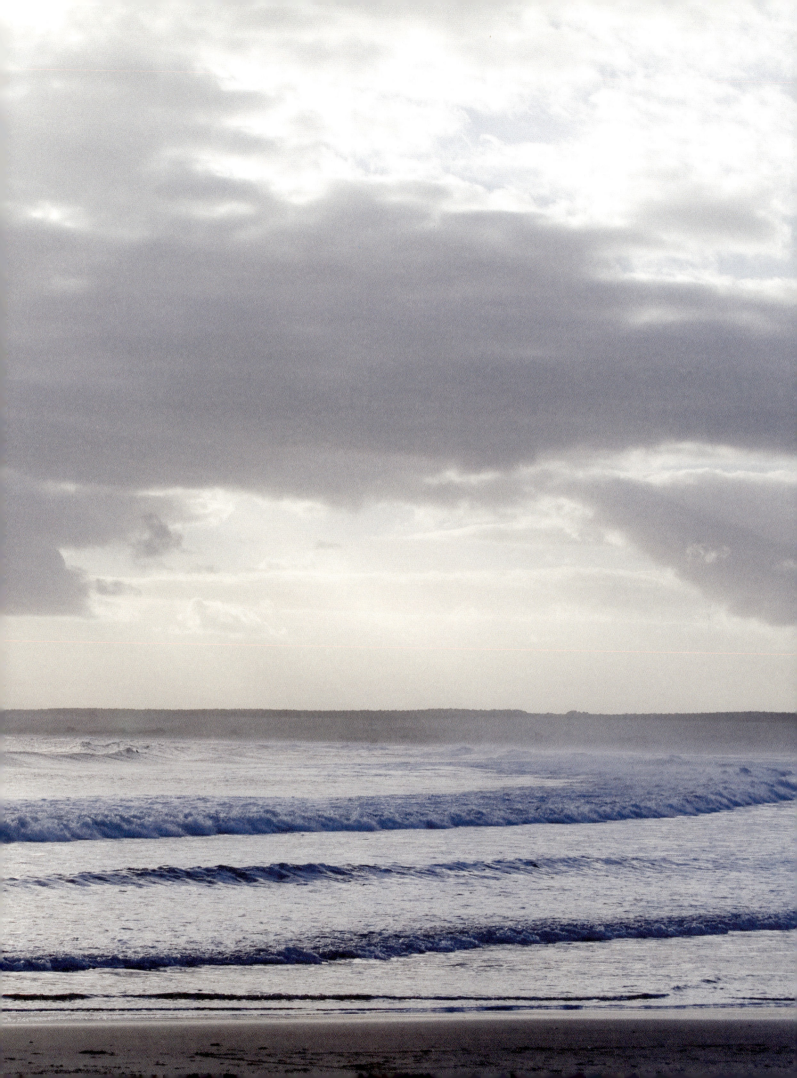

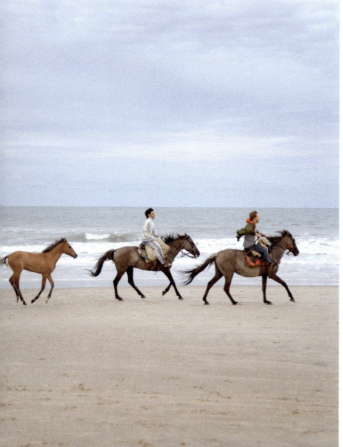

Andres was a Cabo Polonio pioneer: the first visitor to build his home there. Many more have followed in his footsteps over the years - people with a sense of adventure looking for freedom in an untouched environment. They have built huts, houses and other structures, casually spread out among the dunes. At times it is reminiscent of a campsite or hippie colony. One of the most special houses of all is situated slightly higher up than the others. It belongs to Mariano Moriguer and Gabriela Saludes, a young couple from Buenos Aires. They got to know 'El Cabo' when they rented a house there during their first holiday together. They fell in love with each other and also with the place, and decided to buy a plot of land. The house they built there is little more than a single room, cleverly and efficiently decorated: no luxury, nothing expensive, but it is done with generous love and a superb sense of style. They create beautiful still lifes from small objects that wash up on shore, and although their crockery seems to consist of random pieces, the collection was actually carefully selected with an eye for detail, harmony and design.

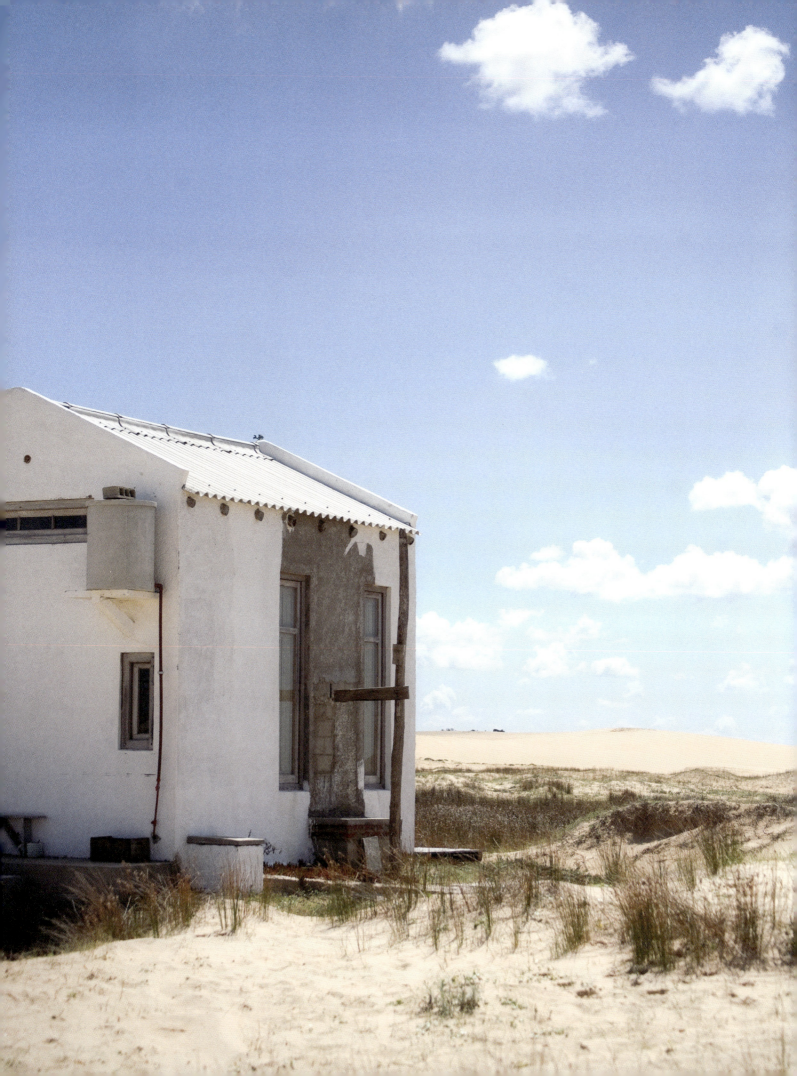

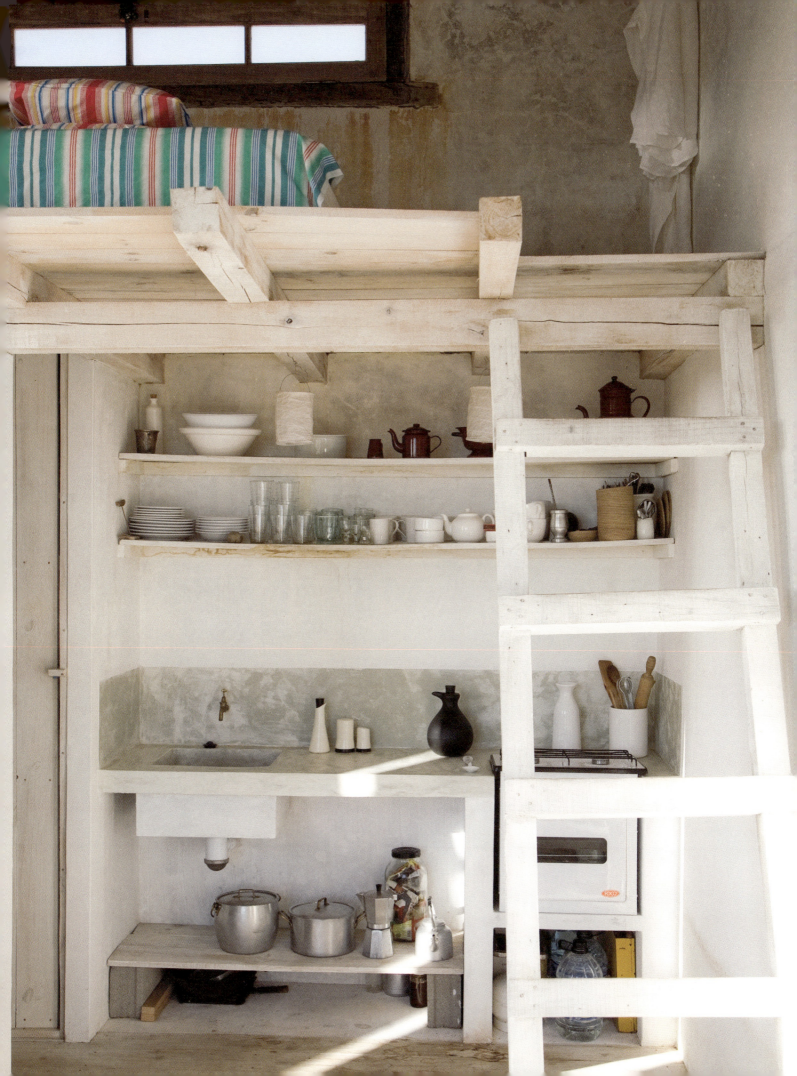

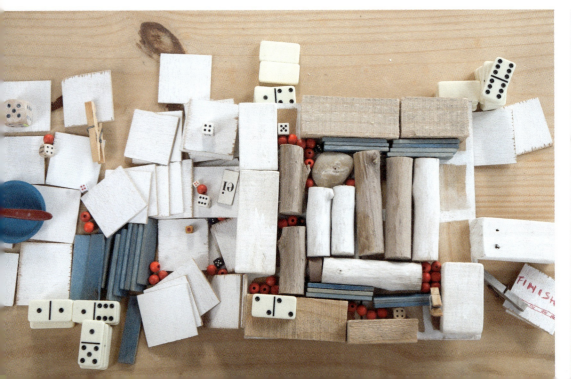
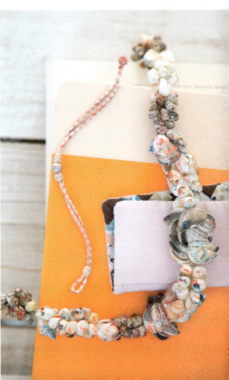

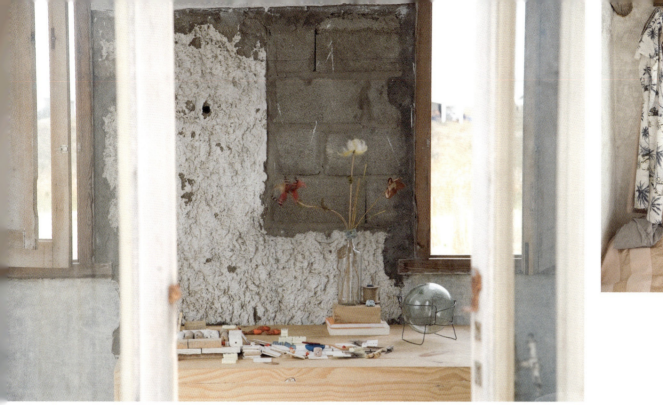

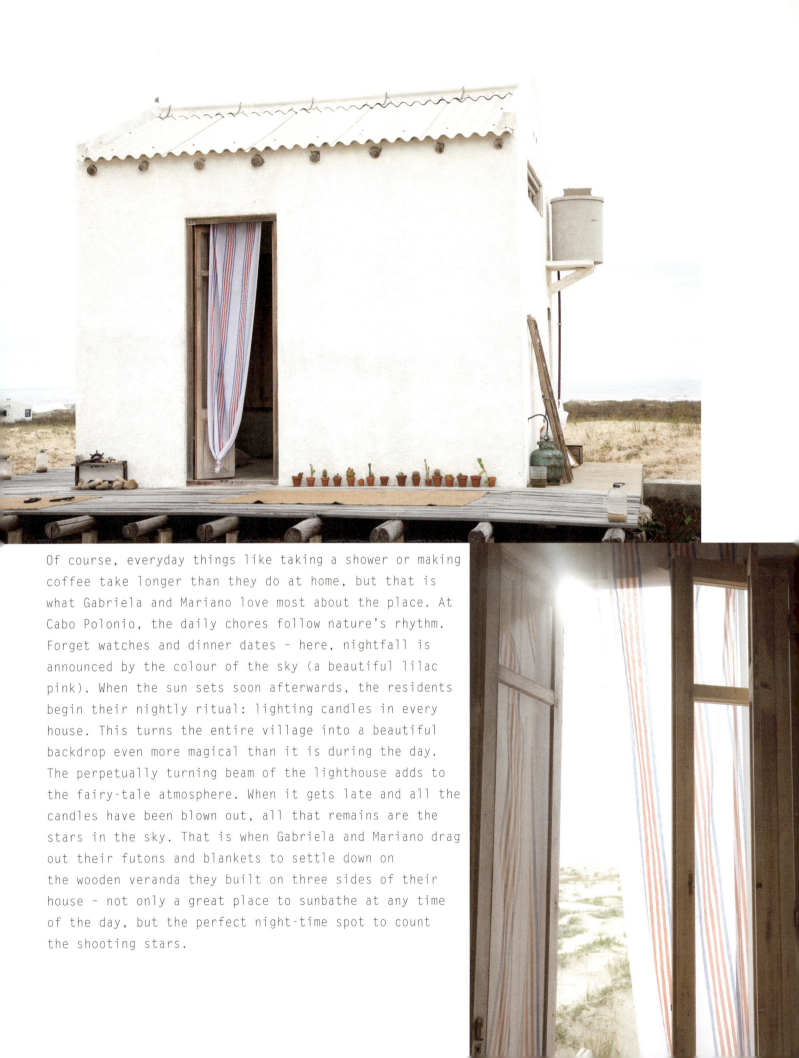

Of course, everyday things like taking a shower or making coffee take longer than they do at home, but that is what Gabriela and Mariano love most about the place. At Cabo Polonio, the daily chores follow nature's rhythm. Forget watches and dinner dates - here, nightfall is announced by the colour of the sky (a beautiful lilac pink). When the sun sets soon afterwards, the residents begin their nightly ritual: lighting candles in every house. This turns the entire village into a beautiful backdrop even more magical than it is during the day. The perpetually turning beam of the lighthouse adds to the fairy-tale atmosphere. When it gets late and all the candles have been blown out, all that remains are the stars in the sky. That is when Gabriela and Mariano drag out their futons and blankets to settle down on the wooden veranda they built on three sides of their house - not only a great place to sunbathe at any time of the day, but the perfect night-time spot to count the shooting stars.

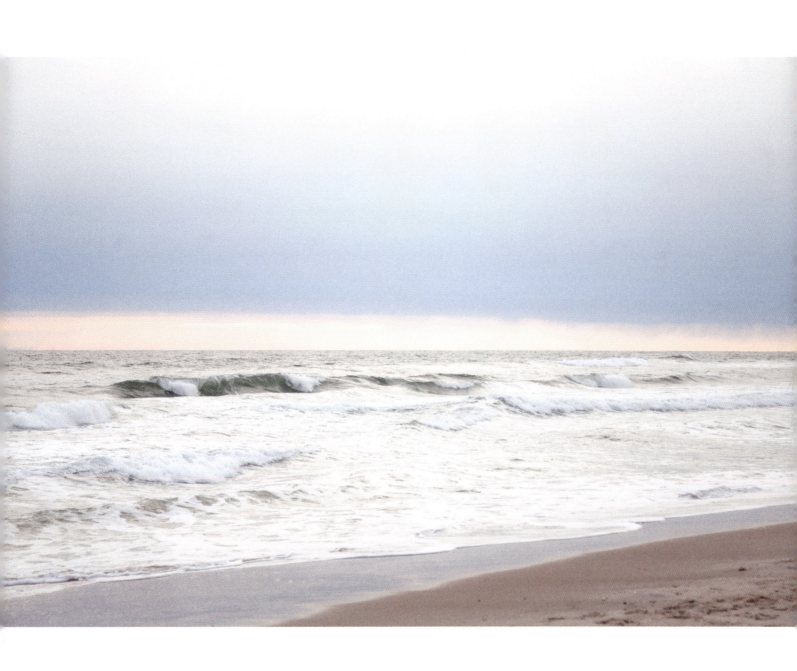

WHERE?

Off the coast of the Arabian Sea, in the Indian State of Goa.

"Provincial India can be very intense: it is always lively and busy. We were longing for peace, sand and water, which we found when we took a scooter ride to a stretch of beach with six small huts. There are several beaches like this one in the area; it is a popular destination for barefoot tourism. It's very different from the kind of tourism you see in places with a beach culture - this Indian beach is not for sunbathing, it's for getting in touch with nature. The huts are ideally suited to that purpose: very basic, with an outdoor shower and toilet and barely any interior furnishings. You can easily make it your own with just a few things and some lengths of fabric."

INDIA

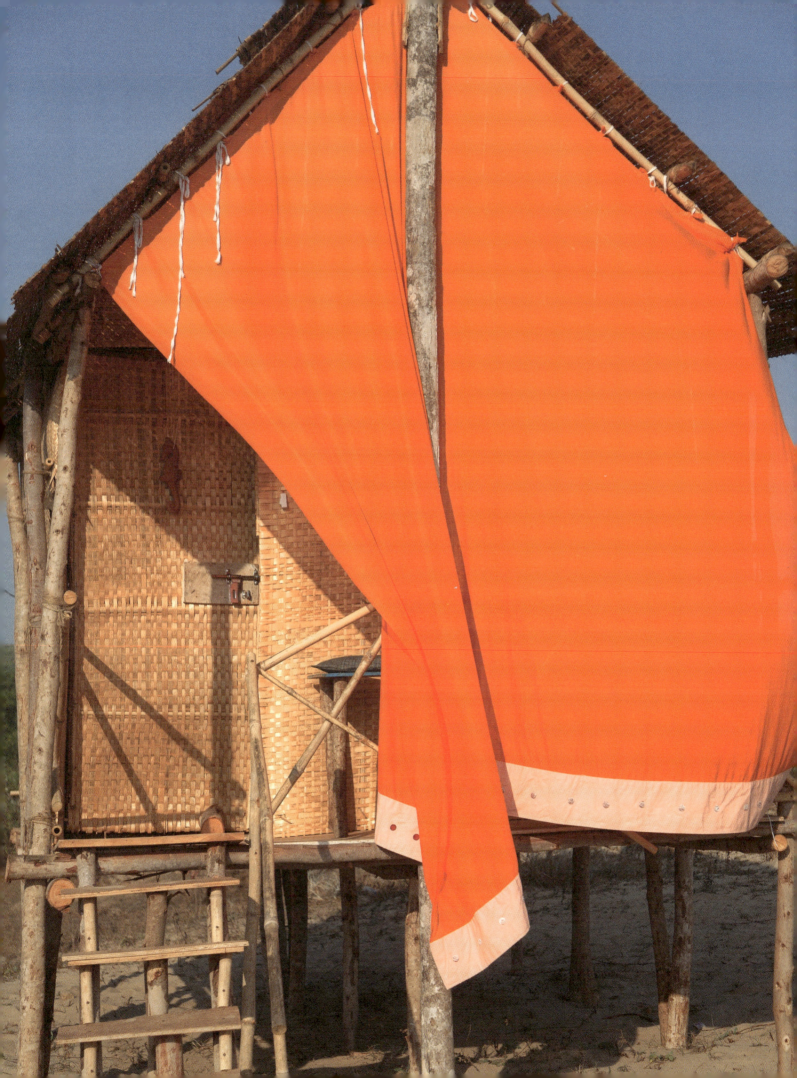

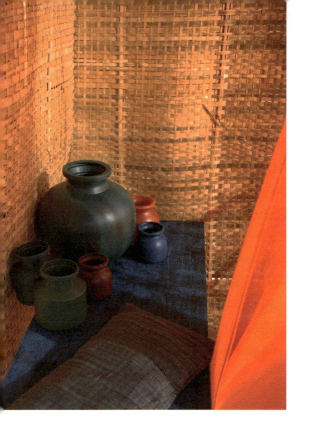

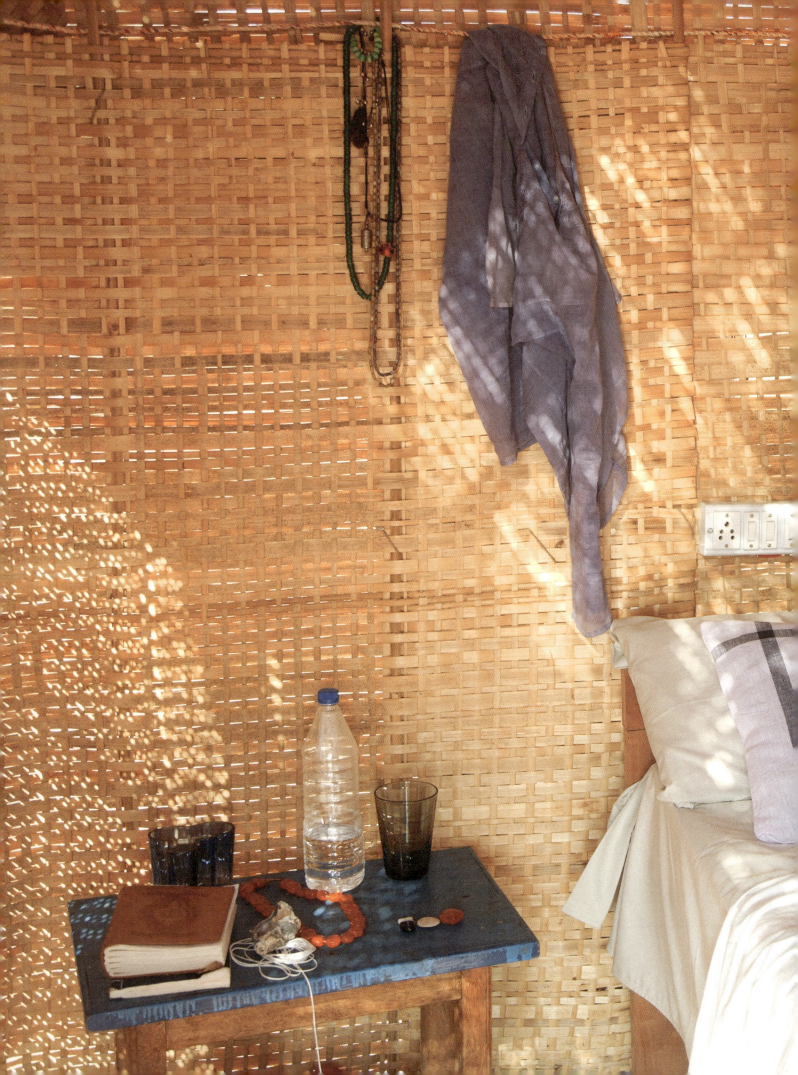

"The fish installation that we have created here represents what we care about when we travel together. This is what we share: the sense of freedom, the way the installation allows you to be open to things that happen by chance, the way you reach out to the locals by going out to look for objects... The installation is open to the elements and passers-by respond to what they see, and that is how you really connect to the place. It allows you to see the country in a different way: not as a tourist, but as part of a whole."

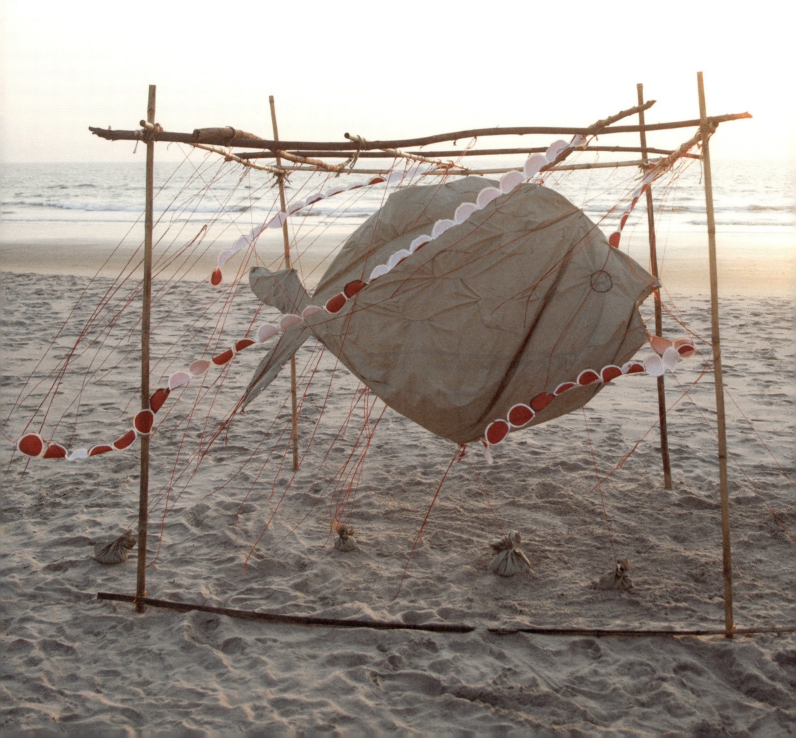

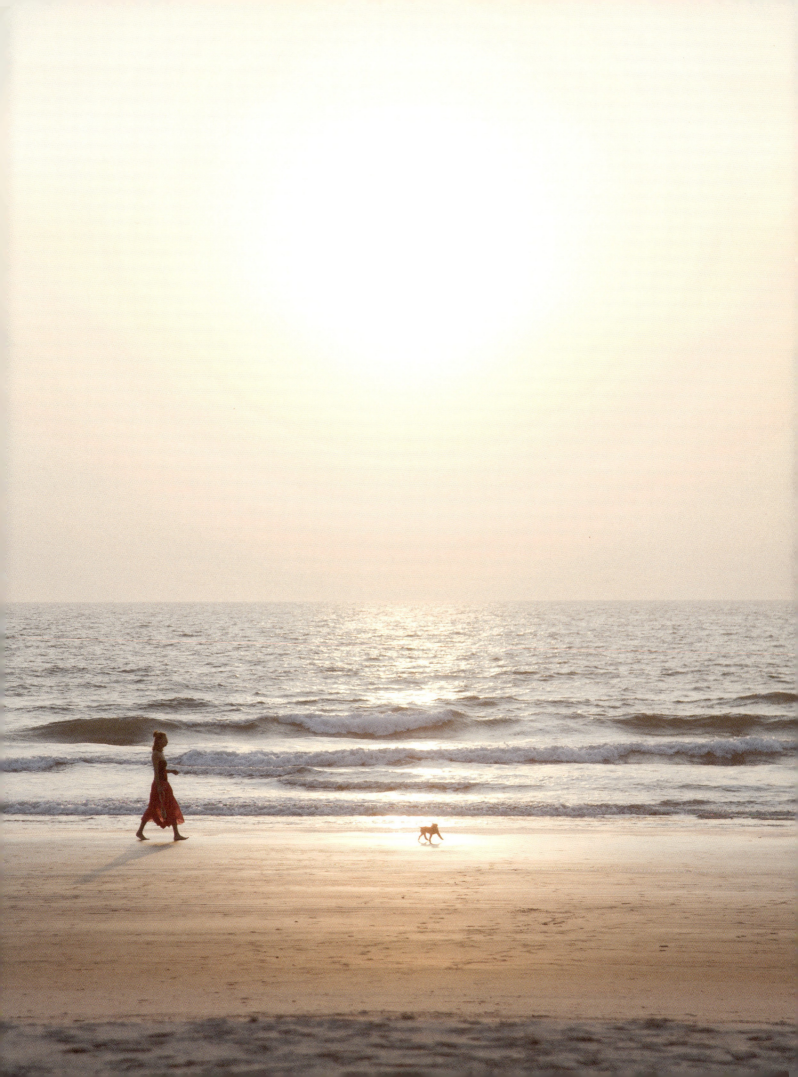

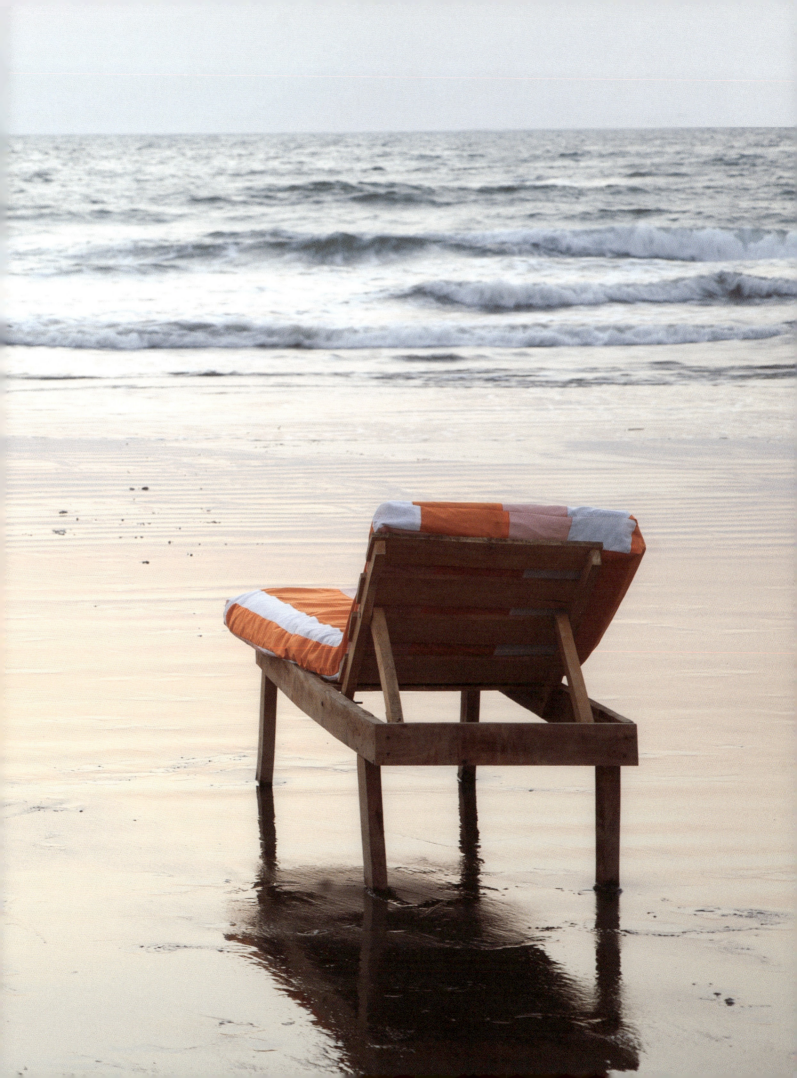

COLOMBIA

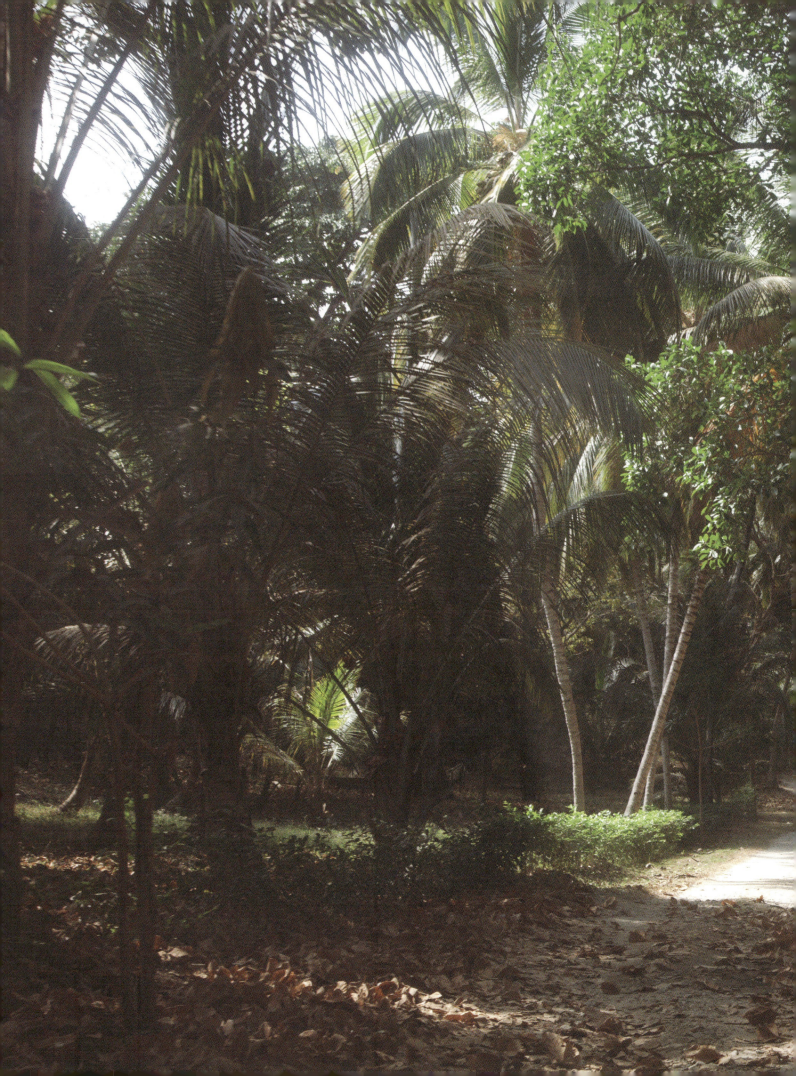

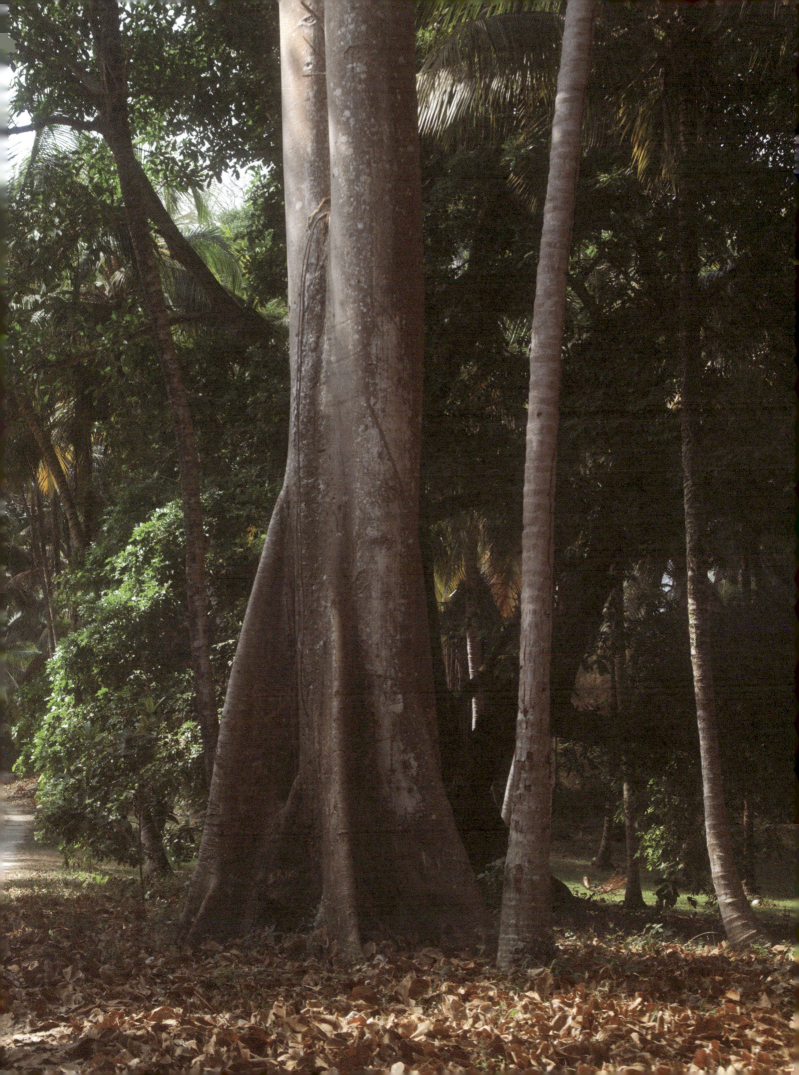

WHO?

Luis Fernando Gómez Mejía is a businessman.
When he is not at his cottage, he lives in a house in the Bogotá mountains.

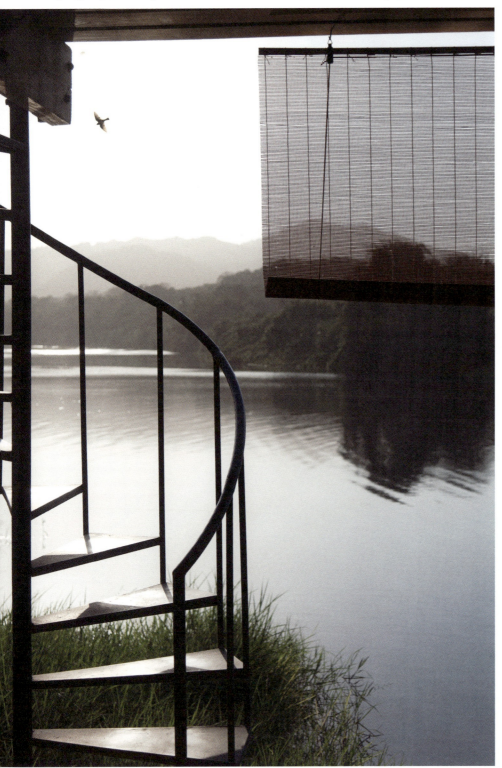
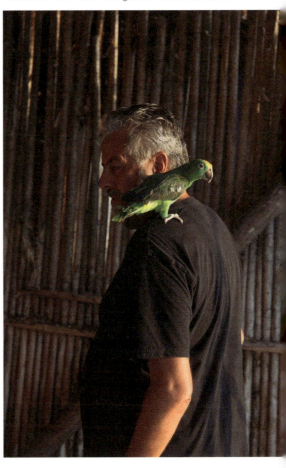

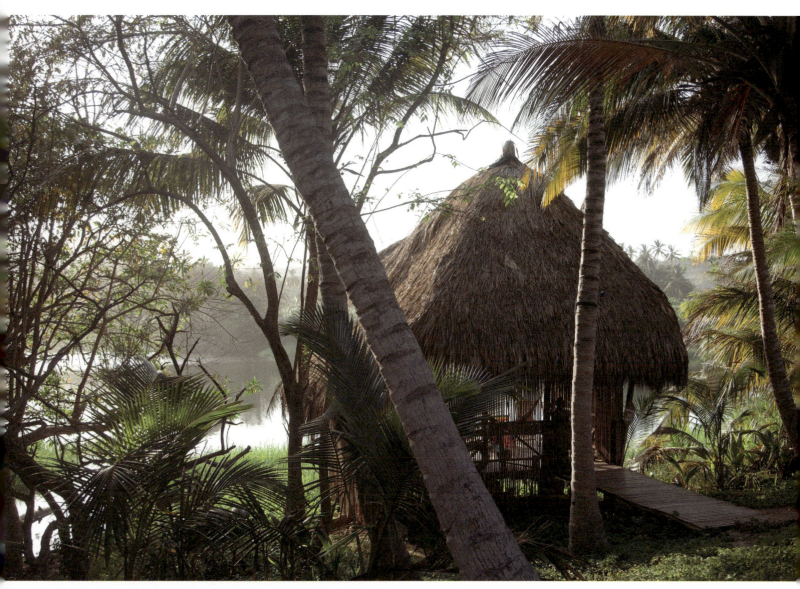

WHERE?

The Finca Barlovento estate, adjacent to the Tayrona National Park near Santa Marta, in Colombia.

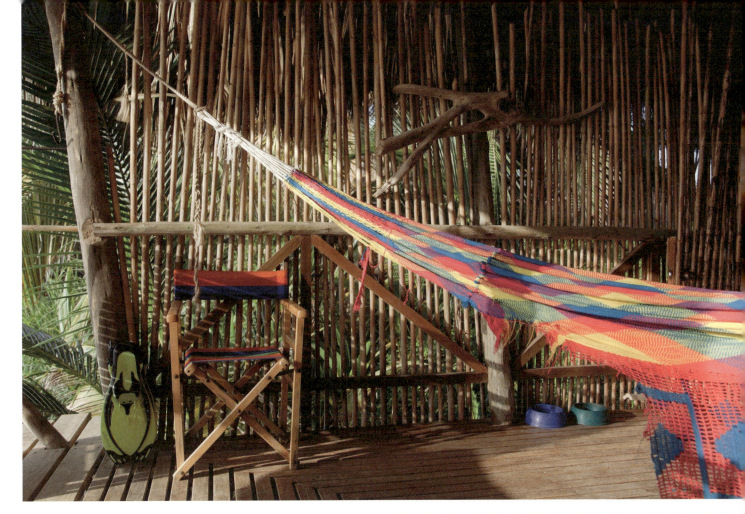

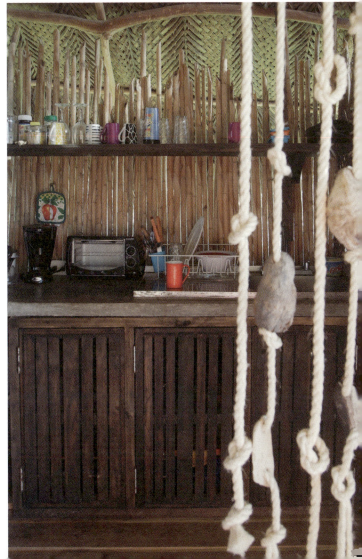

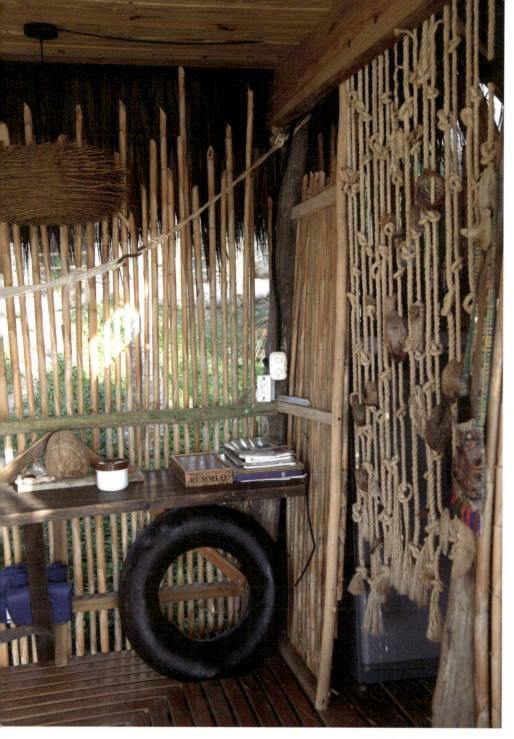
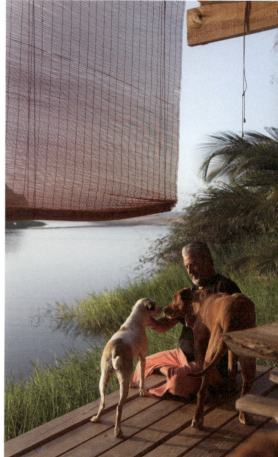

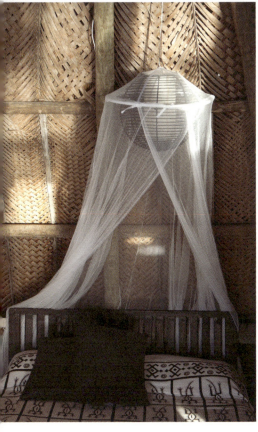
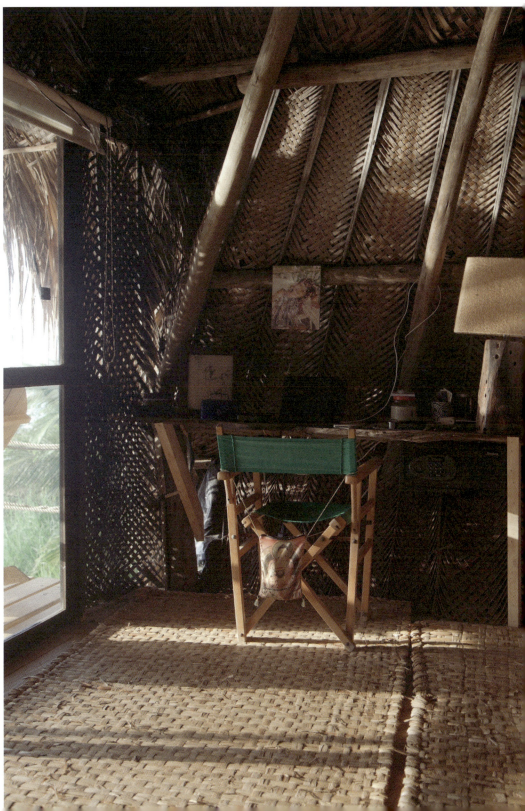

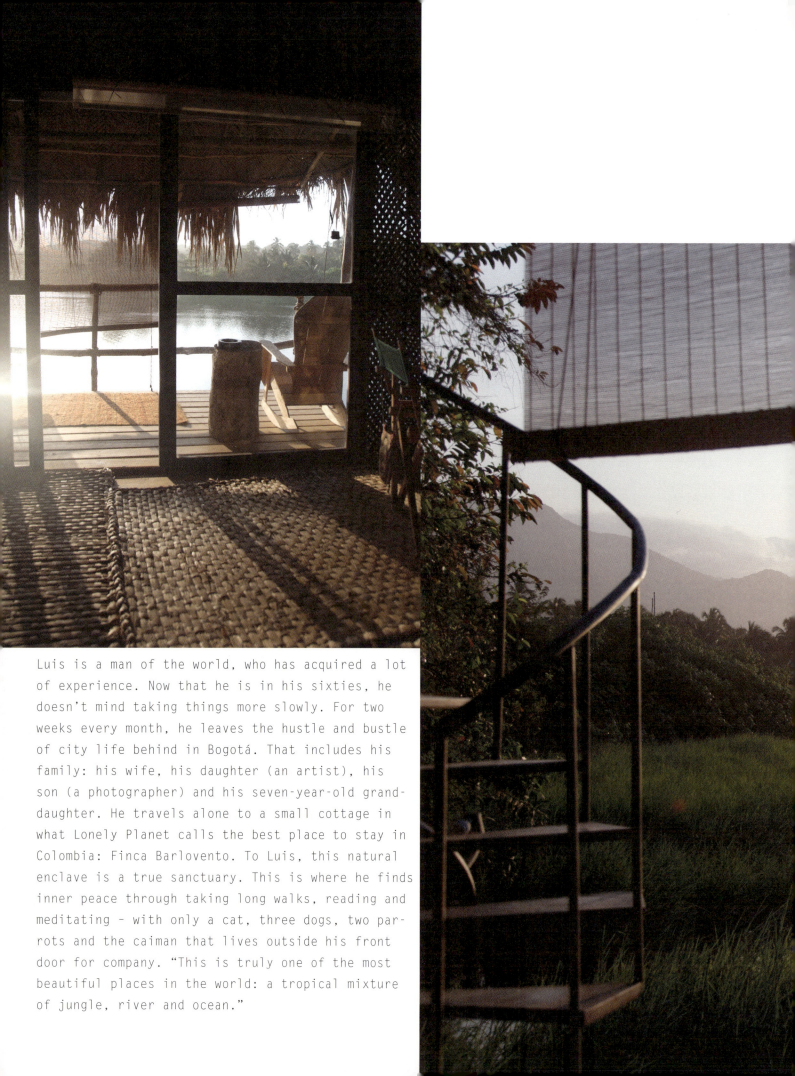

Luis is a man of the world, who has acquired a lot of experience. Now that he is in his sixties, he doesn't mind taking things more slowly. For two weeks every month, he leaves the hustle and bustle of city life behind in Bogotá. That includes his family: his wife, his daughter (an artist), his son (a photographer) and his seven-year-old granddaughter. He travels alone to a small cottage in what Lonely Planet calls the best place to stay in Colombia: Finca Barlovento. To Luis, this natural enclave is a true sanctuary. This is where he finds inner peace through taking long walks, reading and meditating – with only a cat, three dogs, two parrots and the caiman that lives outside his front door for company. "This is truly one of the most beautiful places in the world: a tropical mixture of jungle, river and ocean."

He also keeps an eye on the guesthouses on the estate. Finca Barlovento Cabana is on the beach, right at the water's edge; the Maloka cottage is situated a little higher, up on the rocks. Although the estate has been in the family for 50 years now, the houses built on it had long been almost abandoned. Luis and his wife decided to turn them into guesthouses a couple of years ago. He also had a simple hut built for himself that would serve as a kind of caretaker's cottage: a crude living space with a bathroom, a kitchen unit and as few walls as possible. This arrangement allows the indoor and outdoor worlds to almost overlap. The upstairs bedroom under the thatched roof offers slightly more privacy.

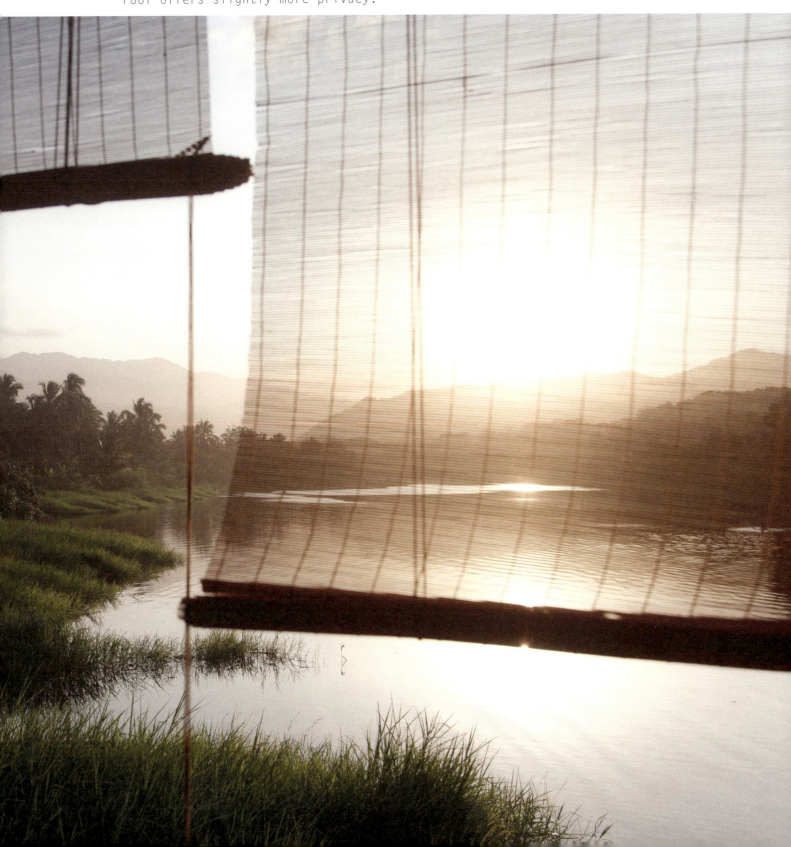

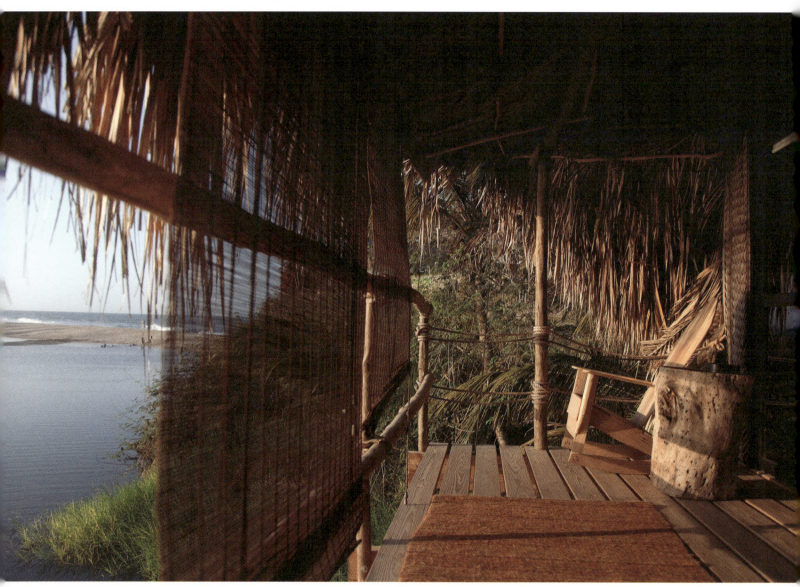

Luis calls the hut his life statement: "It's quintessentially simple – built with local natural materials and items that have washed up on the shore – yet at the same time it has everything: there is air conditioning, satellite TV and internet access." When he is not in his hut or out walking, the host of Finca Barlovento can be found relaxing in his riverside hammock under a simple thatched roof. "I renovated and decorated this little place myself. This is a place to really experience to the full that feeling of being surrounded by beauty, living in total simplicity – but without sacrificing any comfort."

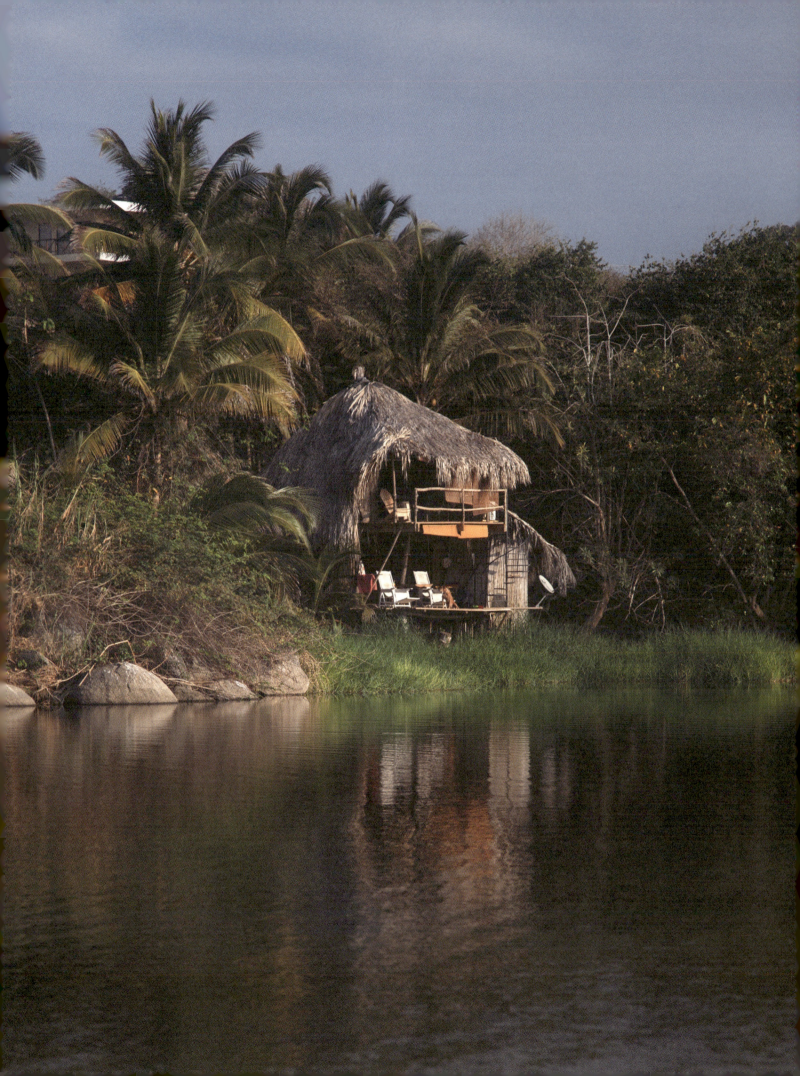

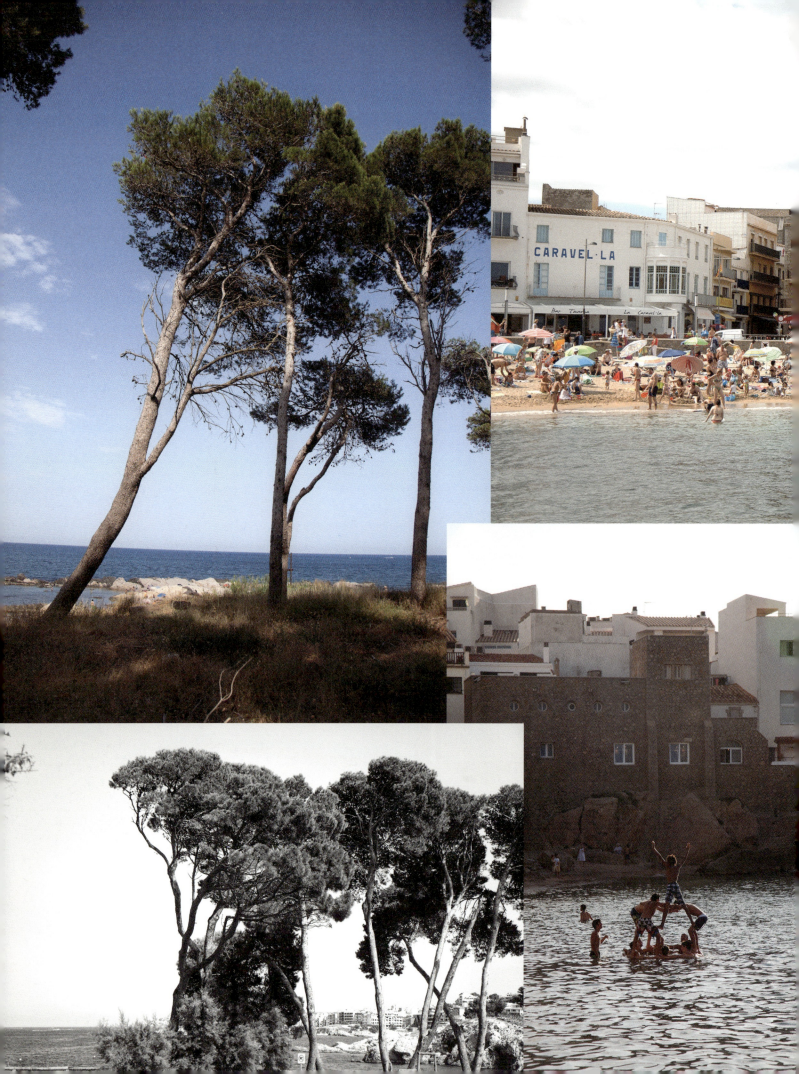

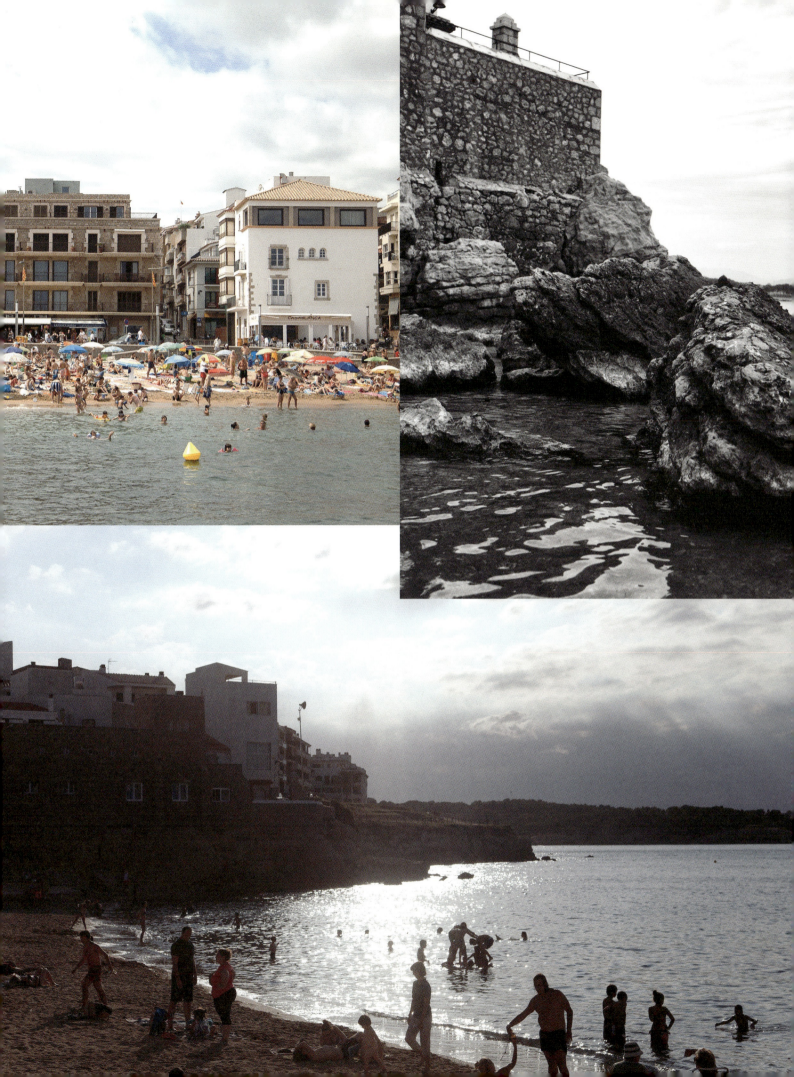

WHO?

Charles and Jet Bergmans and their three children (as well as their children's partners and friends). The Bergmans family are a creative lot: Charles is a freelance shoe designer, Jet is an artist, Sjors is an art director, Pieke is a well known Dutch product designer and Lotje is a creative project manager.

WHERE?

L'Escala, a small fishing port on the Costa Brava, in the north-eastern part of Spain. L'Escala literally means 'sanctuary' and that is exactly what it is: in the past, it provided a safe haven for fishermen fleeing from the Tramuntana wind storms that regularly race across the Mediterranean. Now it is a popular, lively holiday destination that has nonetheless managed to keep plenty of its authentic charm. The Bergmans family's holiday home is a twenty-minute walk from the town centre on the way to Albons, at the foot of a large shrub-covered hill. The hilly landscape surrounding their land is one of many beautiful places in the varied Catalan countryside nearby.

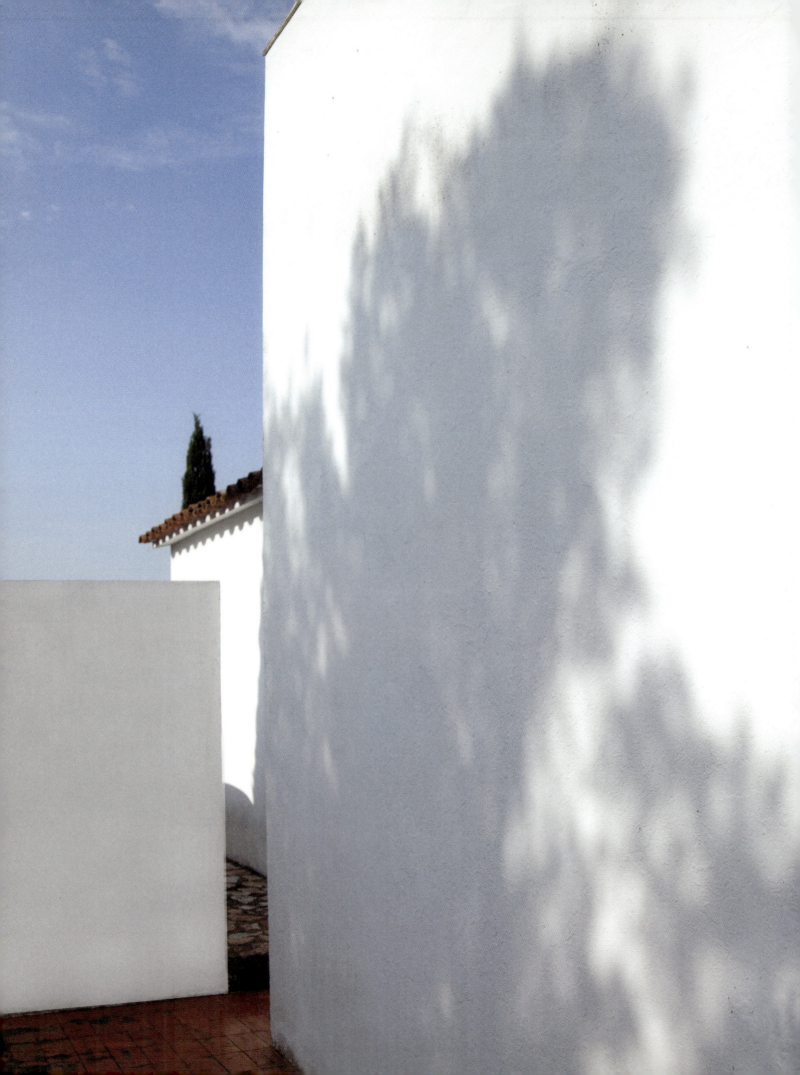

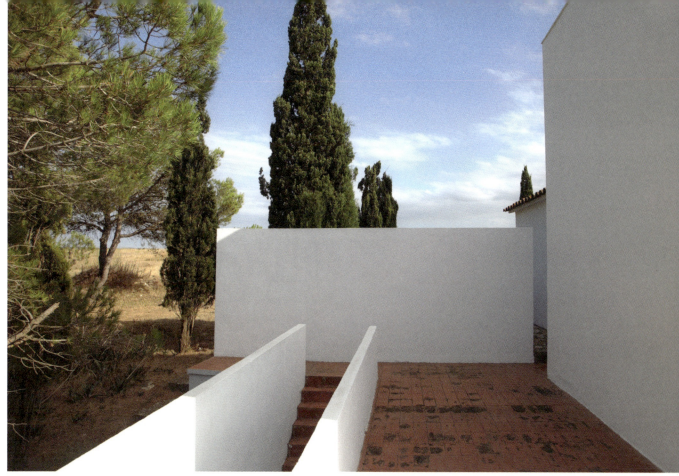

As a child, Charles Bergmans spent all his holidays in L'Escala together with his parents and his nine older siblings. His father bought a house there in the 1960s; it was the smallest of five villas that were built there by Willem Hendrik Gispen (1890-1981) at that time. The Dutch architect gained worldwide renown as a furniture designer and a leading figure in Dutch modern architecture (*Nieuwe Bouwen*), a progressive style of architecture in the early 20th century. The biggest of the five Gispen villas was bought by Dutch architect Gerard Holt. In fact, it was a little too big: Holt soon offered to make an exchange with his friend Koos Bergmans, Charles's father. That way, Holt got a small holiday home to suit him and his wife, while Koos had a larger property that could accommodate his entire family. He named it after his wife: Casa Lucia.

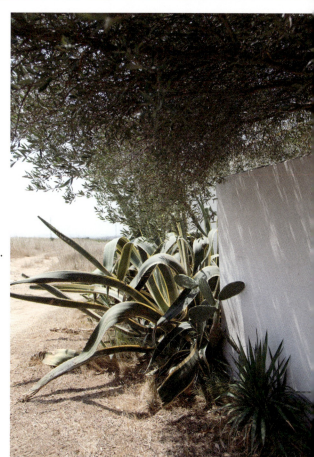

Charles and his wife took over Casa Lucia around 1990. "We soon discovered how wonderful it is to have a place like that to escape to. Some years later, we even bought the property next door and its hexagonal tower. Torre Azul ('blue tower') was built much later than Casa Lucia, and is smaller and more intimate. We use it as a workshop and studio – it offers wonderful views of the Pyrenees on one side and the Mediterranean on the other. Together, these two totally different houses form a wonderful and balanced combination which works perfectly for us: Torre Azul is more closed off, a place to withdraw to with a shaded patio; Casa Lucia is open, sunny and focused on the outside. This is where our kids and their friends stay, often with our own friends thrown into the mix too. We cook elaborate dinners at night: cooking is important to us, which is why we put in a well-equipped kitchen."

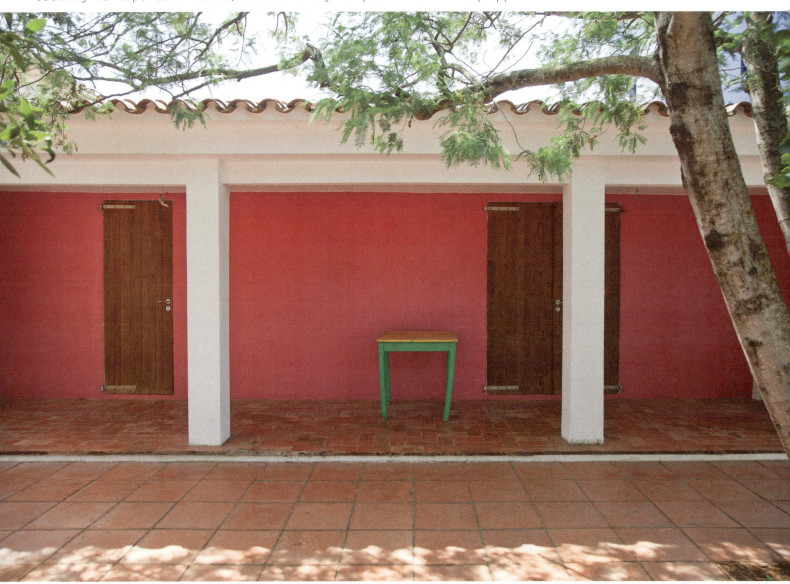

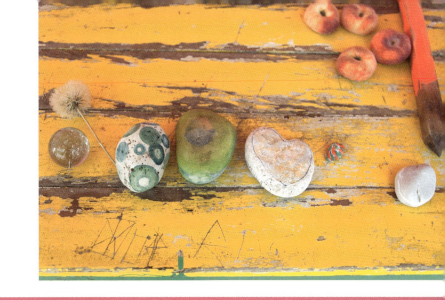

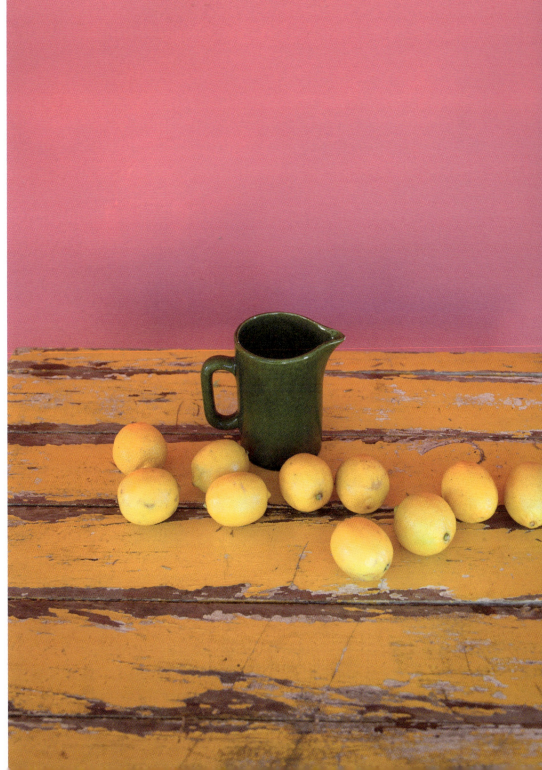

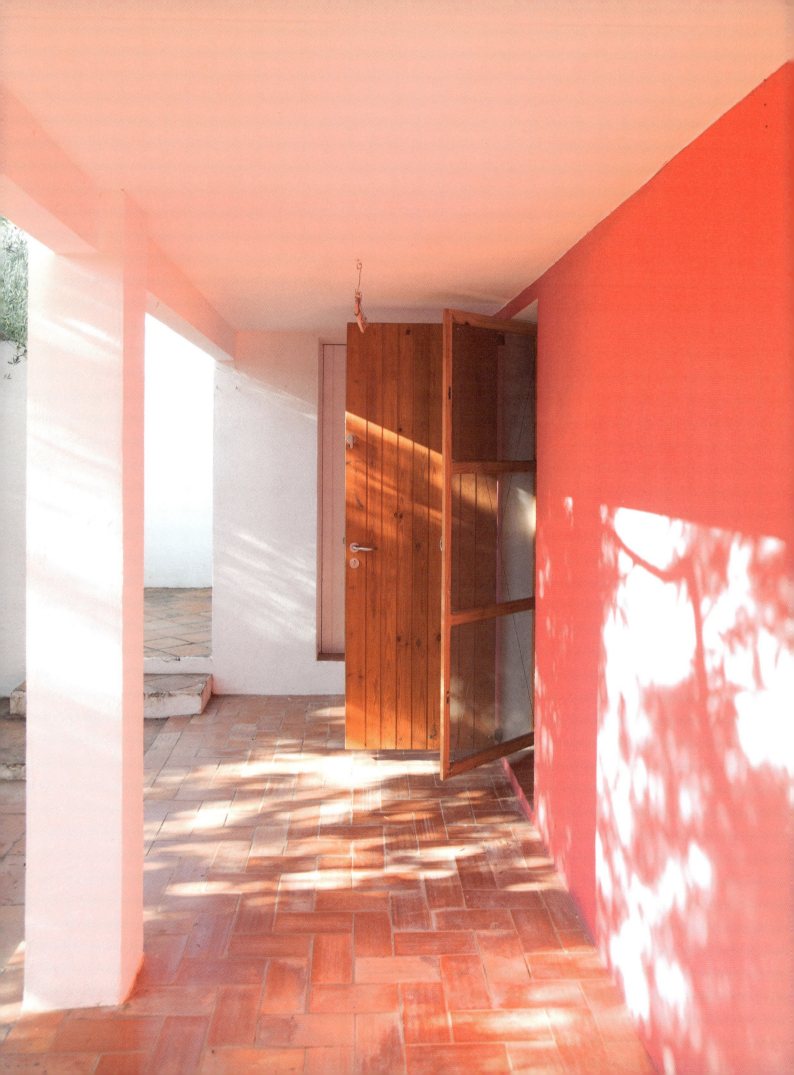

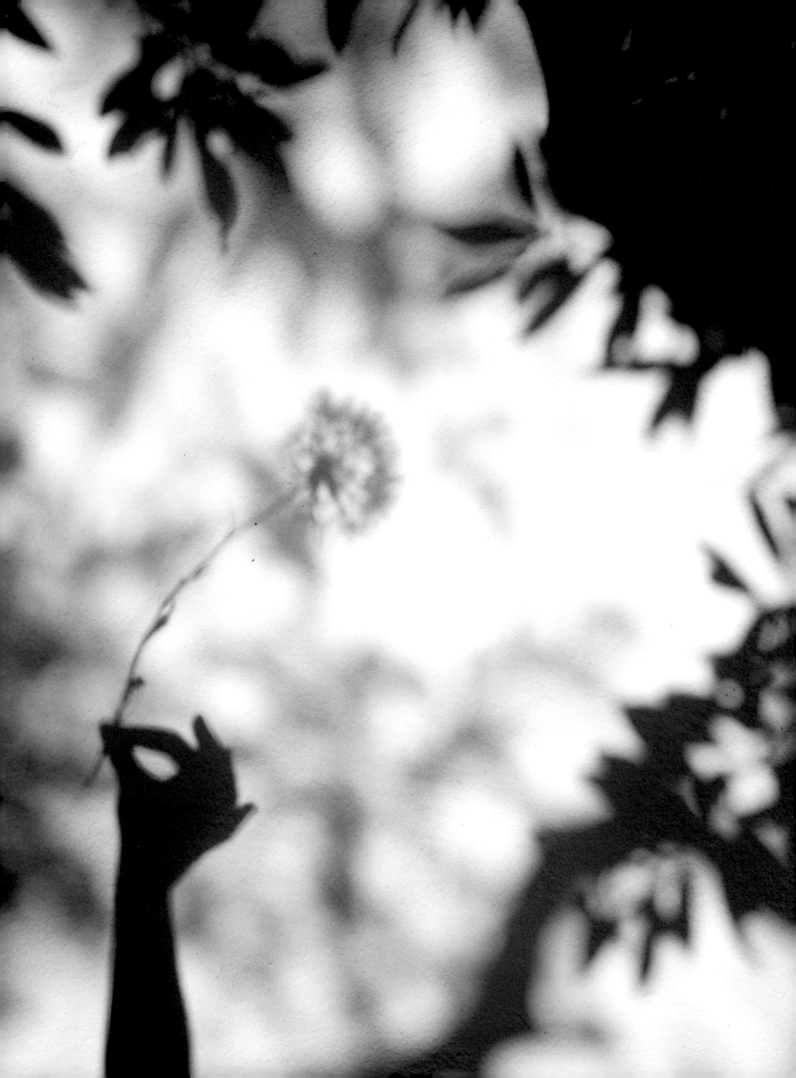

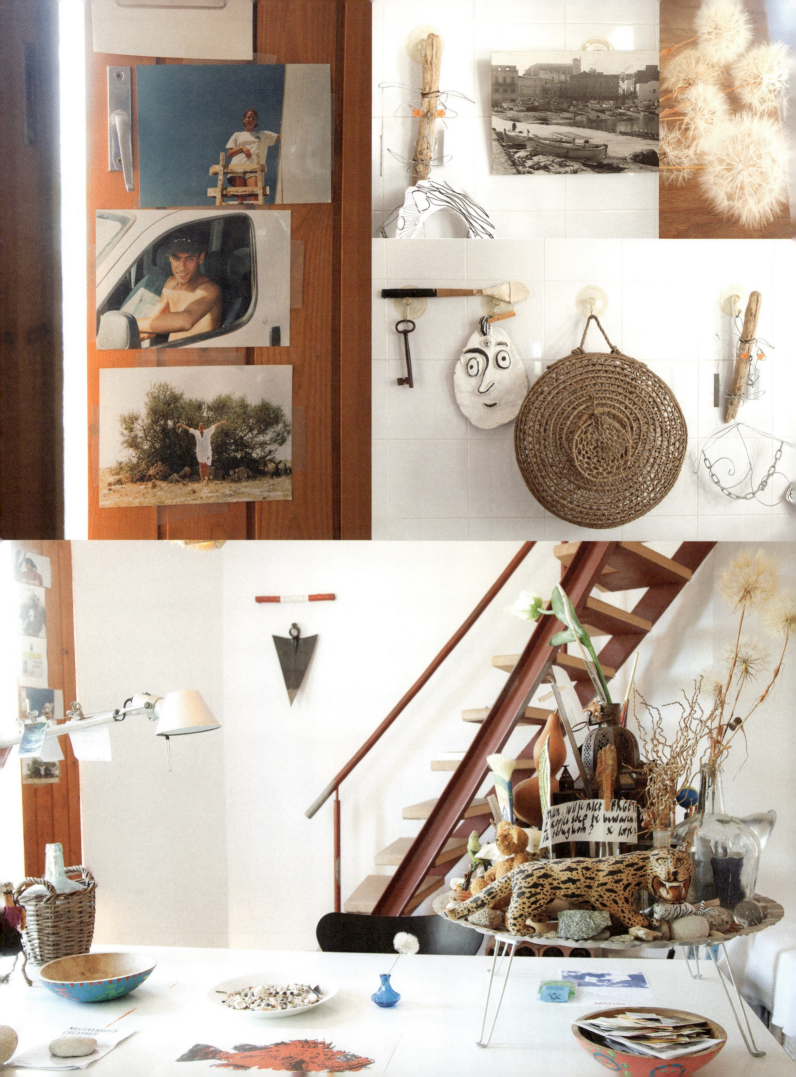

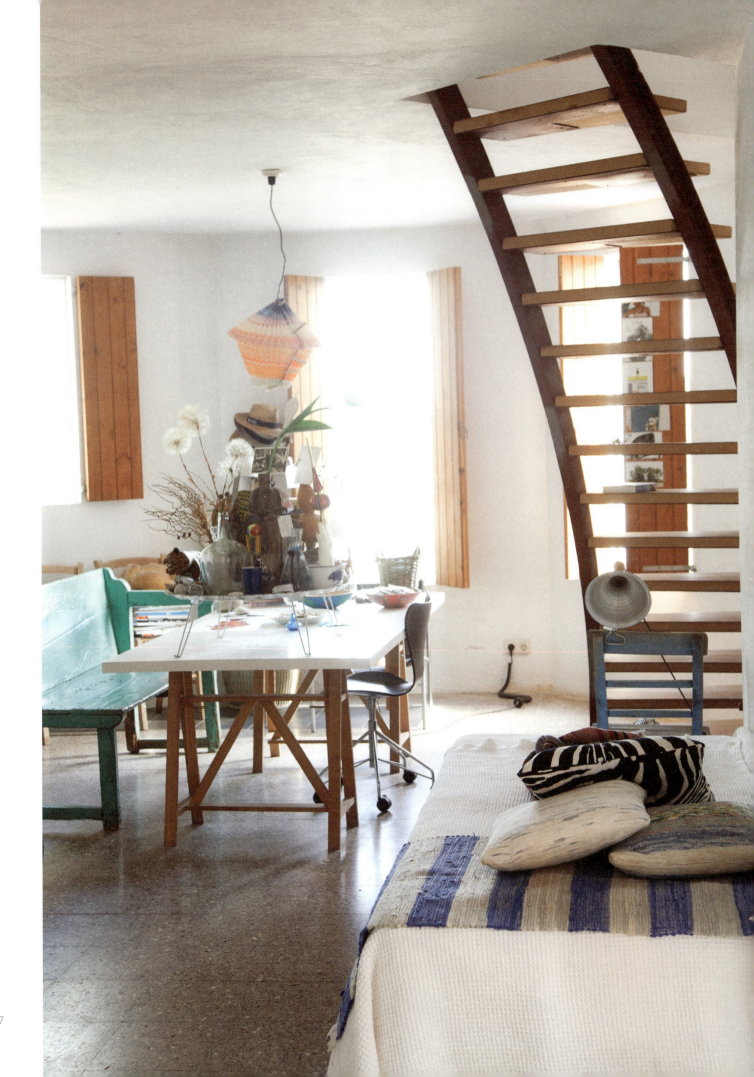

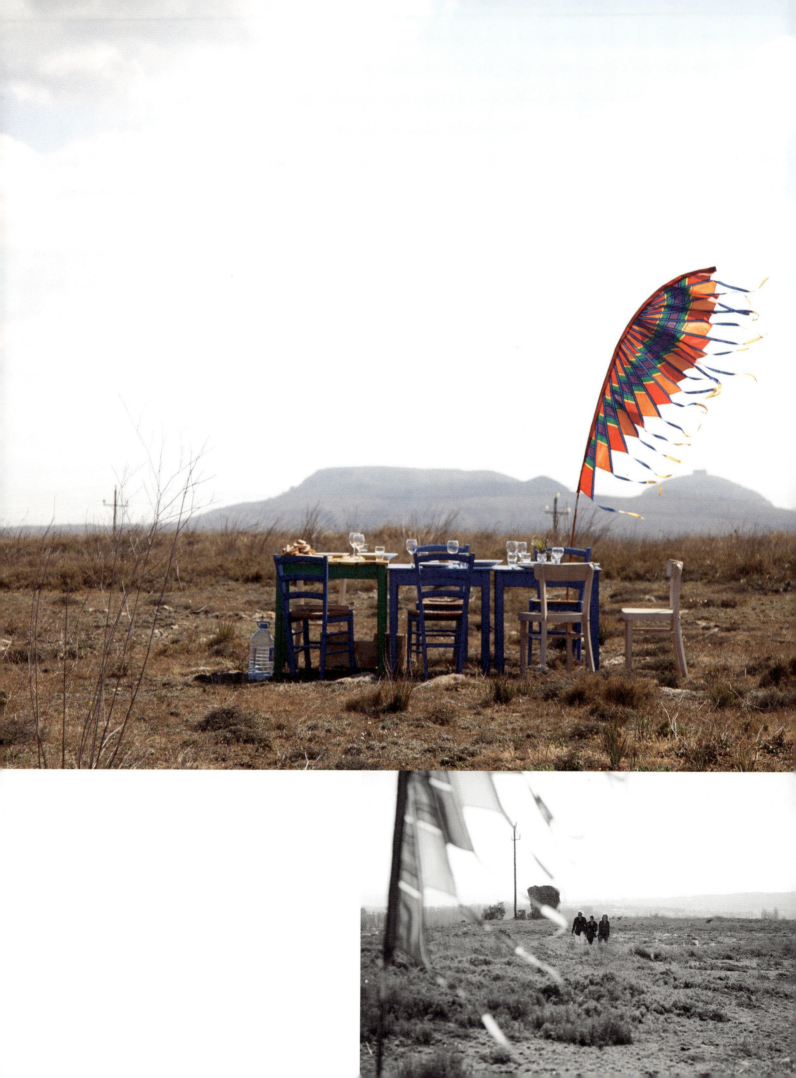

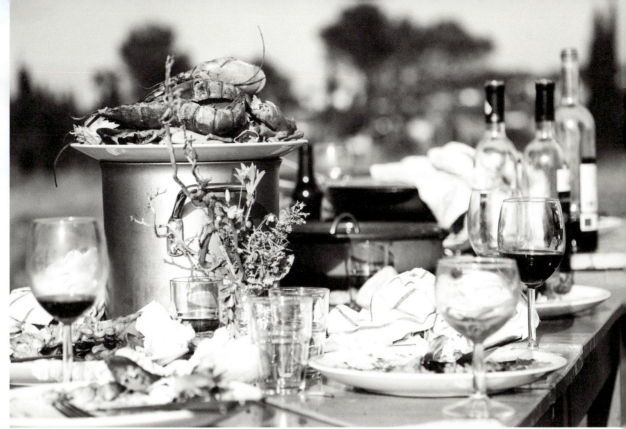

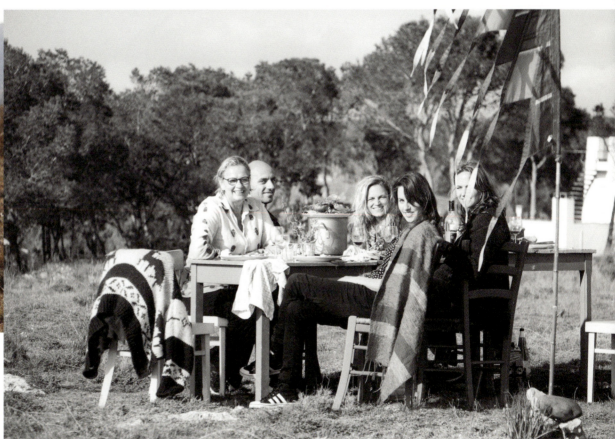

"We all love to just sit down at the table: indoors, outside on the patio or at the foot of the tower... We even eat 'in the wild', on the large shrub-covered hill - our house is right at its foot. The landscape around us is one of many beautiful areas in the wonderfully varied Catalan countryside nearby and provides a beautiful setting."

Casa Lucia is quite traditional in appearance and it reflects local building traditions. One striking element of Casa Lucia is its solid walls, in which Gispen systematically left out alternate stones. He filled the openings with panes of glass. This creates a very special effect both inside and out, giving the walls a kind of transparency. When Charles and Jet bought the house, they did change a few things: "The floor plan was very old-fashioned, with a hallway, living room and kitchen.

There was a fantastic view with the most spectacular sunsets behind the Pyrenees from the living room, but if you really wanted to be there, you had to go outside through the hallway. In many ways that hallway created a large obstacle in the middle of the house. By removing it and shifting the entrance to the other side of the house, we created a totally different perception of the interior space. We then converted one of the windows in the living room to sliding doors opening out into the front patio. Apart from those changes, we wanted to respect the authentic look and feel of the house - Casa Lucia is very comfortable, but it is not a luxurious villa. That is perfect for us; in fact, we enjoy having to shower outside on the patio."

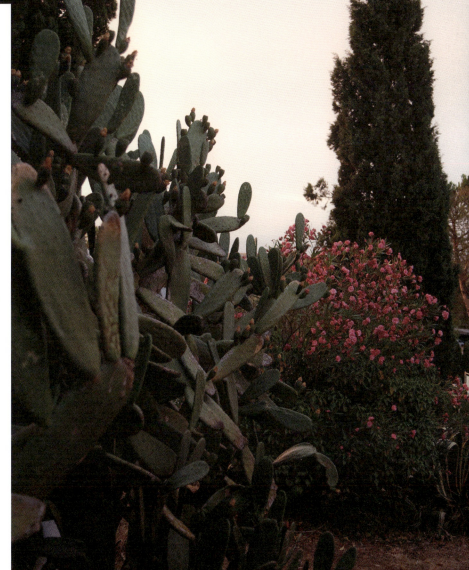

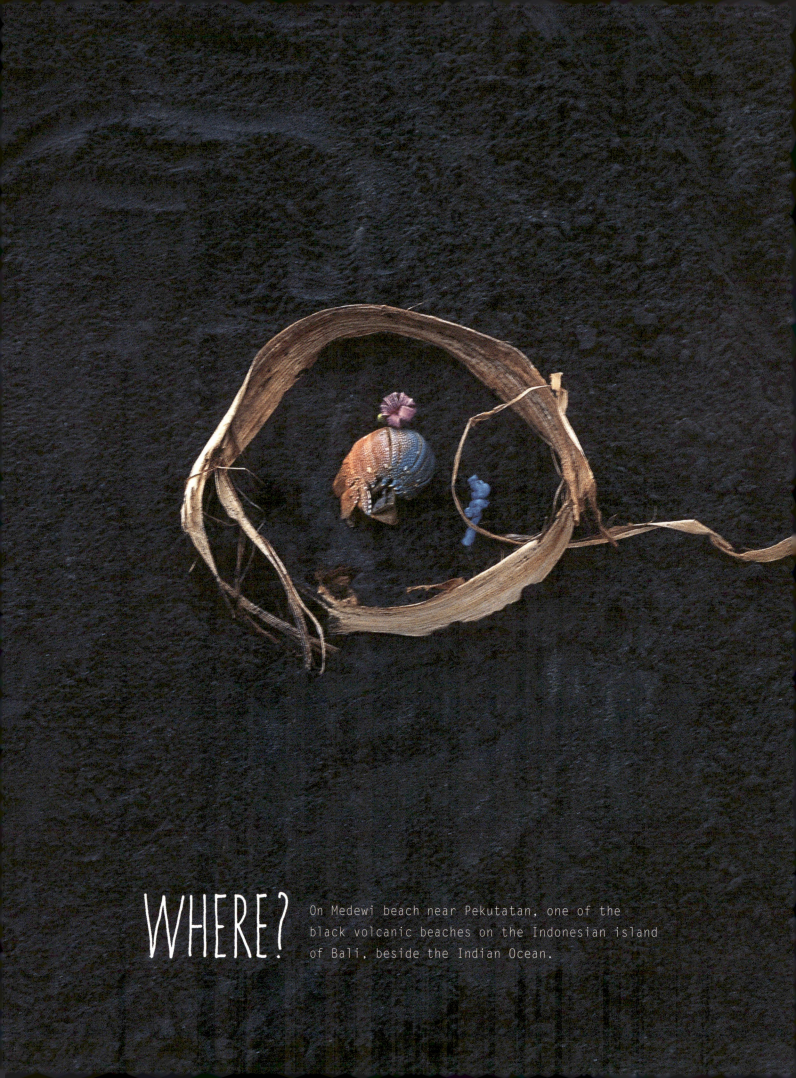

WHERE?
On Medewi beach near Pekutatan, one of the black volcanic beaches on the Indonesian island of Bali, beside the Indian Ocean.

EXPLORE

"The sea is wild and powerful here, so it is much too dangerous for swimming. This place intrigued us because the black volcanic sand makes the beach very special, and because there are so many objects to be found here, of all shapes and sizes. The locals make offerings to the sea on this beach according to the traditions of their faith, which is a Balinese form of Hinduism. Since the waves are so strong, many of these offerings wash back up on the beach. We started working on a number of still lifes using things that we found in this way and some fabrics we bought on Bali: temporary creations that are open to the elements. It was a very powerful experience: spending the whole day outdoors, constantly hearing and feeling the intensity of the crashing waves. You become aware of the sand and the wind, and find yourself in the zone, simply working on whatever it is you are creating on the beach. We thought this was absolutely wonderful; at times we were excited like children. It was also really interesting to see how the locals responded to our work. They were very curious and often came to sit with us; we would exchange glances and nod to one another, but there was very little talking. They didn't mind that we were using their offerings, as long as we didn't remove them from the beach: once something has been given to the sea, you cannot take it away."

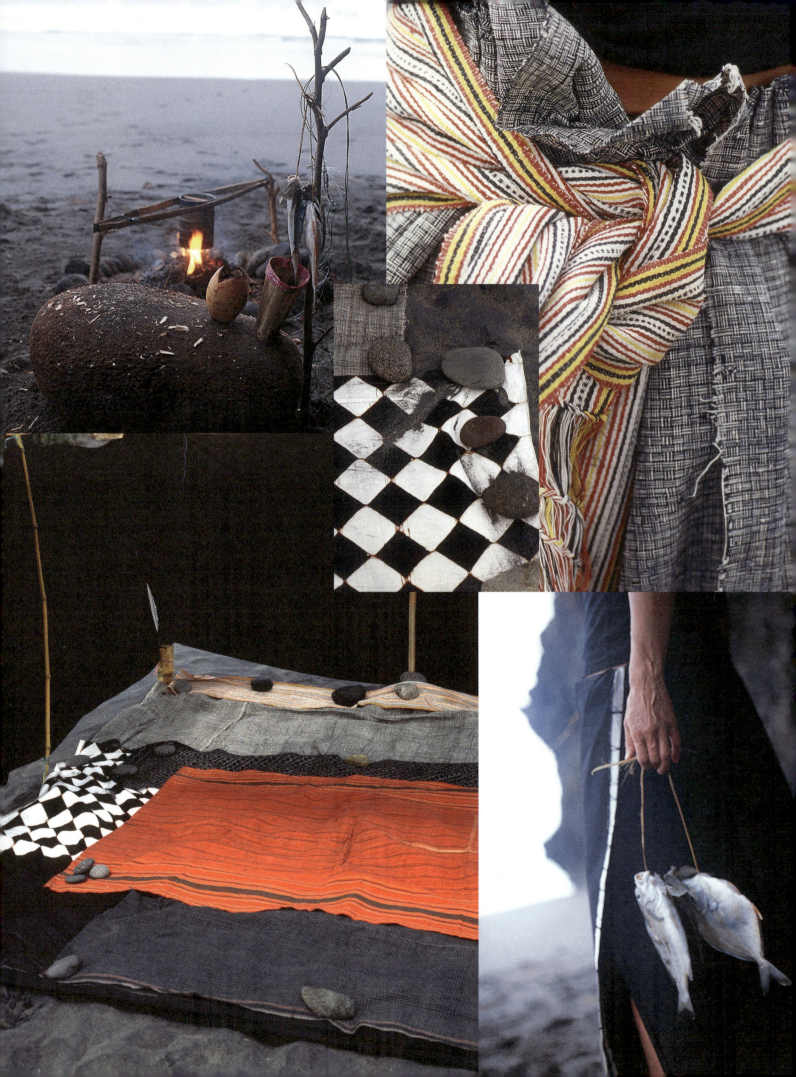

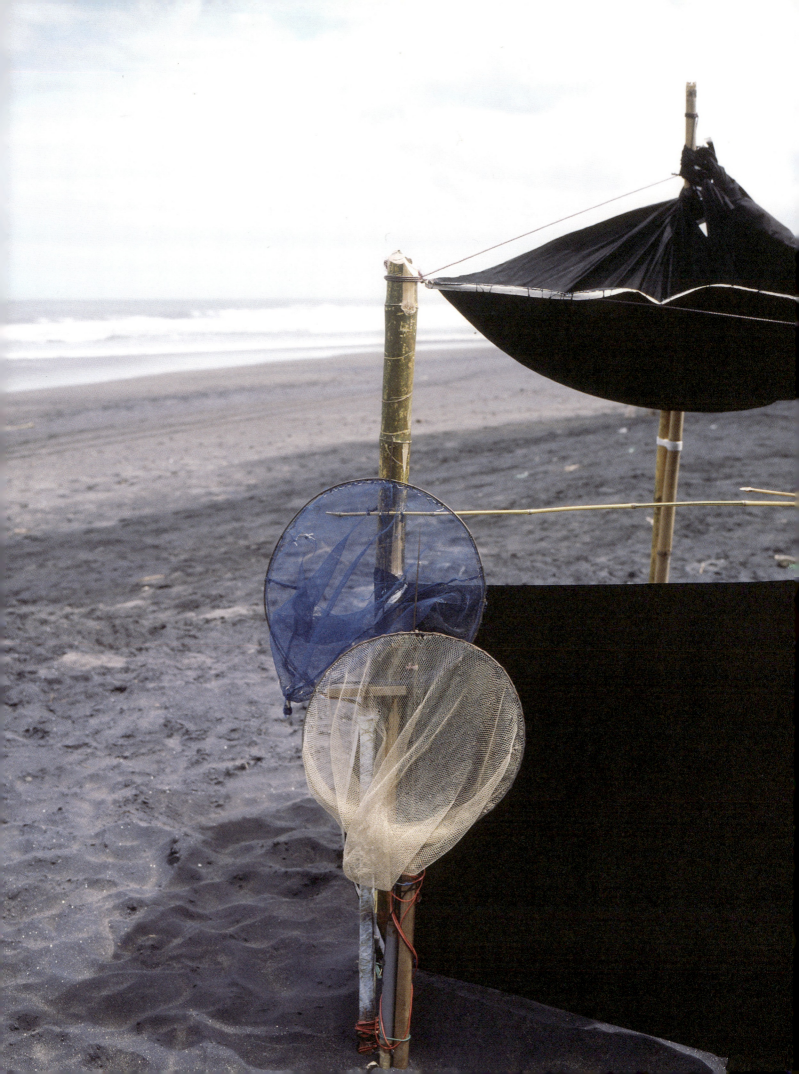

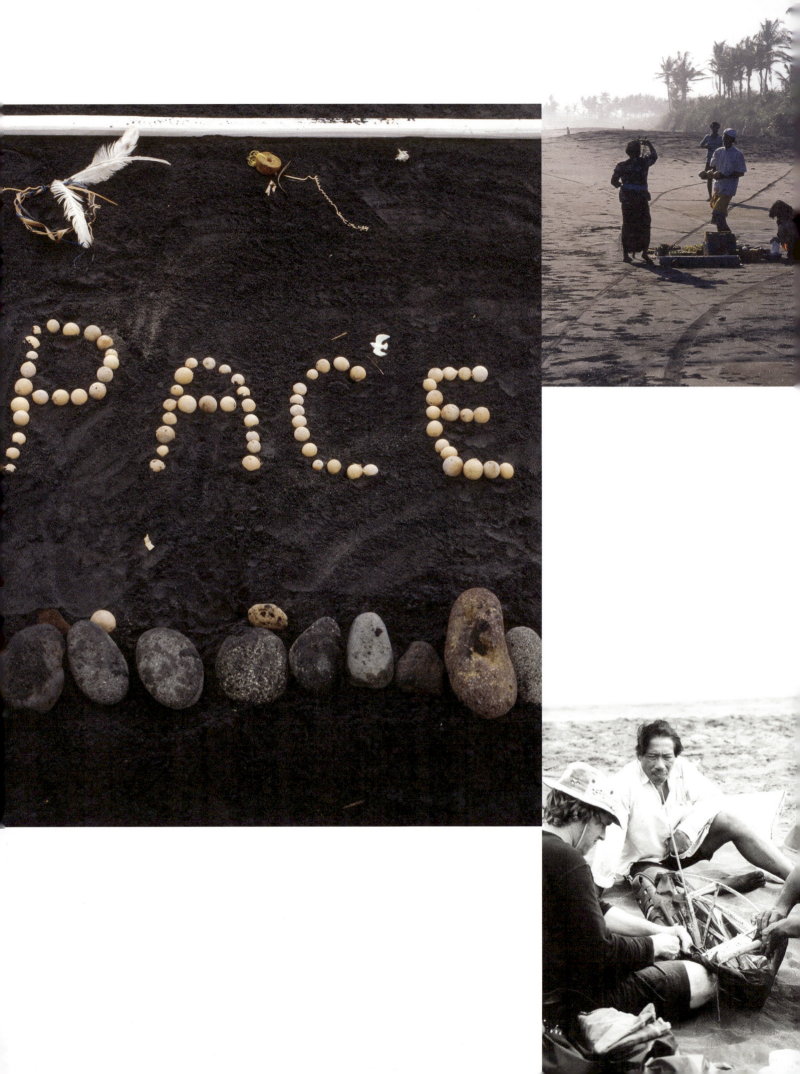

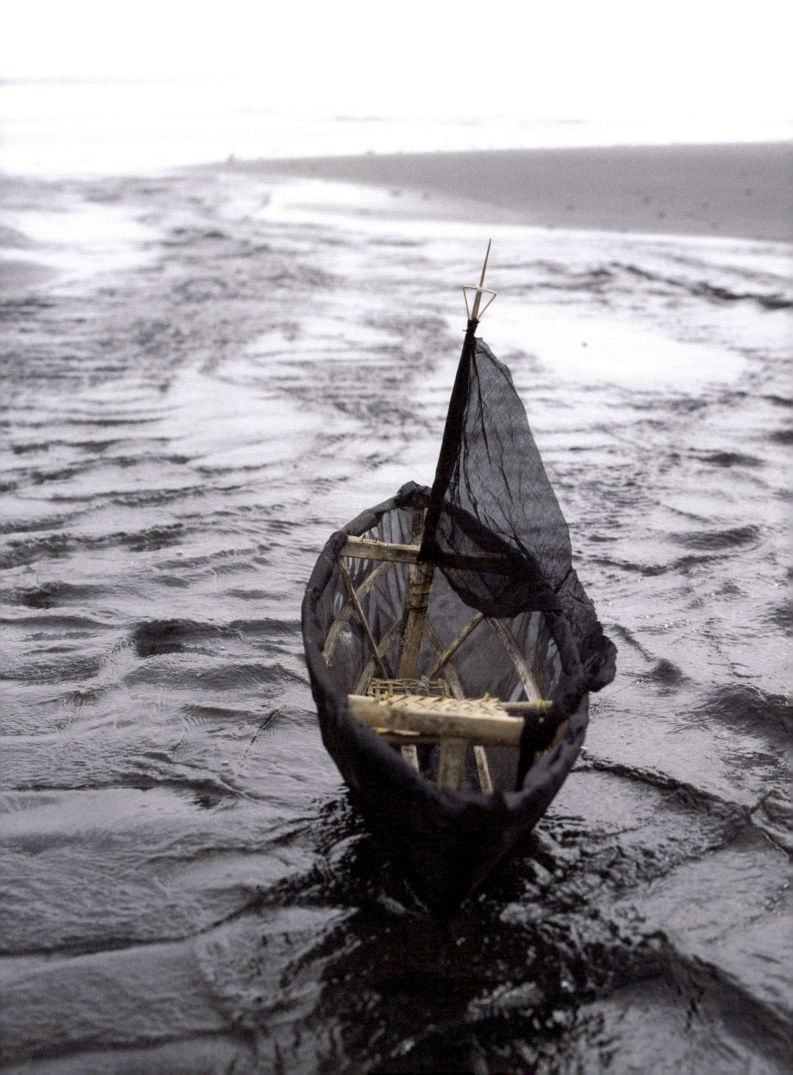

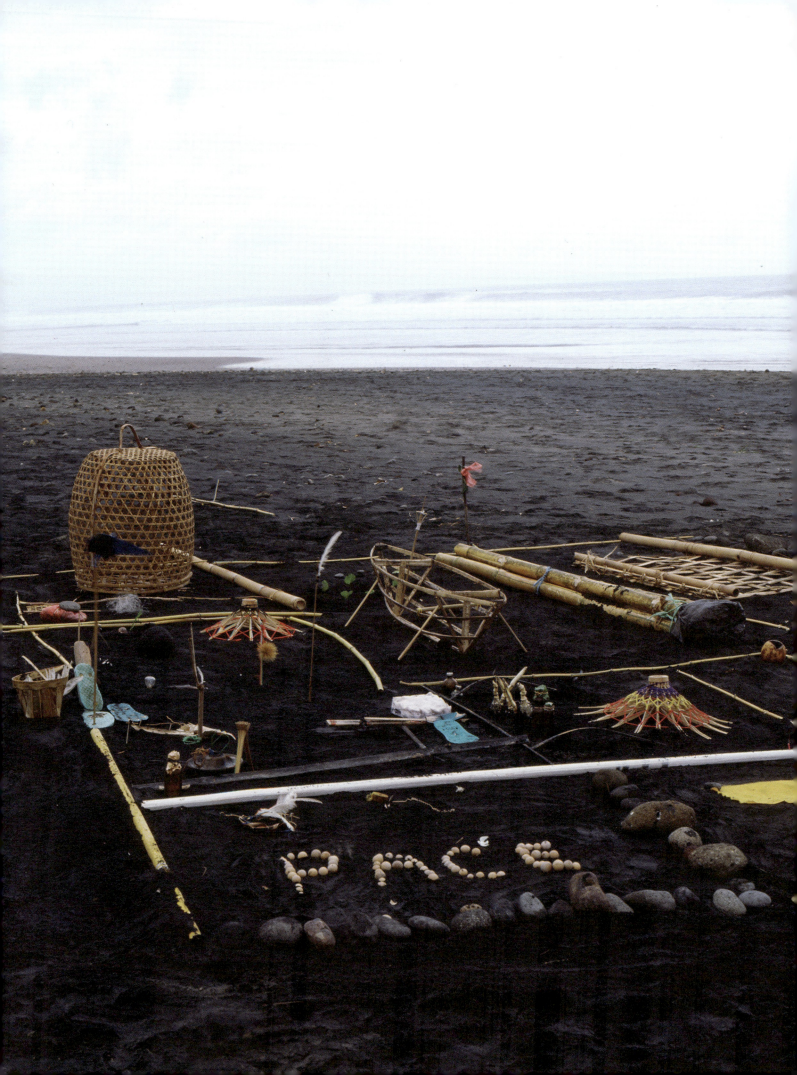

TENERIFE

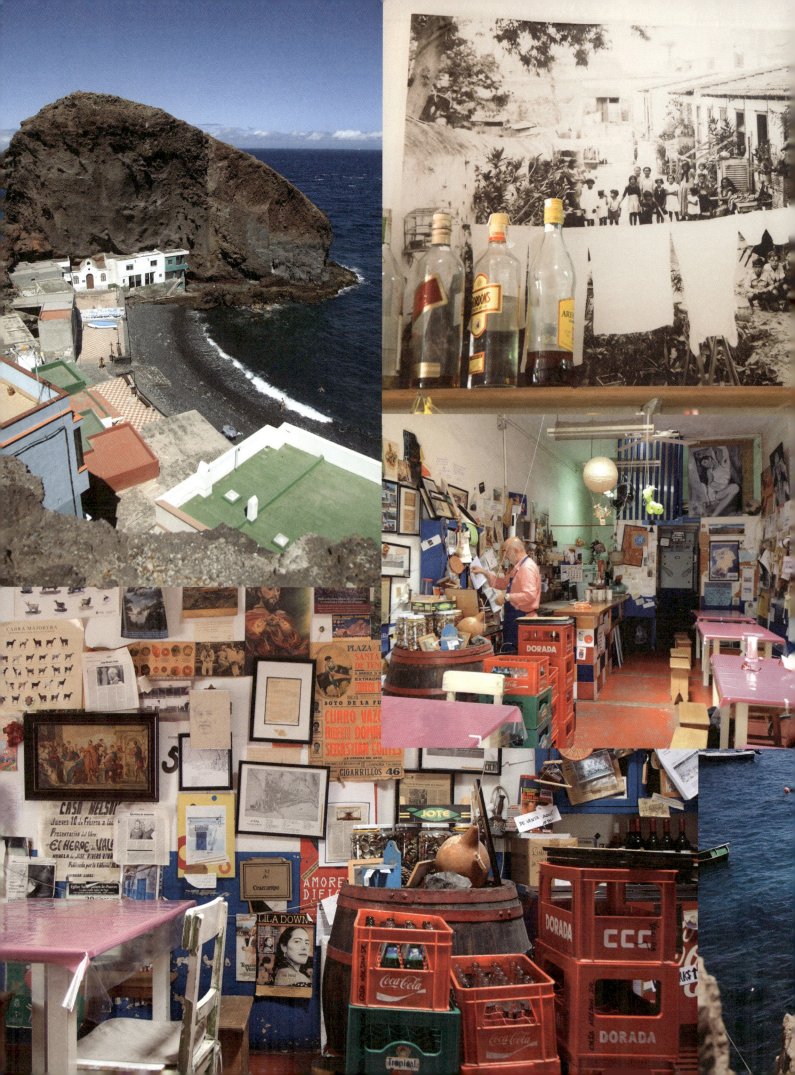

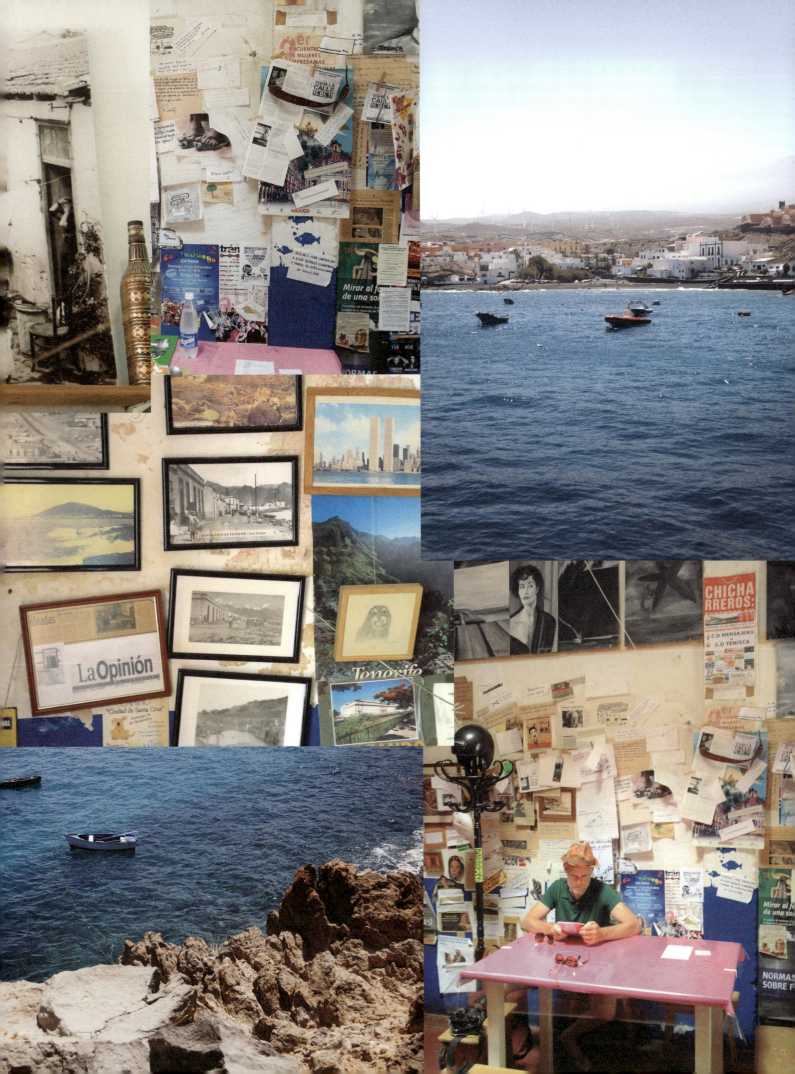

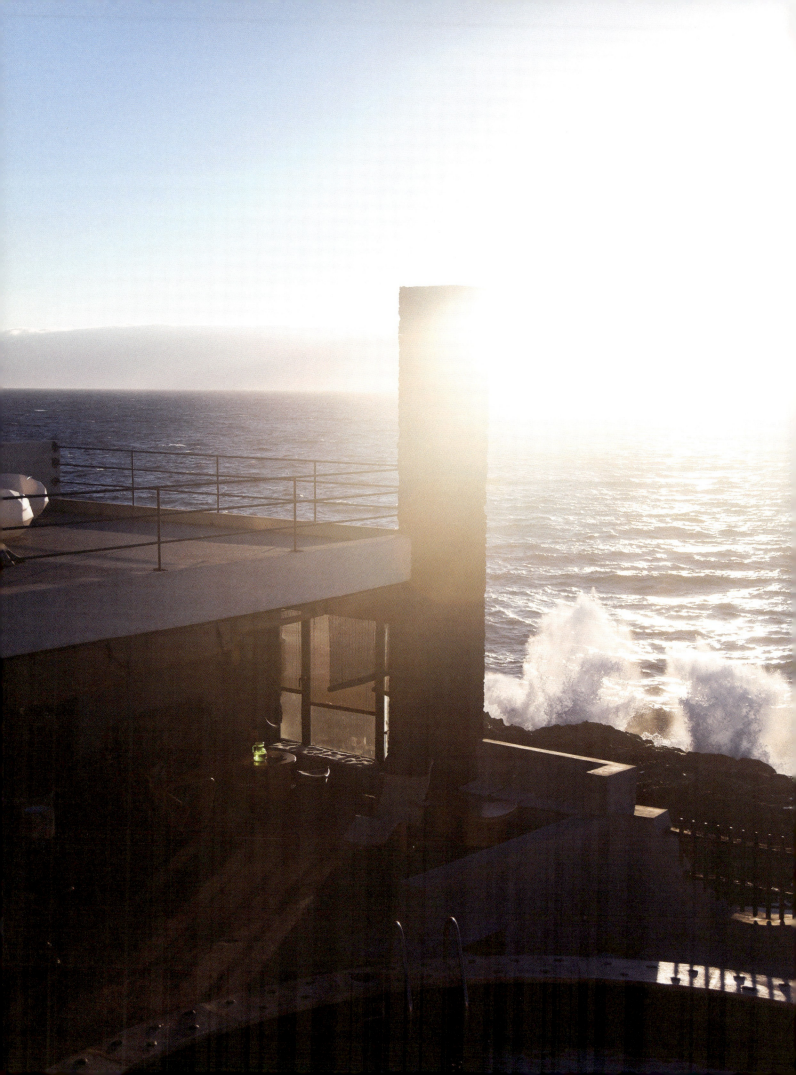

WHO?

Susan Theunissen and Leo Coolen, and their children Jana (17), Max (15) and Coco (5). Leo and Susan run Sprookjes.eu (Fairy Tales), an impressive and inspiring collection of theatre props, vintage items, antiques and curiosities which they sell or hire out all around the world.

WHERE?

El Poris, a thirty-minute drive from Santa Cruz, the capital of Tenerife in the Canary Islands, located at the easternmost tip of the island.

Susan and Leo bought their holiday home, a modernist villa built in the late 1970s, in 2011. Since then, they and their children have spent as many holidays there as possible. They stumbled upon the house by chance, as Susan explains: "We weren't looking to own any property abroad and our image of Tenerife was even slightly negative. But then we came here to visit friends and explored the island with them. We went out to look at a house Herzog & de Meuron had built here at the coast and right next to it we saw the villa for sale that would be ours."

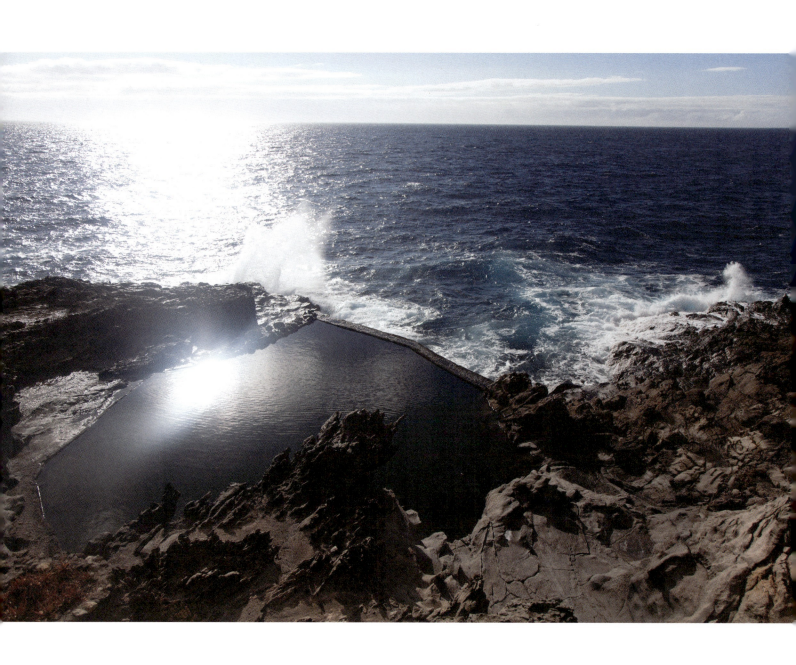

The family immediately loved the quirky, modernist building and its exceptional location on the rocks, right by the water. They realised, however, that remodelling the house would be an enormous operation. "The first and only owner before us had built the house himself, bit by bit. He had died a while back, and time had stood still ever since." Susan trained as an architect, so she became responsible for the remodelling. "We kept the original dimensions, including the large patio that all bedrooms open out onto, but we've changed almost everything else: everything still looked exactly the way it was 30 years ago. That may sound charming, but it definitely needed a complete renovation - all the rusty piping needed to be replaced, for example."

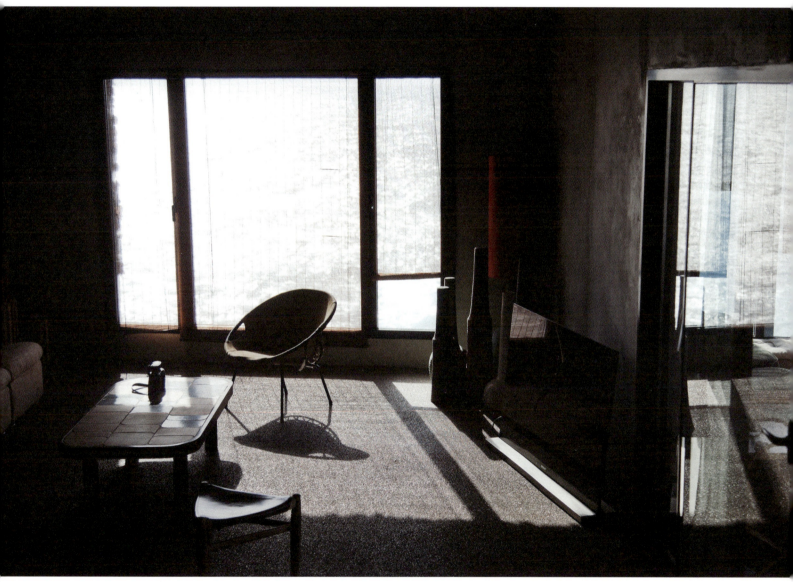

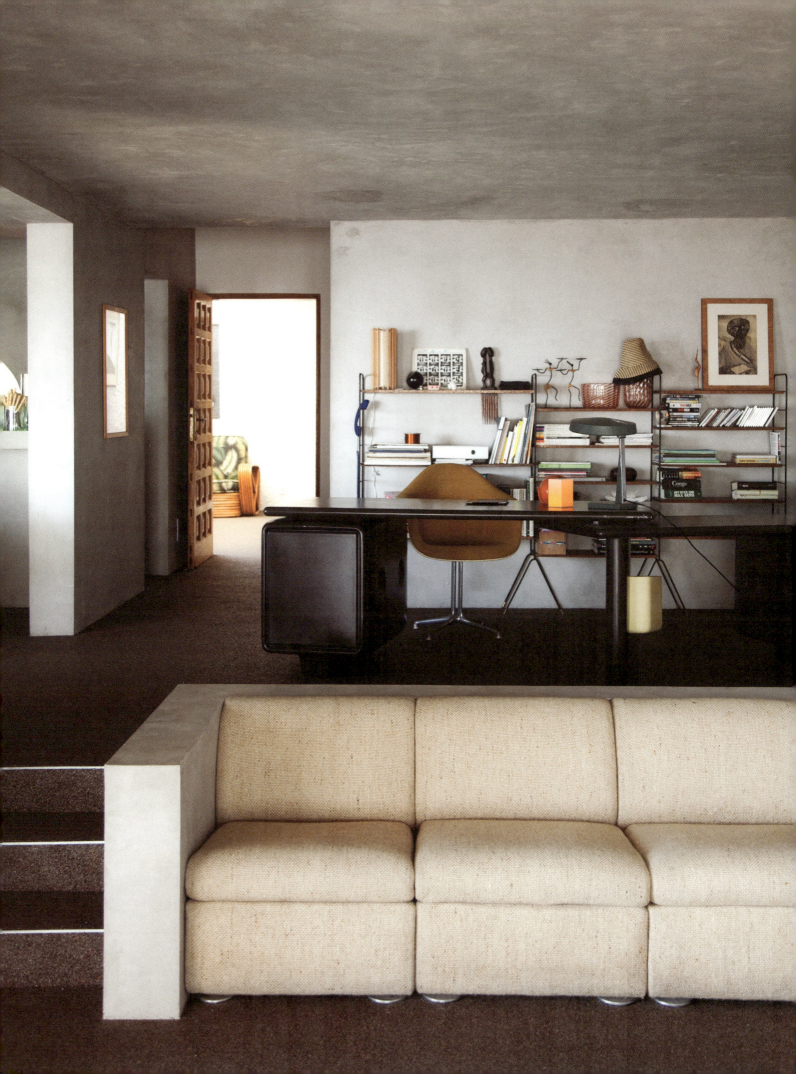

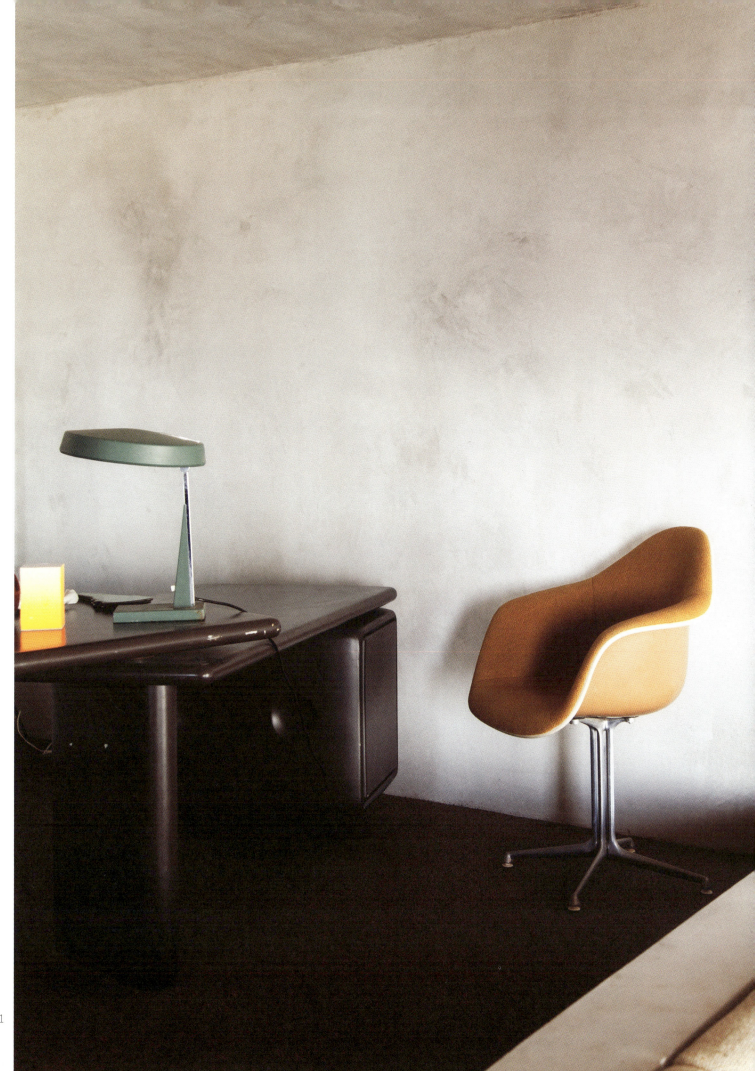

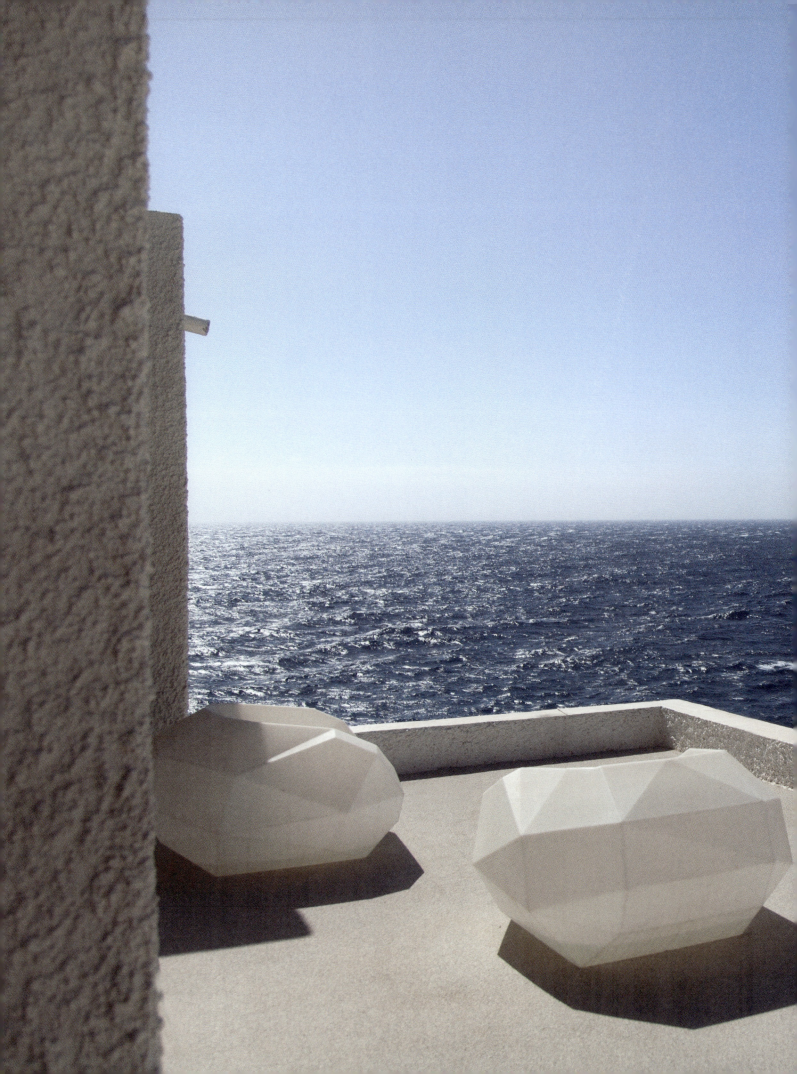

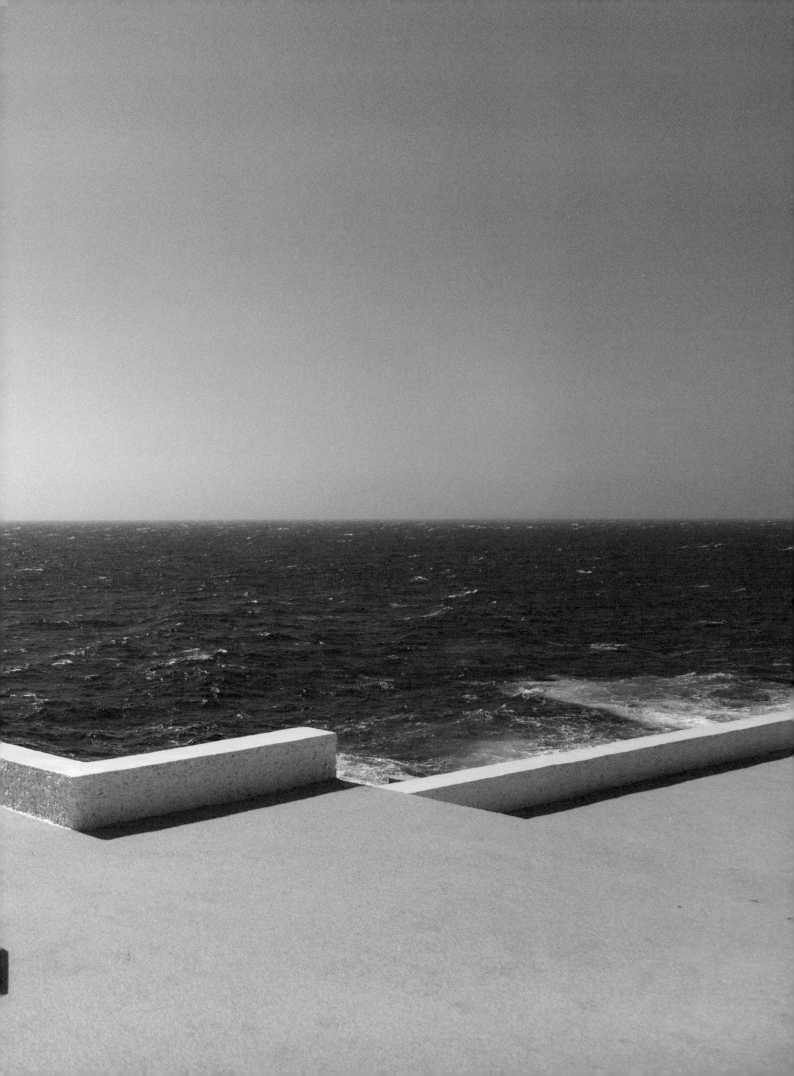

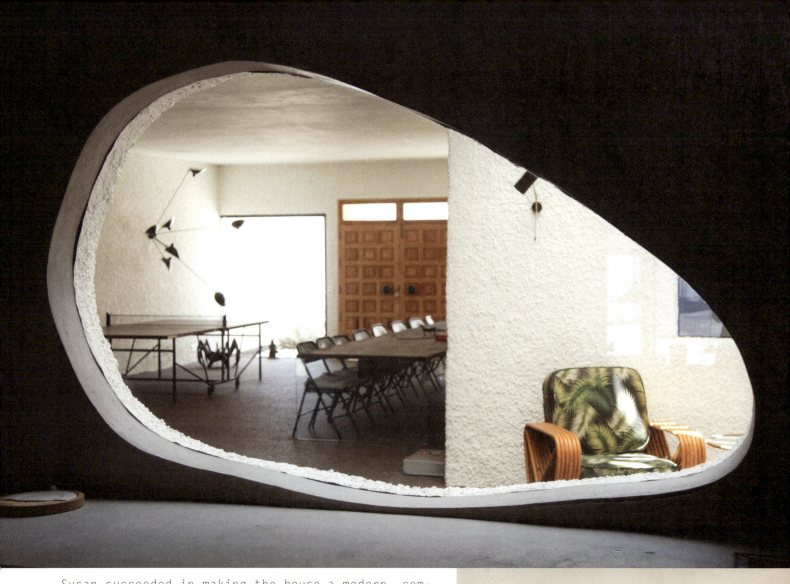

Susan succeeded in making the house a modern, comfortable and authentic holiday home, with special details like the wooden closet doors in the bedrooms to create an original, warm, Spanish look and feel, windows to create the perfect sightlines both indoors and outside, and an impressive tidal pool right on the Atlantic Ocean. Another special feature is the café, which was built by the former owner at the edge of the rocks. It's a great place to relax with friends, who are always welcome to spend a holiday in their home – it certainly has enough bedrooms. And then there's Susan's latest project: the integration of a big apartment into the house – the apartment lies directly on the water and is available for rent. "To me, remodelling the kitchen is perhaps the best project we have done. I came up with the idea of the whimsical, round window; it creates a sense of space. We probably spend most of our time out on the terrace though, that includes being in and around the swimming pool on top of the rocks, right next to the ocean."

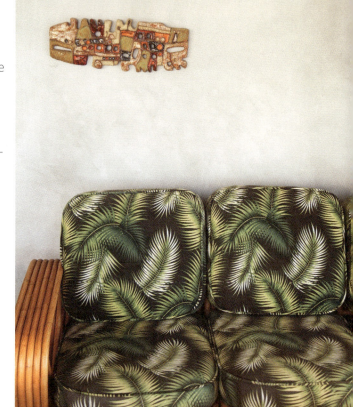

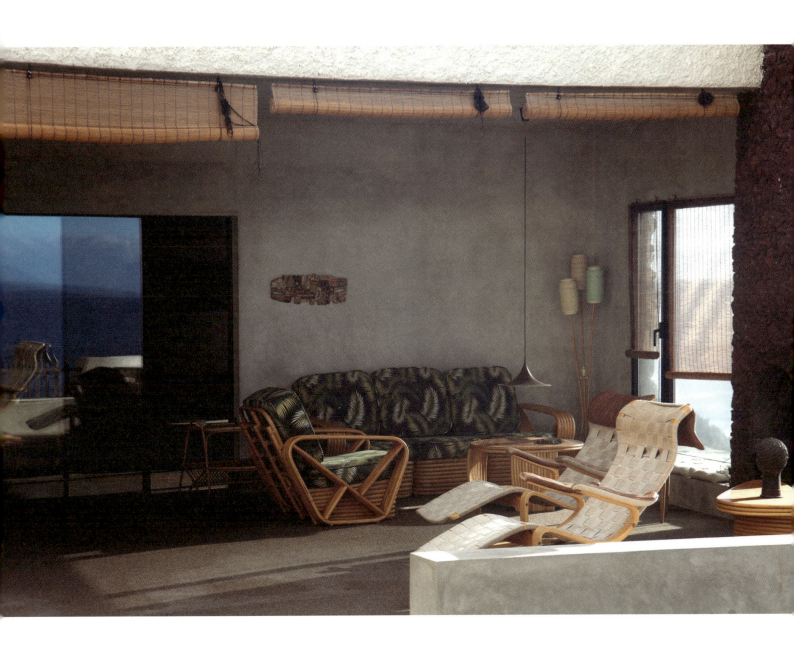

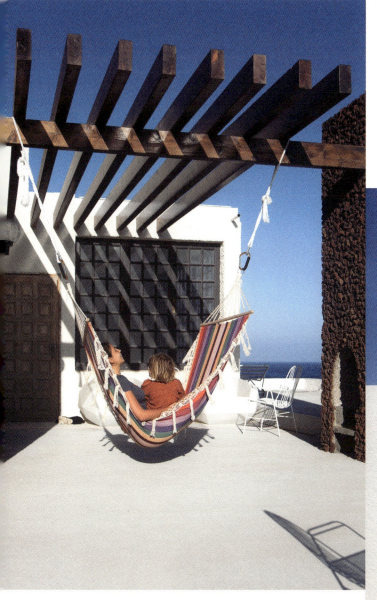
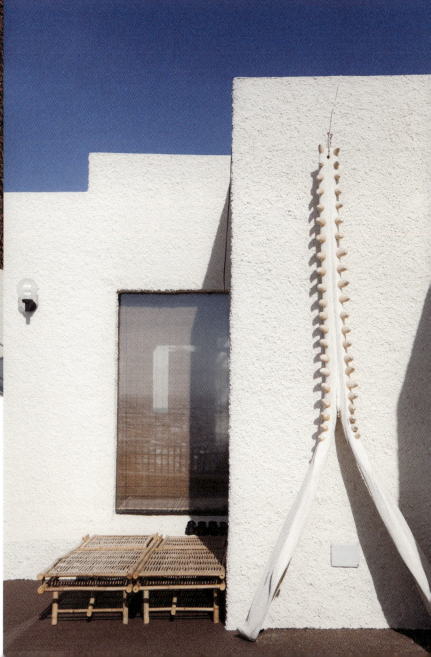

137

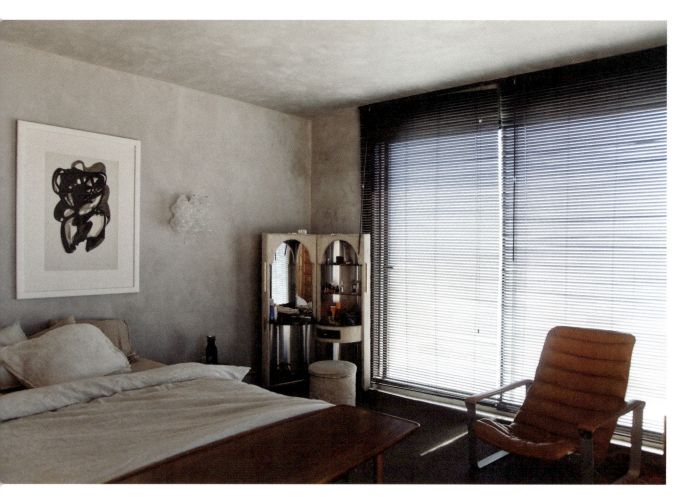

Although Susan, Leo and their children did not originally feel any special connection to Tenerife – it was the house they fell in love with, not the island – they have developed one now. "Much of our remodelling has been done by local craftsmen. I kept an eye on things as much as I could; you get to know the people and the culture of the island in a different way than you do when you're a tourist. The locals and their way of working and living reminds me more of South America than it does of Spain. The customs, the colours, the old-school atmosphere of Santa Cruz... The 10 million tourists that have given the island something of a bad reputation mostly congregate in the south."

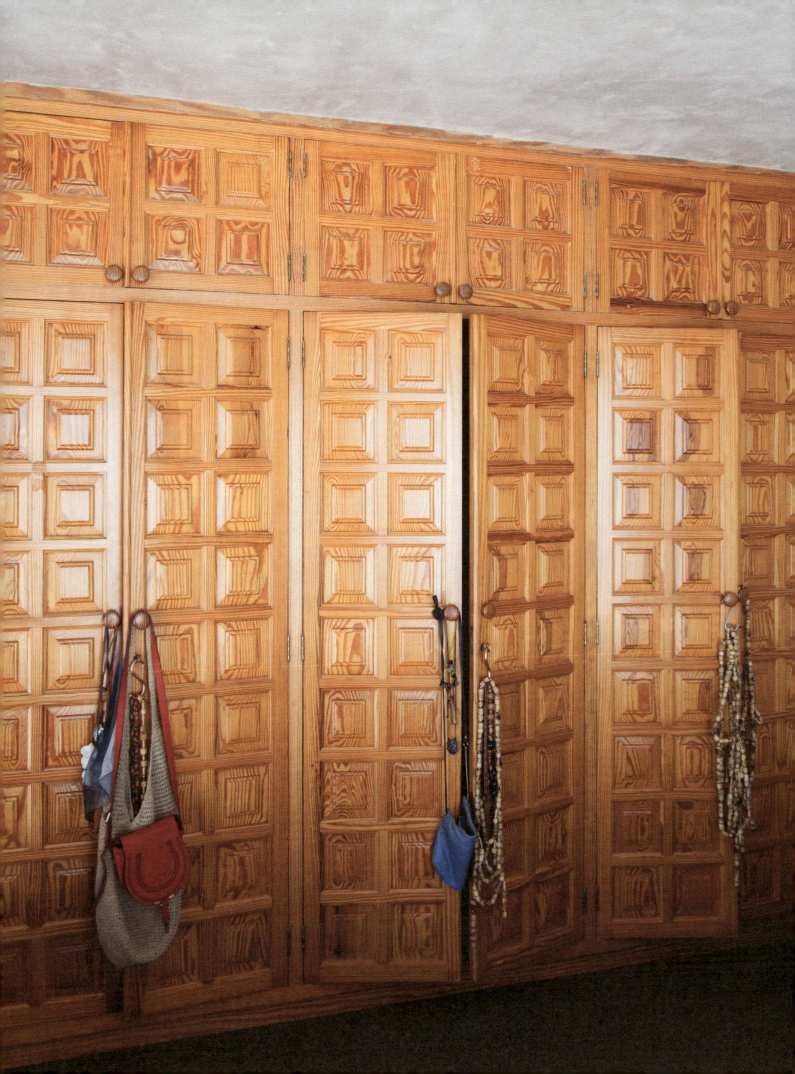

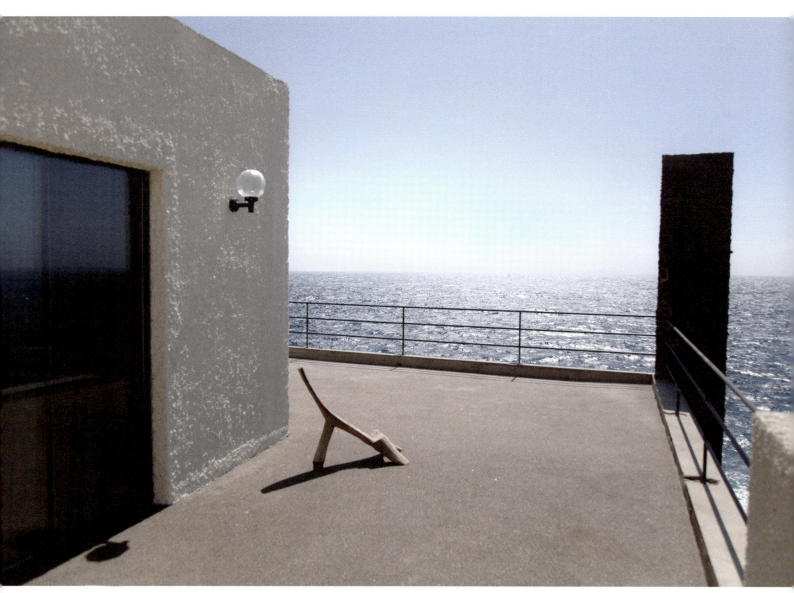

"It's much quieter where we live, and the atmosphere in the charming villages we've discovered is more authentic, with great restaurants and interesting arts and culture initiatives. Tenerife mostly consists of beautiful and unspoilt scenery: half of this small island is a national park under government protection. It's unique and diverse: you can swim in the warm waters of the Atlantic, explore tropical rain forests or take adventurous hikes through breathtaking rugged landscapes of volcanic rock. Our oldest children love kite surfing; they take lessons when we're on holiday here. The windy beaches right next to our house are perfect for that."

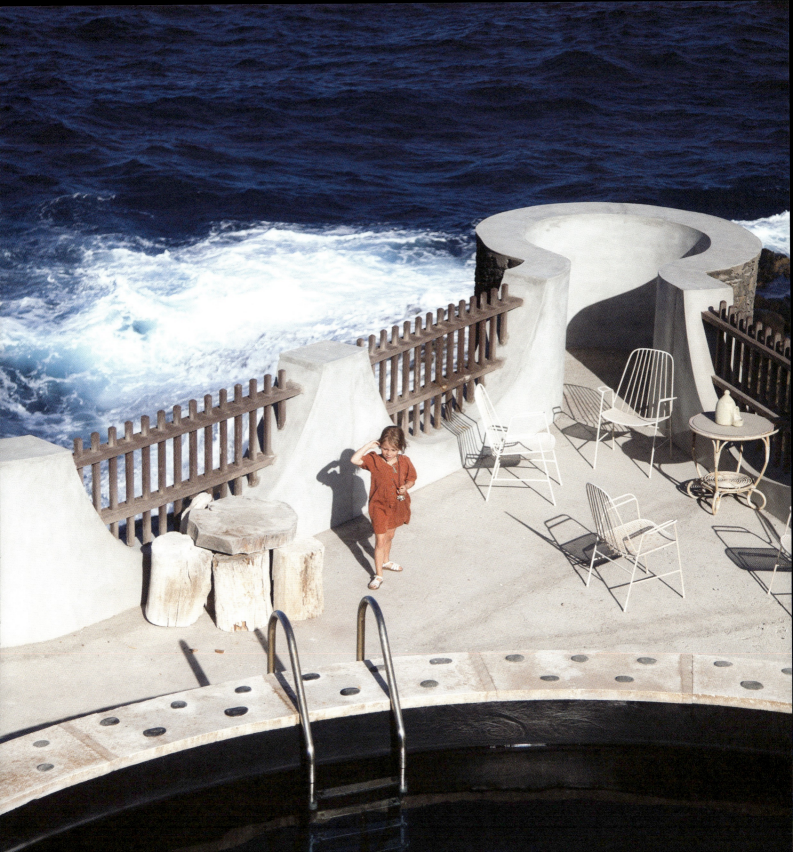

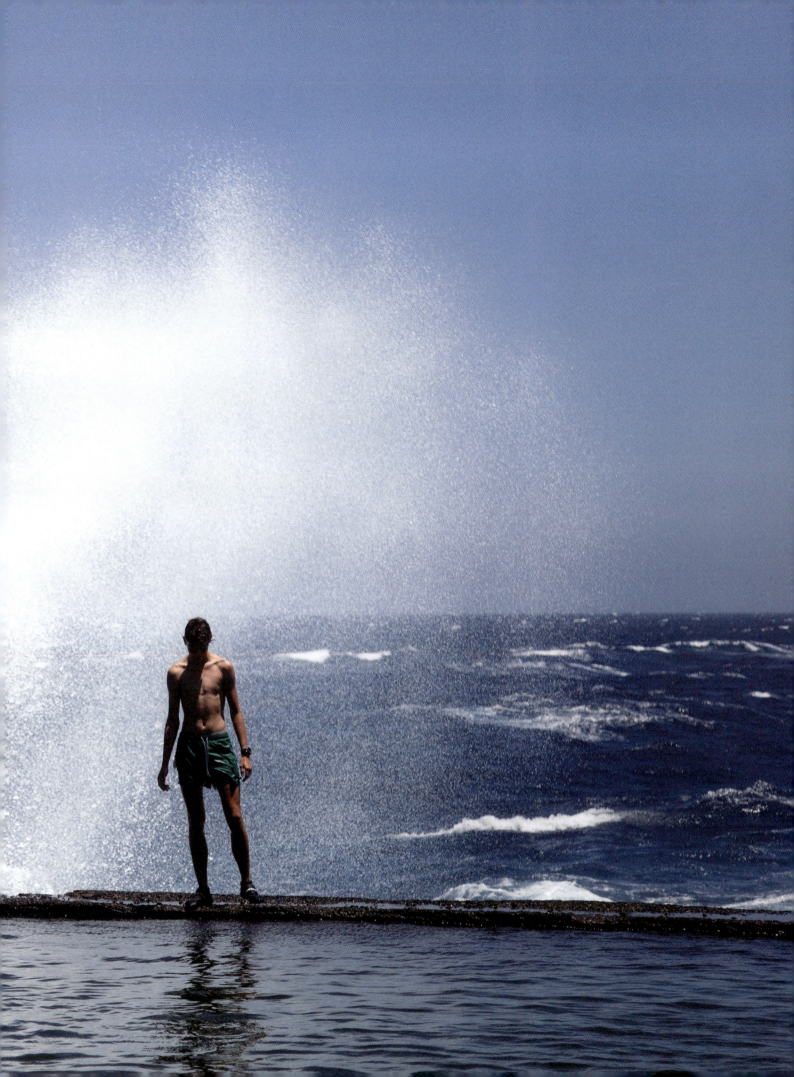

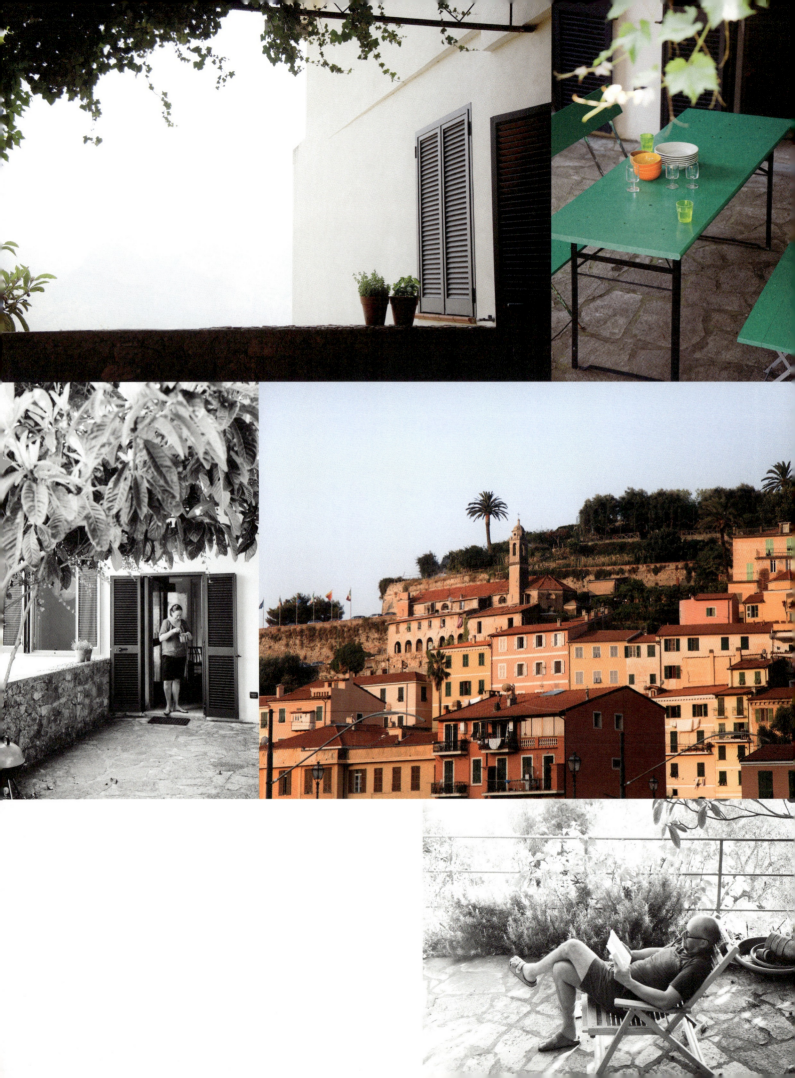

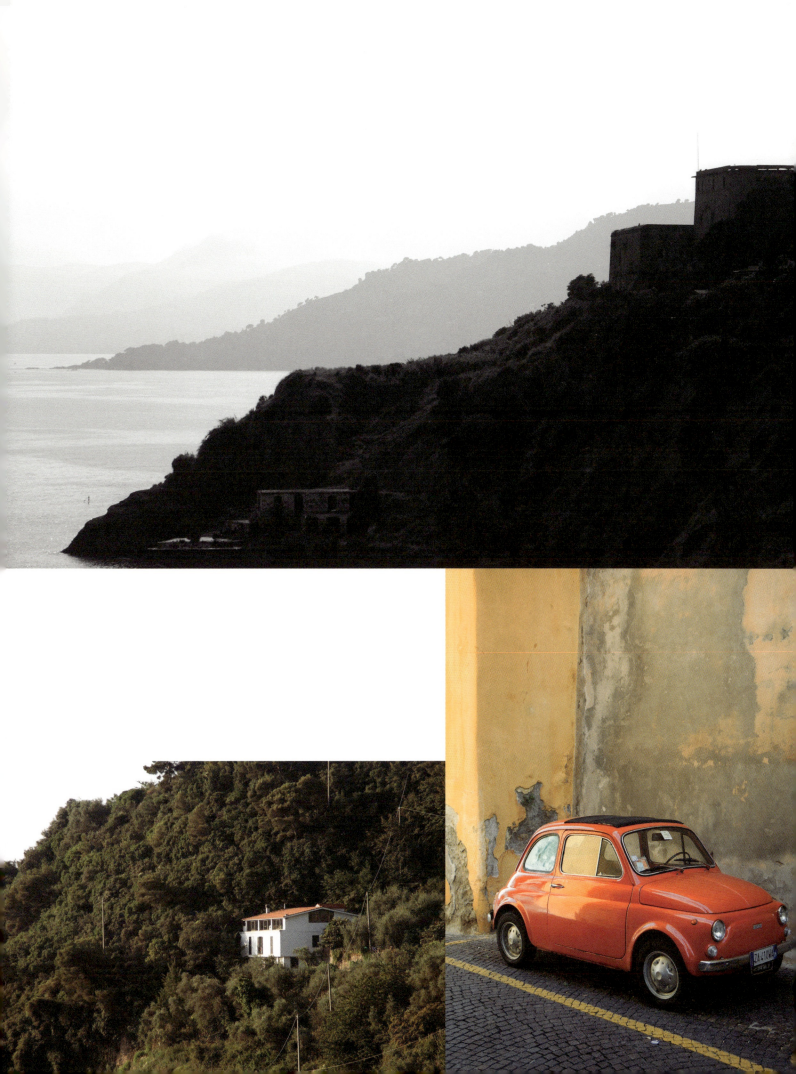

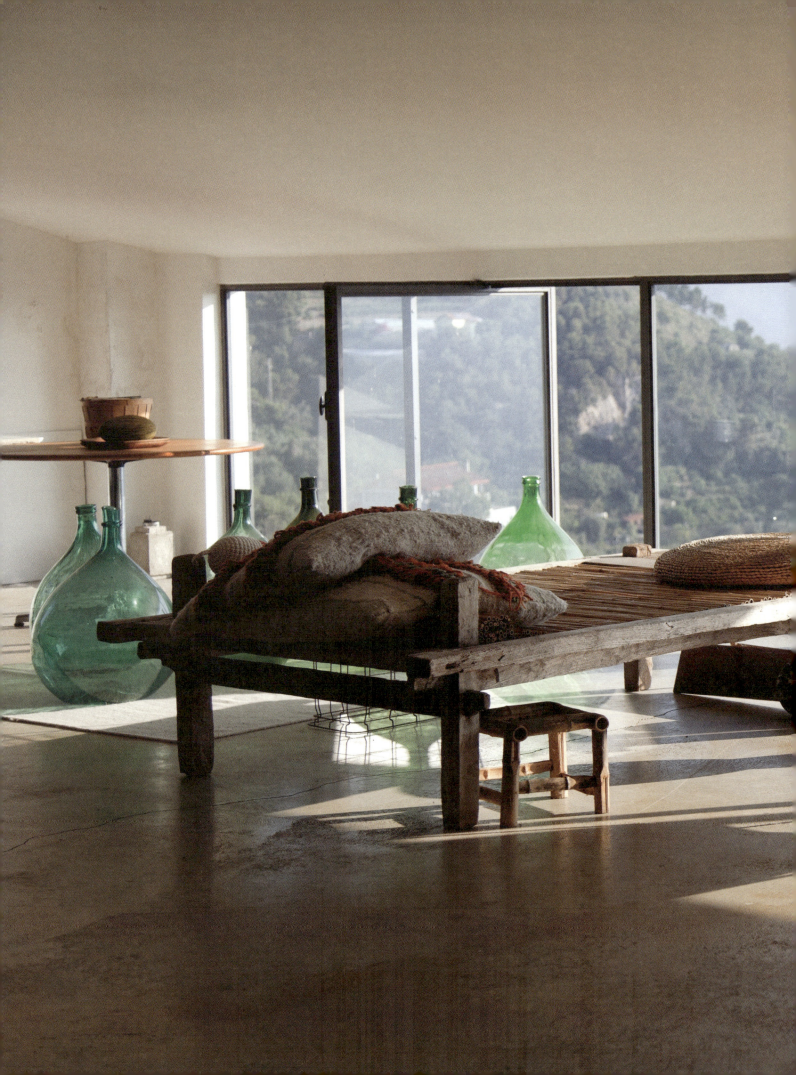

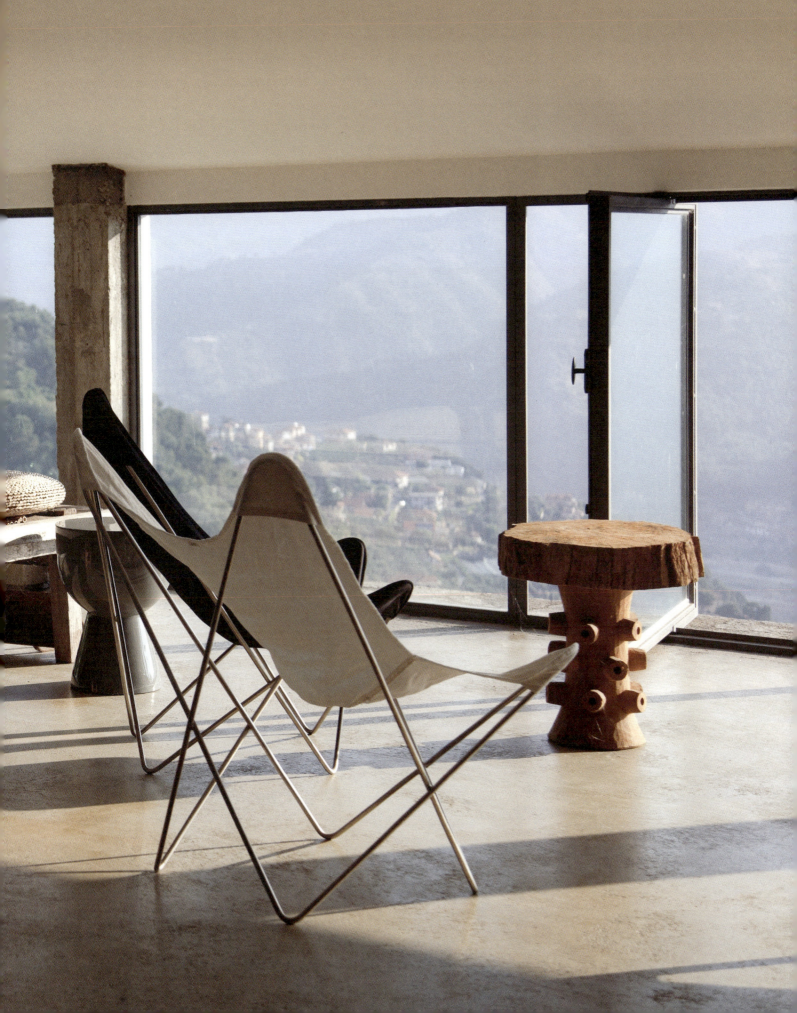

WHO?

Jan Wolleswinkel is the joint owner and product designer for interior design company Pols Potten. His wife, Anne-Claire Petit, has her own line of colourful and mostly handmade children's and interior design objects in natural materials: Anne-Claire Petit Accessoires. The Dutch couple have two sons, Marius (17) and Toon (14).

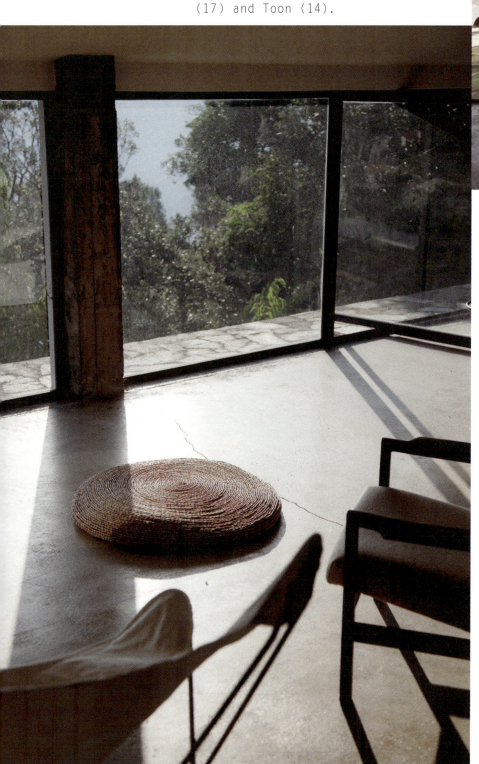

Anne-Claire and Jan bought their holiday home in 2005, mostly because they loved the location. "We got to know the village when we rented a house from friends during the summer holidays. It's a wonderful place, with both the sea and beautiful rivers nearby. We go swimming and sailing, take canoeing trips and we can body raft on the river. And then of course there are the Alps for hiking and skiing. The fact that the place is easy to get to is an added bonus: we're not far from Nice (which has its own airport), San Remo and Genoa."

WHERE?

In Ventimiglia, right on the border between France and Italy. The house is located on a spur of the Maritime Alps.

Most importantly of all, the house they fell in love with has a fantastic view of the Alps. It was built in 1986 but was never really completed. Until Jan and Anne-Claire bought it, a Calabrian family was using the structure as a party venue. It had a large fireplace and a very basic kitchen; the rest was mostly storage space. The property also included several greenhouses filled with lush vegetation. Jan and Anne-Claire have turned the house into a great holiday home. "We installed stairs, incorporated the lean-to into the ground floor and changed the floor plan. We live on the top floor (which includes a kitchen unit), so we can take full advantage of the beautiful panorama."

The interior design adds to the sense of space and seems to emphasise the beauty of the stunning view even more. "We try to keep things simple but also functional. What is most important for us is that we can relax here, because we both travel a lot for work. We try to spend as much time as we can here during holiday periods, reading, cooking or working on the house or on the land – especially in the olive grove. It's very relaxed, and a great place to invite friends and family over. Our sons love to bring friends here too."

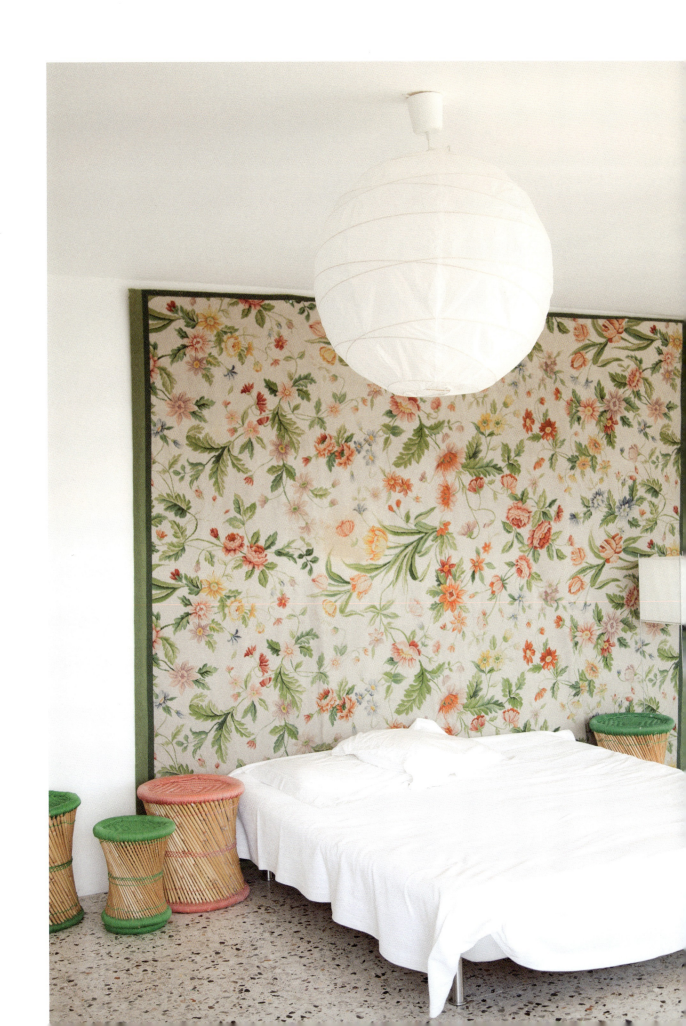

COSTA RICA

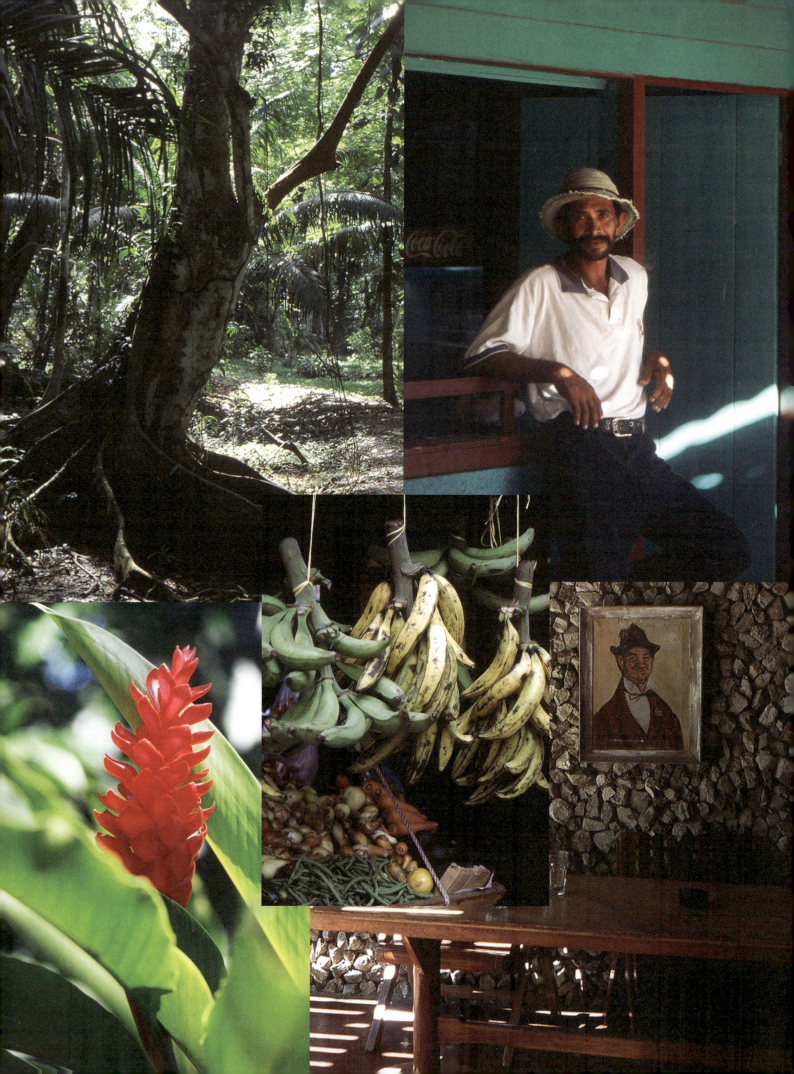

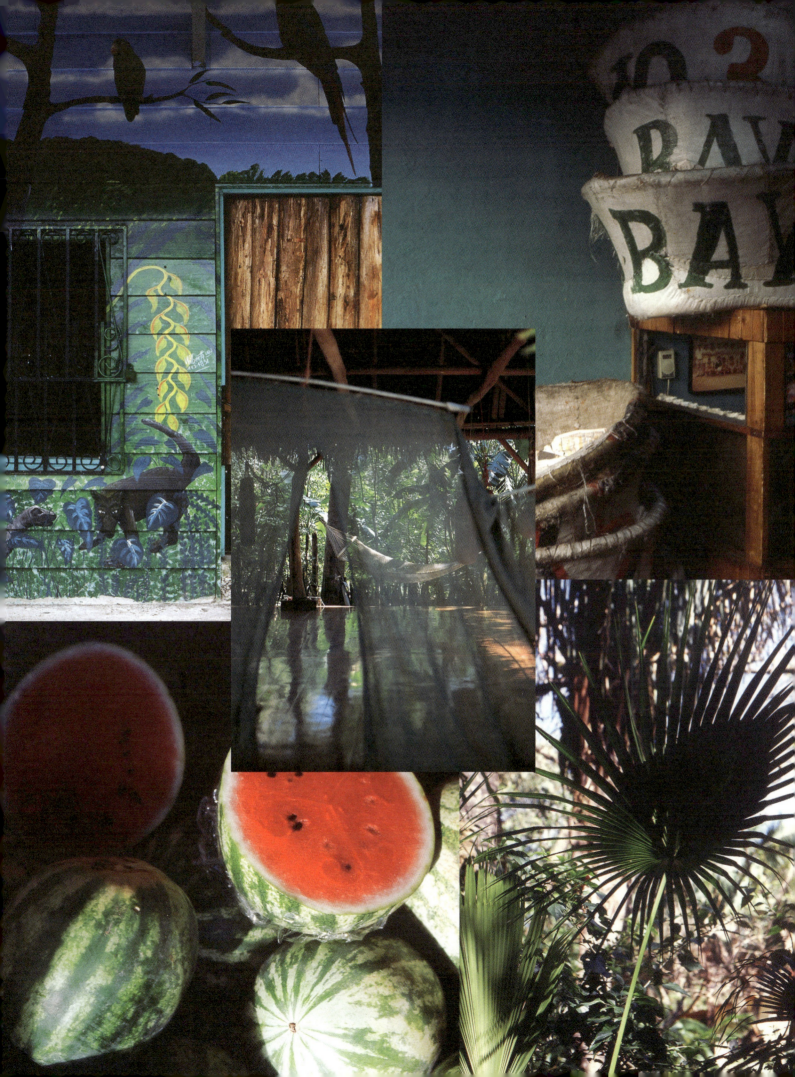

WHO?

Dutchman Daan Nelemans and his wife Marisol (she is originally from Nicaragua) run holiday resort Congo Bongo. They have a daughter, Masai (12).

WHERE?

At the Gandoca-Manzanillo wildlife refuge on the Caribbean east coast of Costa Rica, close to Manzanillo, a small town just north of the border with Panama.

Daan Nelemans used to run a flower shop in Amsterdam, but at the age of 28 he opted to look for a different life. He set off for Costa Rica with no specific plans, met Marisol and bought a 5-hectare plot of land on the Caribbean coast. He decided to build not only their own house but five wooden huts as well. He and his wife rent these out as private holiday homes with hotel services. To achieve this, Daan had to start by using his machete: the estate is situated in the midst of the jungle, in a lush, overgrown area with a huge variety of tropical vegetation. In this unique place, colours seem more intense than anywhere else in the world, from the deep green of the large leaves on the cecropia trees to the bright red of the heliconia flowers. As you gaze at the beautiful views, it is possible to hear the monkeys screeching as they swing from tree to tree. Daan's holiday resort owes its name to them - the Congo is one of two species of monkeys found in the wildlife refuge.

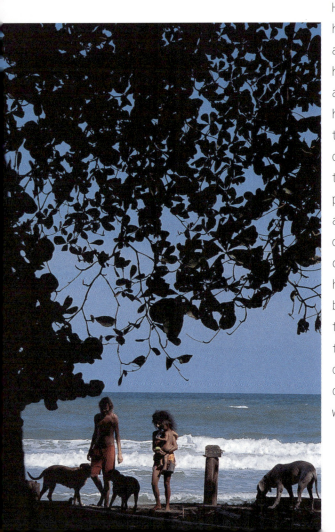

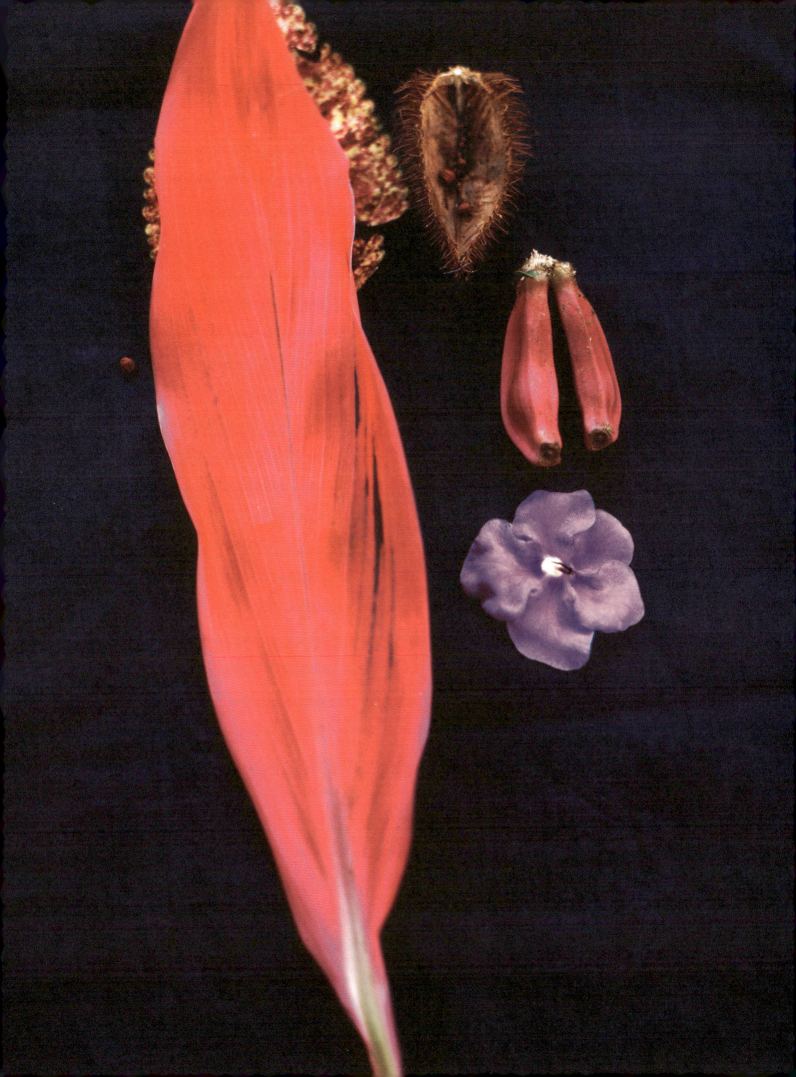

The most special thing about this area of jungle is that it is right next to a pearl-white beach. This is where Marisol searches for the seashells and other natural materials which she uses to create jewellery. Close proximity to the beach, where the sea is perfect for swimming, snorkelling, diving and dolphin-spotting, makes Manzanillo the ideal refuge. This is a place to come and leave all your stress behind. The locals have a perfectly relaxed attitude to life. This may have something to do with their Jamaican roots - this is a place for dreadlocks, colourful clothing and houses and a local bar where everyone knows everyone else.

The houses Daan has almost single-handedly built in the jungle are not so much colourful as in keeping with their unique environment. They are never more than two storeys high, built of wood and almost entirely open to the elements. Every comfort is provided - including mosquito nets, for example - but there are no walls and almost no glass windows: the only thing separating the residents from the fragrant, colourful jungle is a series of thin screens.

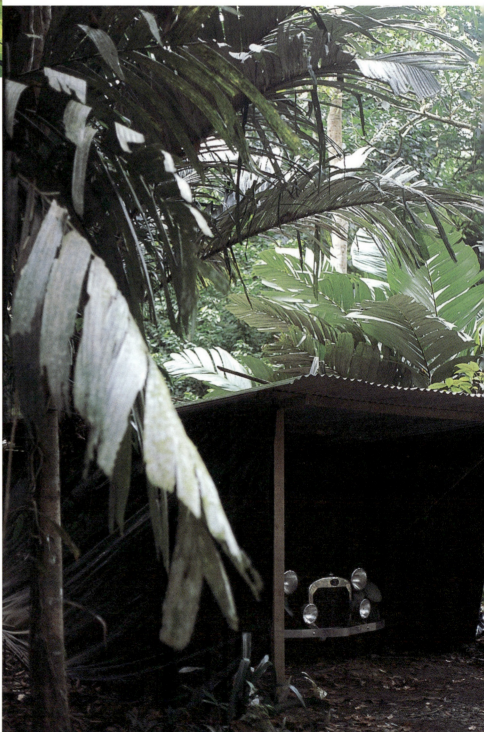

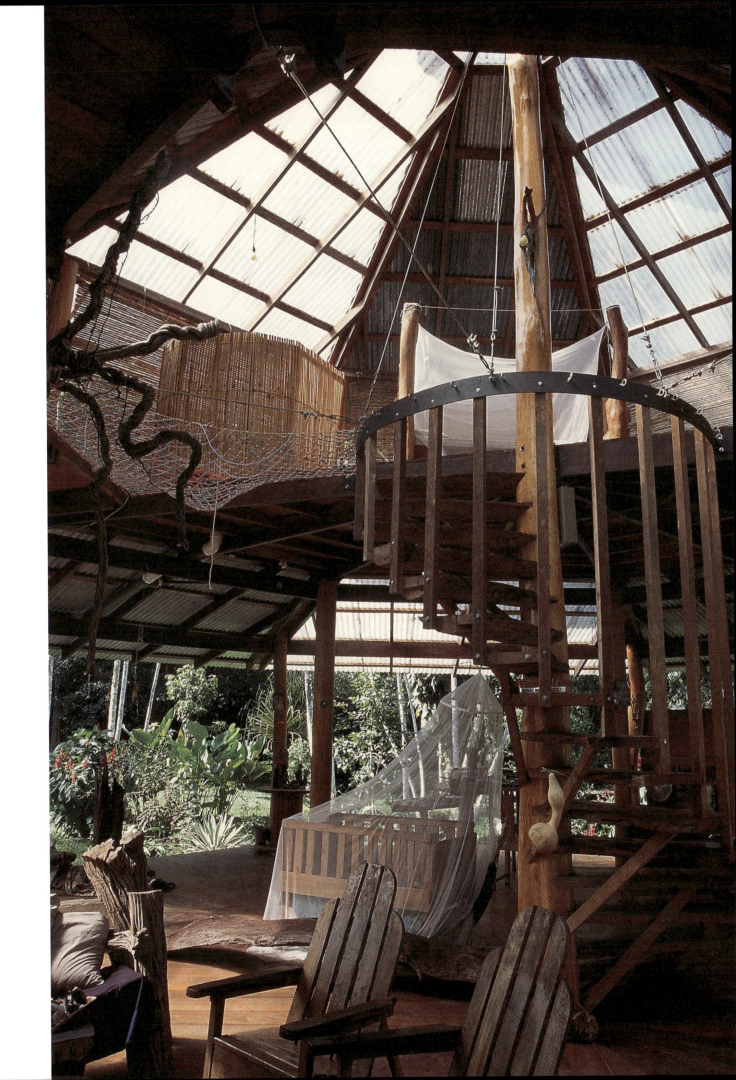

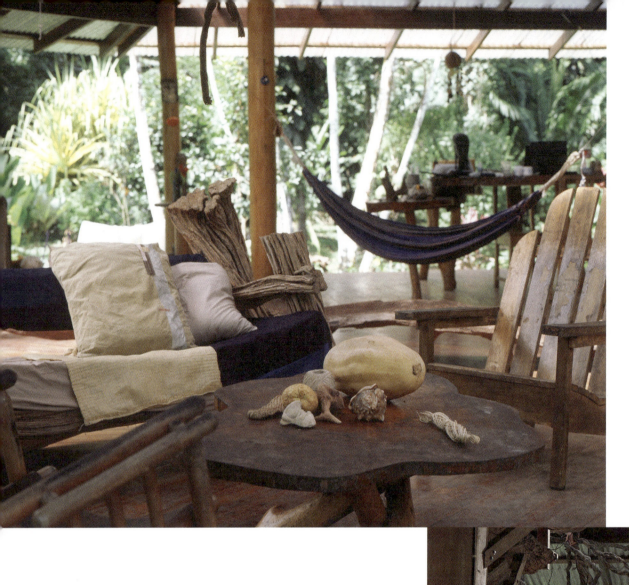
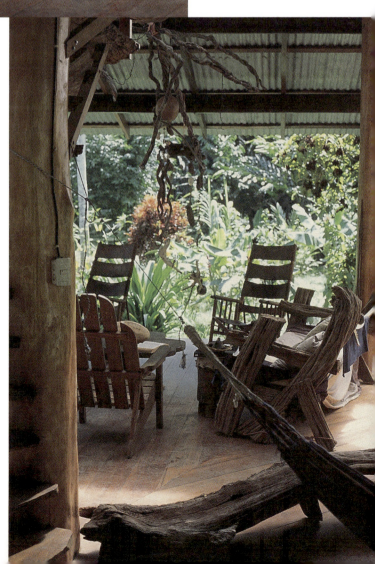

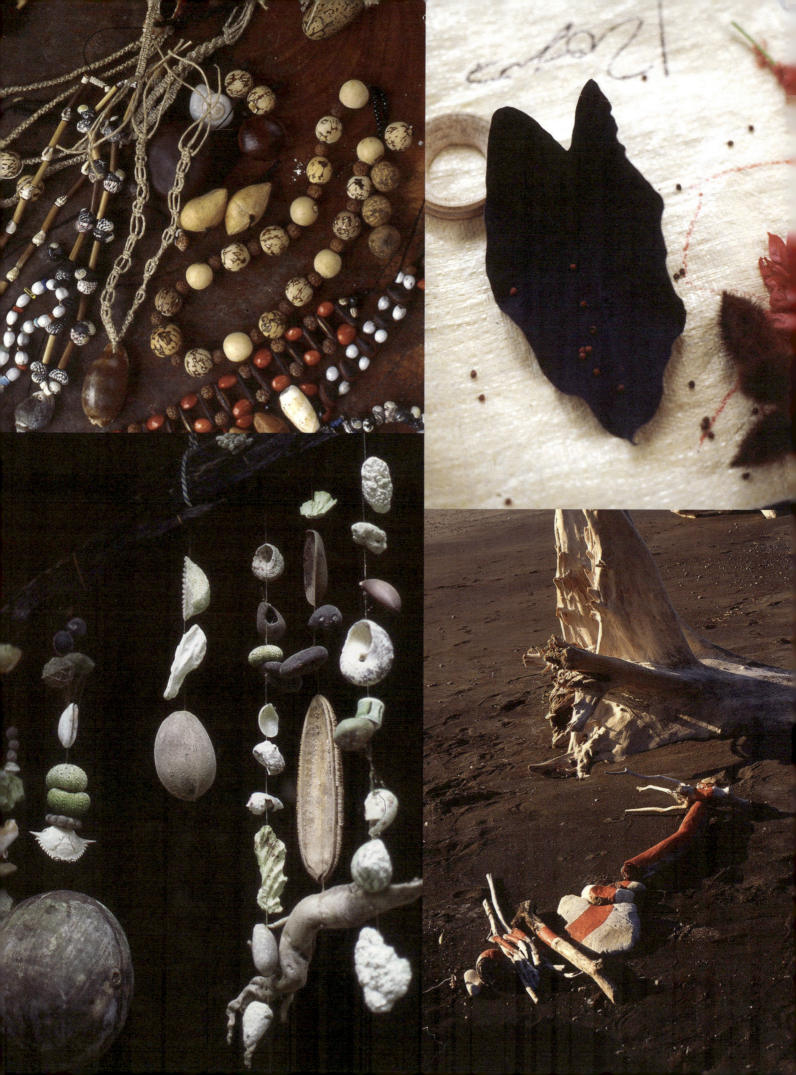

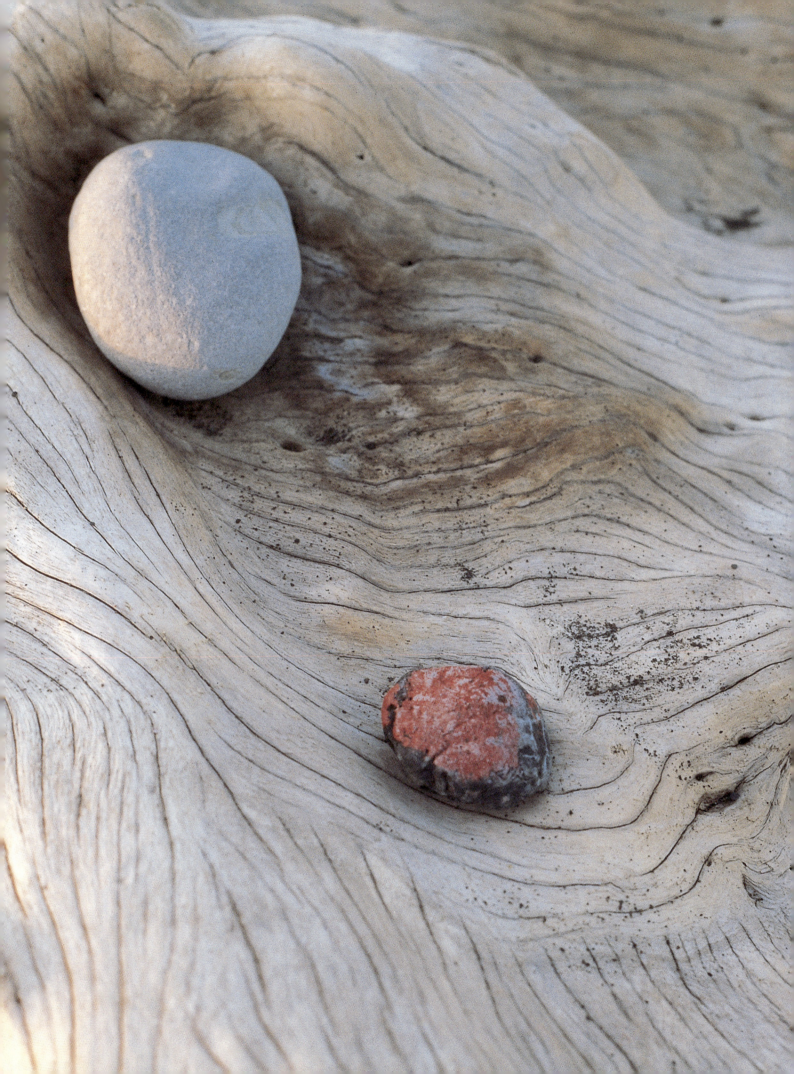

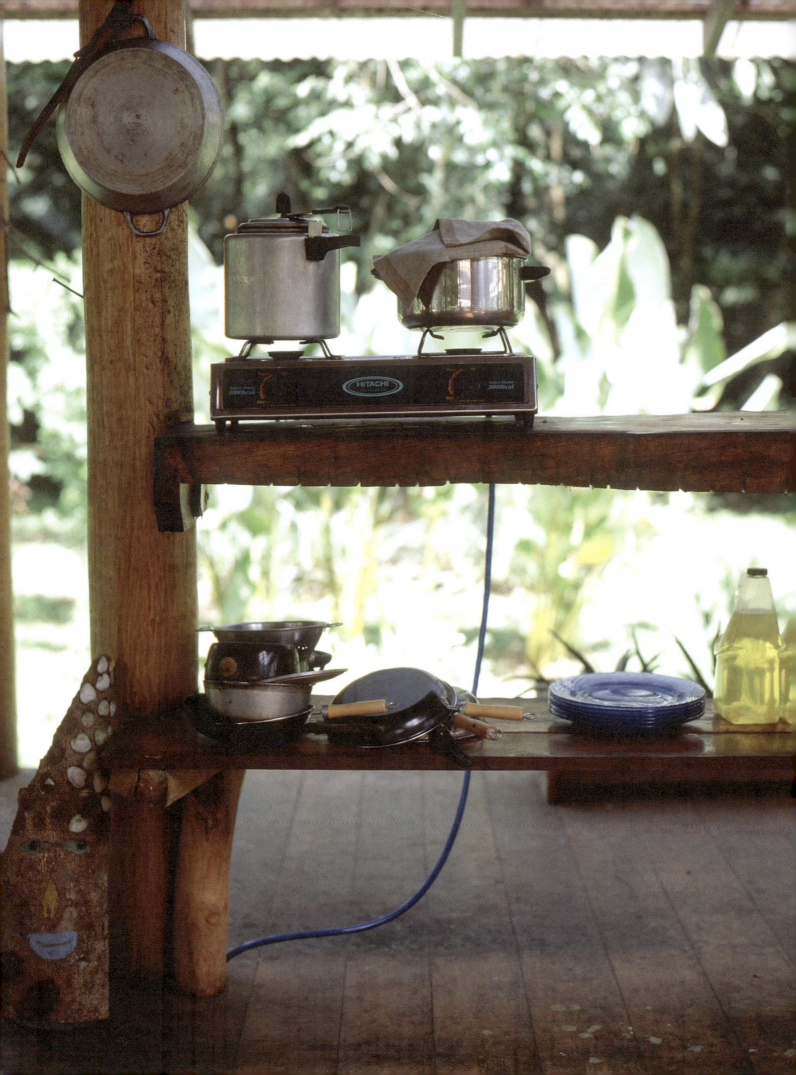

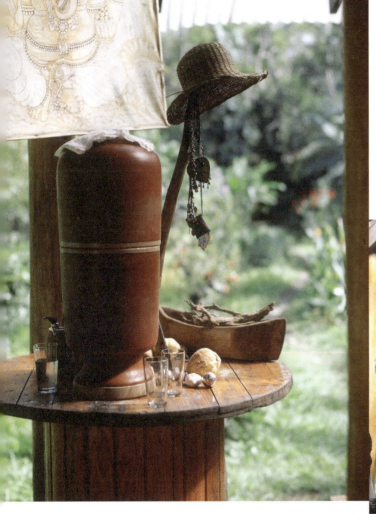
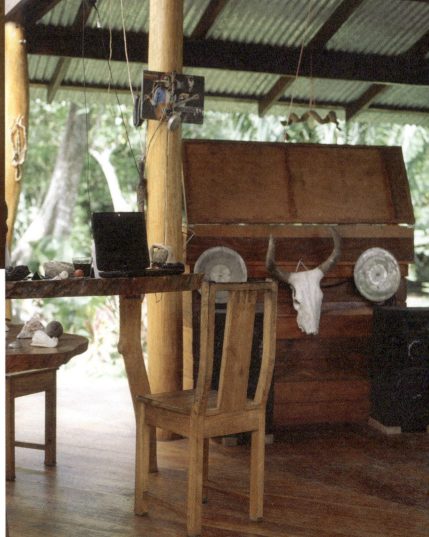

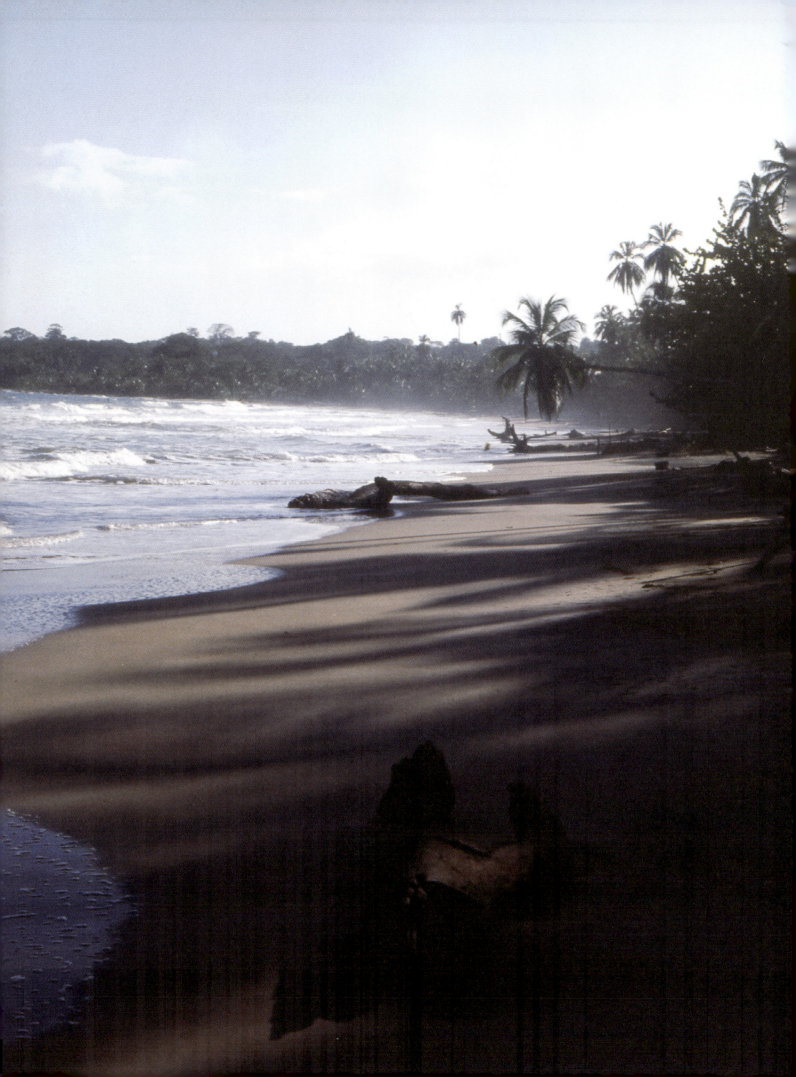

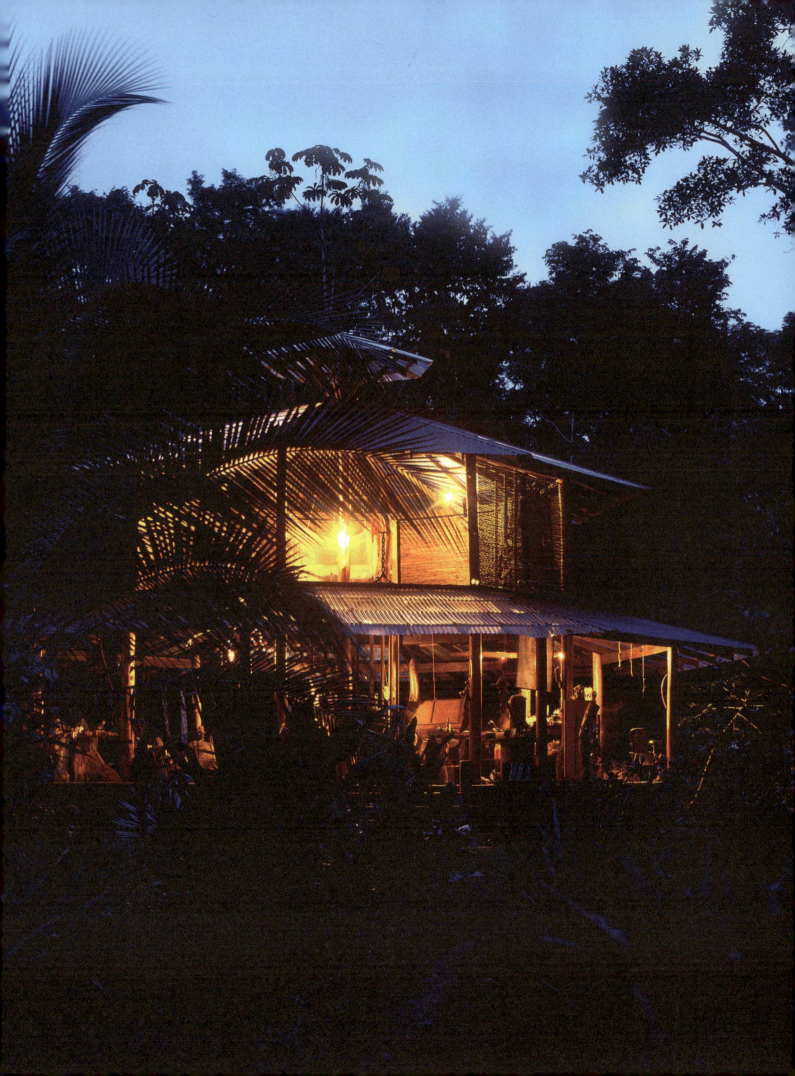

SWEDEN

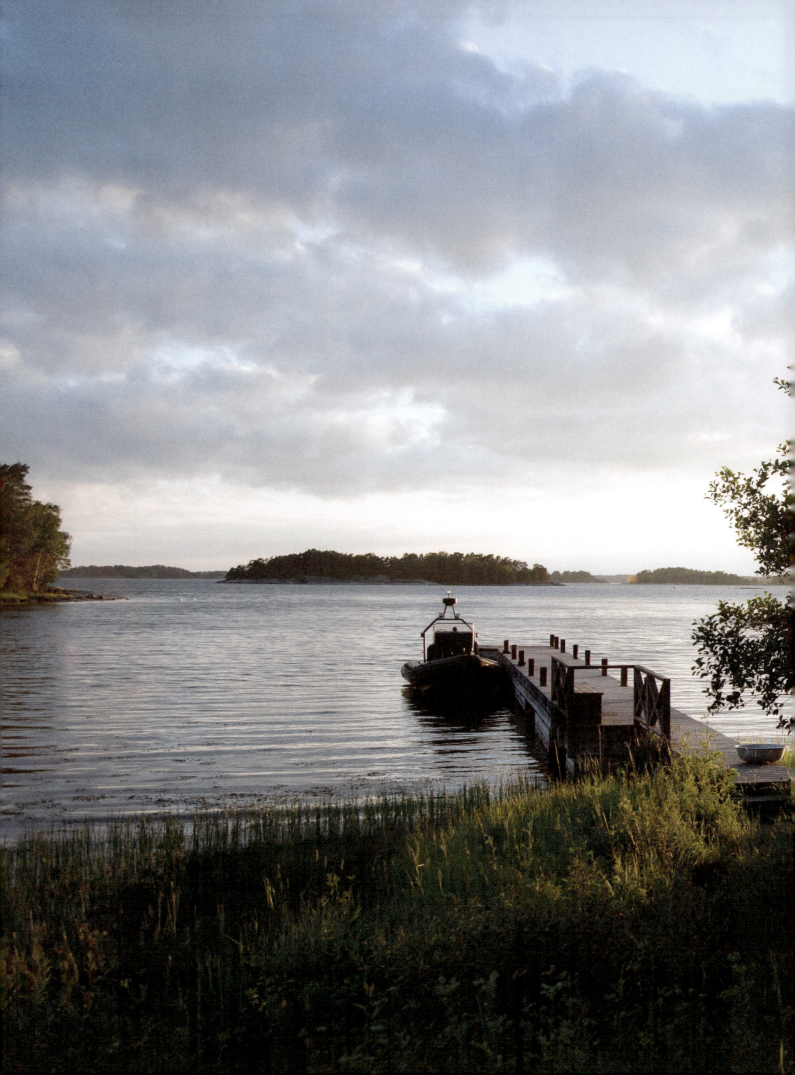

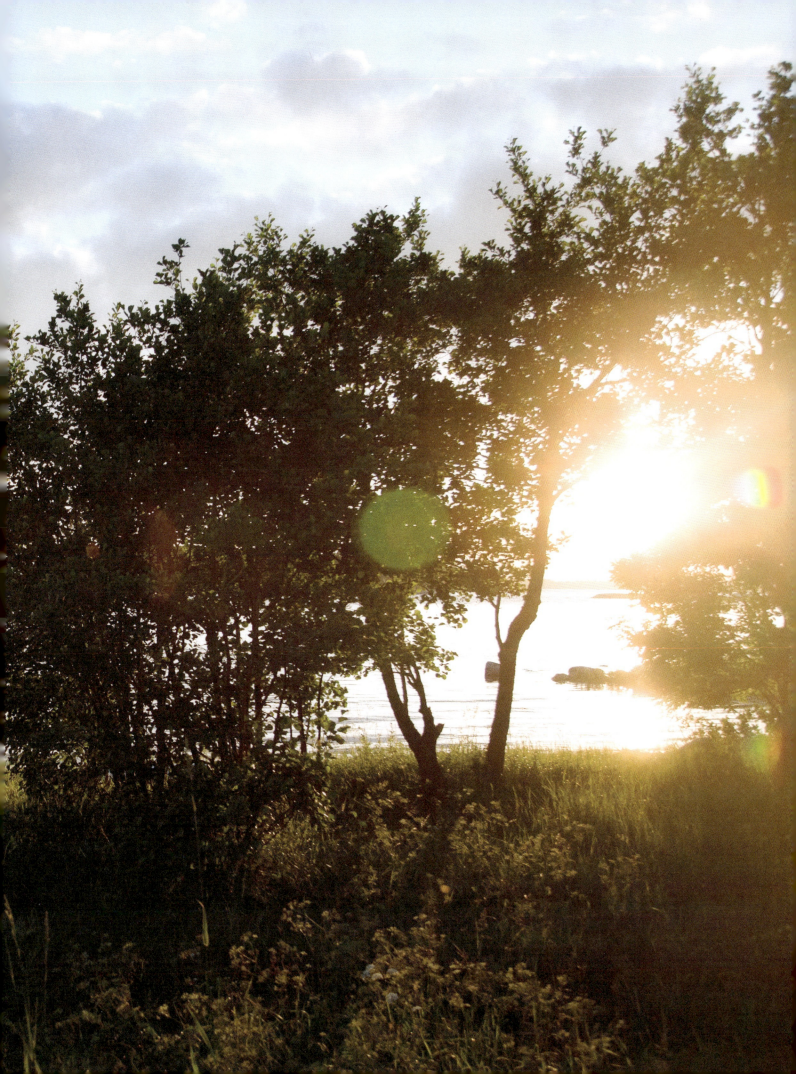

WHO?

Carouschka Streijffert is a Swedish architect and artist. She works on a wide range of projects, including converting and remodelling living spaces, public spaces and small houses, creating designs for exhibition stands and constructing sets for both stage and cinema. As an artist, she has had about thirty exhibitions and has participated in a large number of joint exhibitions.

WHERE?

A small island in the Stockholm archipelago, which can only be reached by private boat.

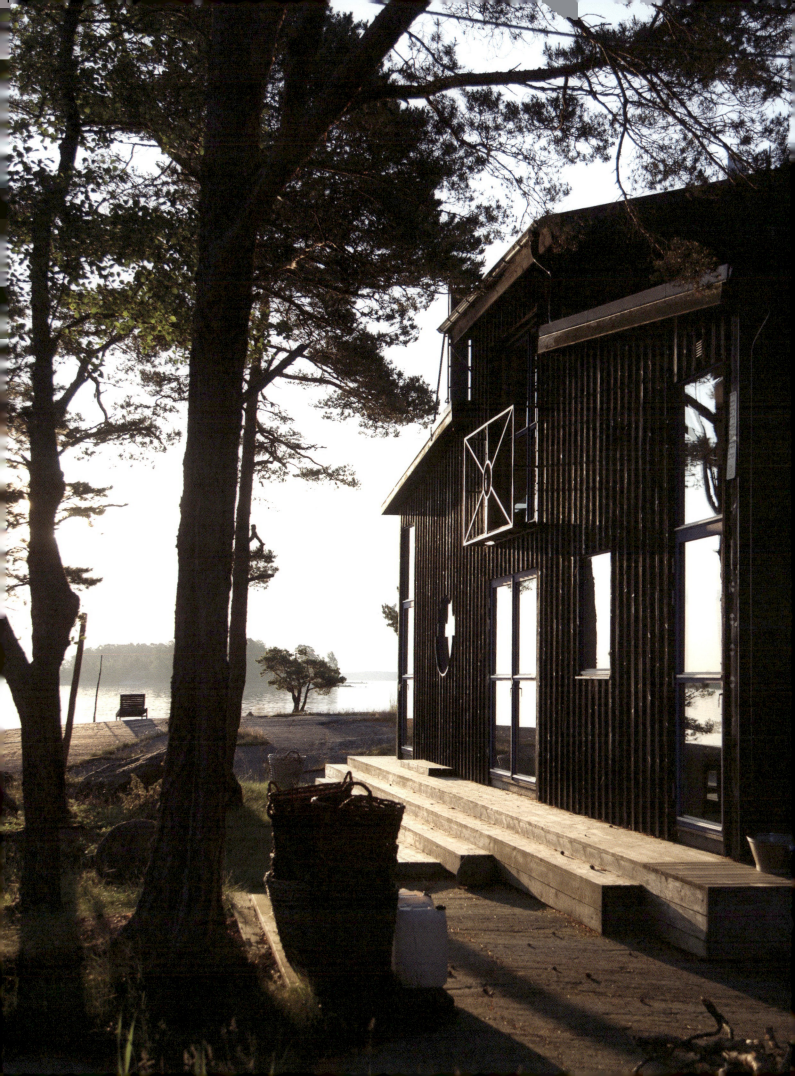

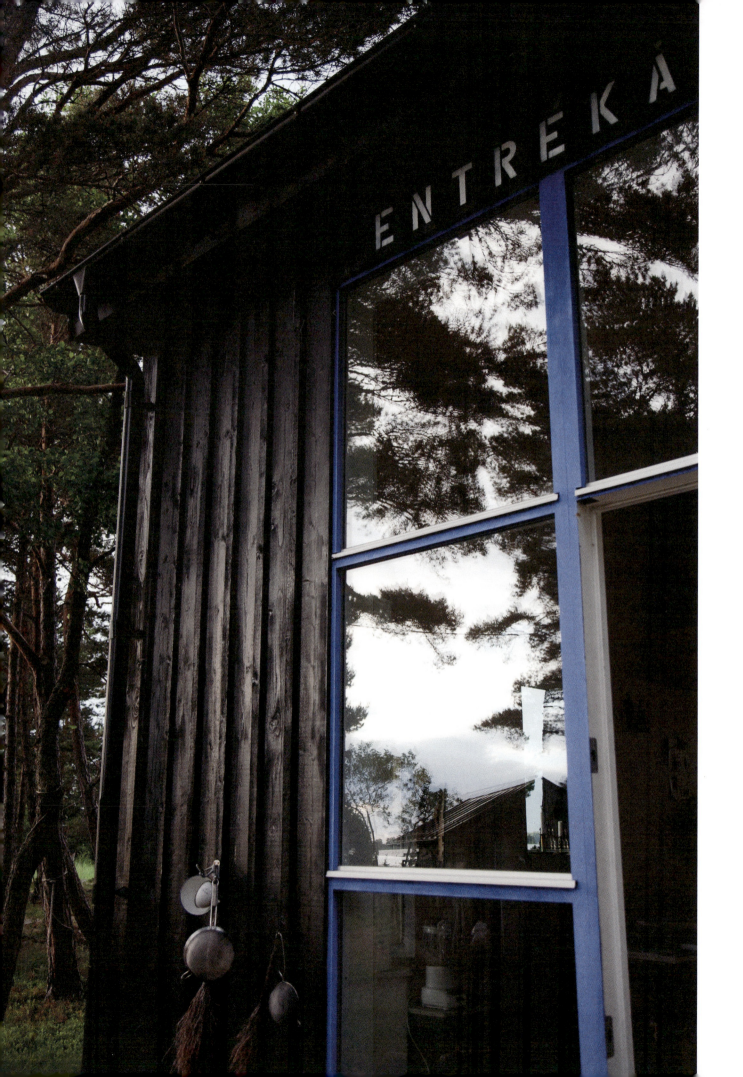

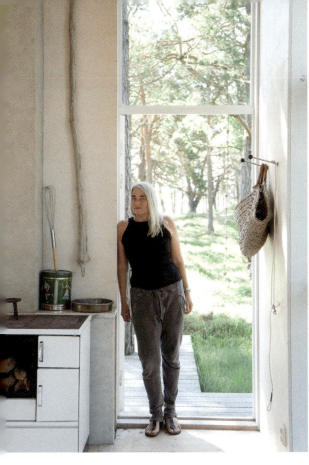

Carouschka found her island when her son was still a little boy. She was travelling in the archipelago with him, looking for a quiet, beautiful and natural spot to start her studio. "When we went ashore, I knew right away that this island was the place I had been yearning for. A small, desolate hut was there, which had been built in 1955. Other than that, the island was completely deserted. There was no running water, no electricity, just trees, the sea and endless light. I immediately started enquiring whether I could buy the island and as it turned out, I could. That was a lot easier back in those days, than it would be now."

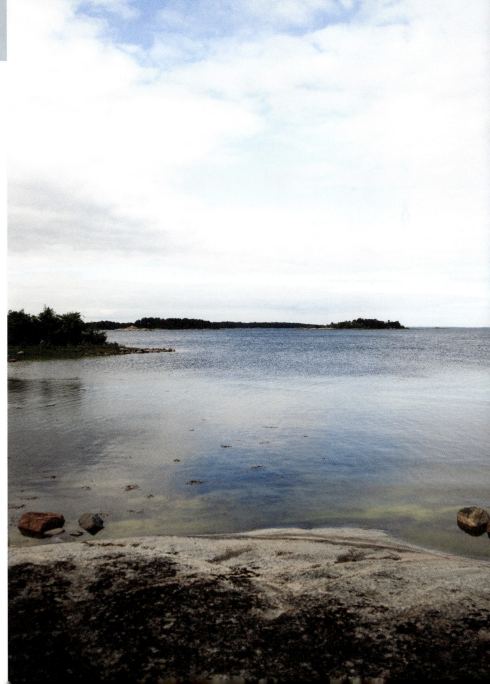

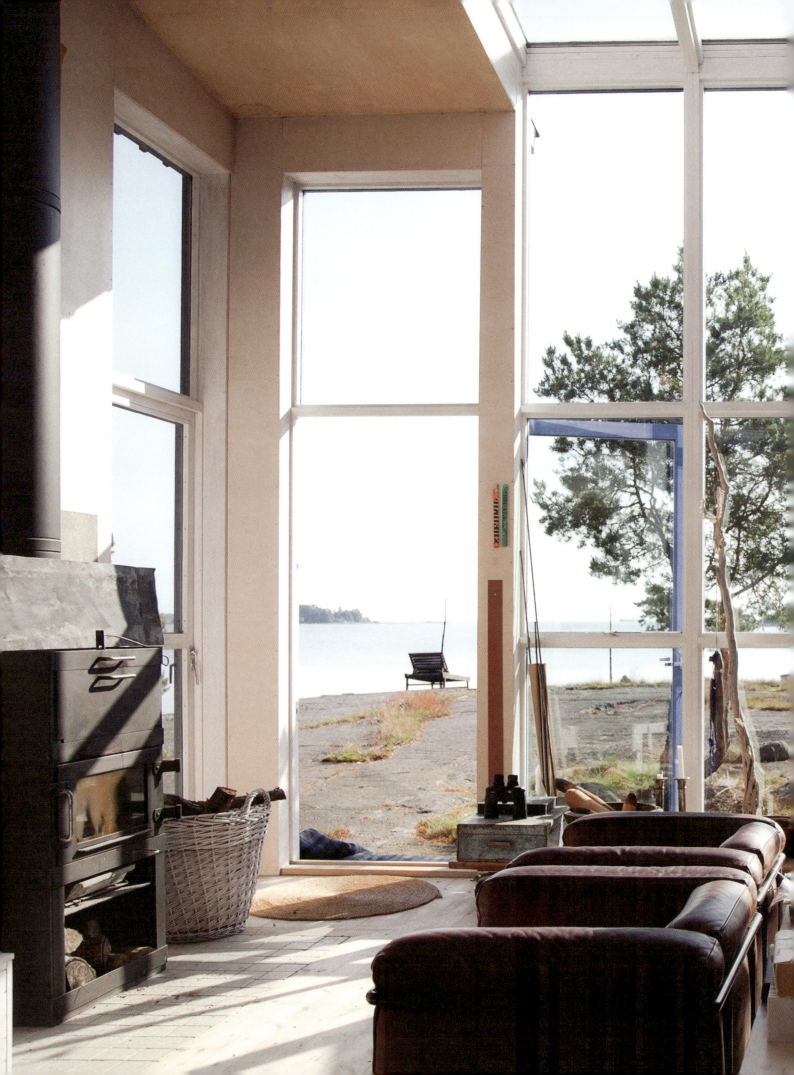

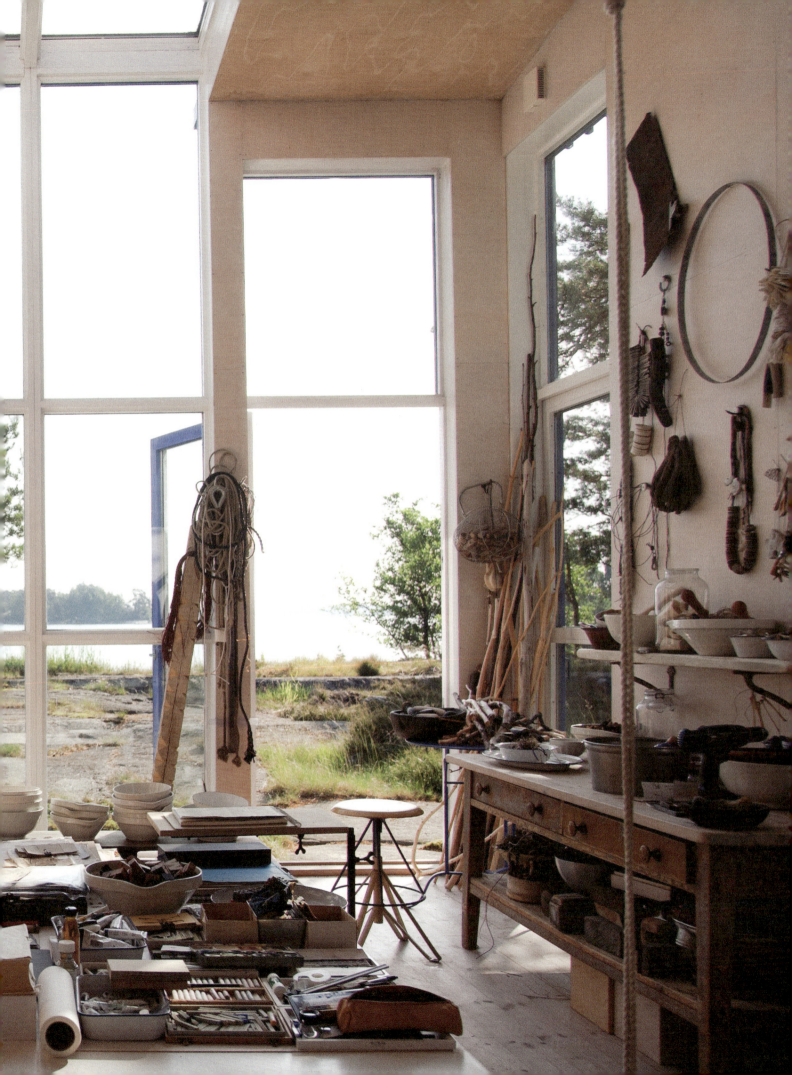

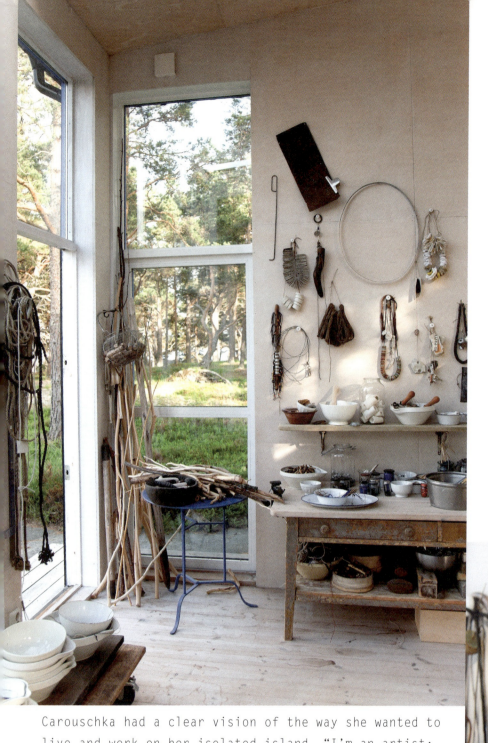

Carouschka had a clear vision of the way she wanted to live and work on her isolated island. "I'm an artist; working is like breathing to me. I did not want a normal residence on the island, I wanted a studio. I knew exactly what it had to look like: one big, open space in which I could work and create, with as much light as possible. Almost everything is made of wood, including the outer walls. I did not want any dividing walls, but there are fourteen doors that all open (with the exception of a few small windows). I always open a few of the doors depending on which way the wind is blowing, so the outside world - water, sand, wind, the sound of the trees and the birdsong - has an opportunity to come in."

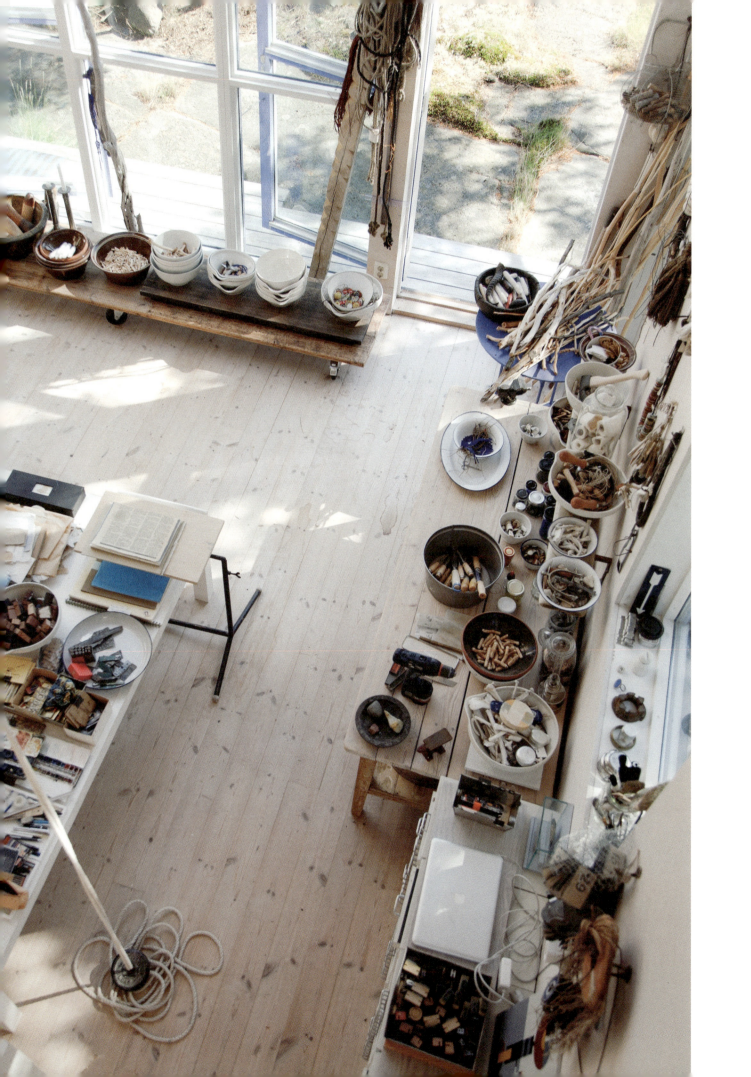

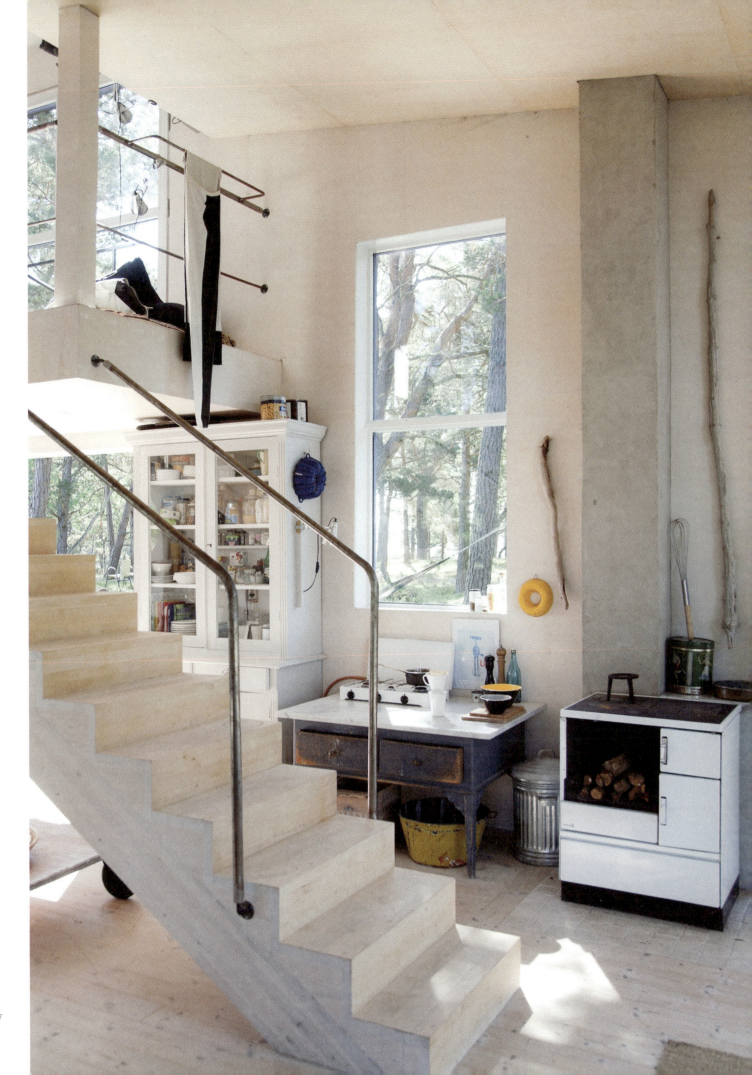

Light, space, a fireplace and a bed: that's all Carouschka needs, so that's all there is. In all its starkness, however, her design and the way she has built it are poetic too; perhaps even magical. To live entirely alone, with no luxury of any kind, in what might be called the Swedish jungle, waking up with the sunlight on your face... it definitely fires the imagination. "If there is a recurring theme or style in all my interior design and art projects, it is this sense of poetic functionalism. My studio was designed to be the perfect working space, isolated from the outside world. Much of what you see is actually working material - I use it to create sculptures, collages or paintings."

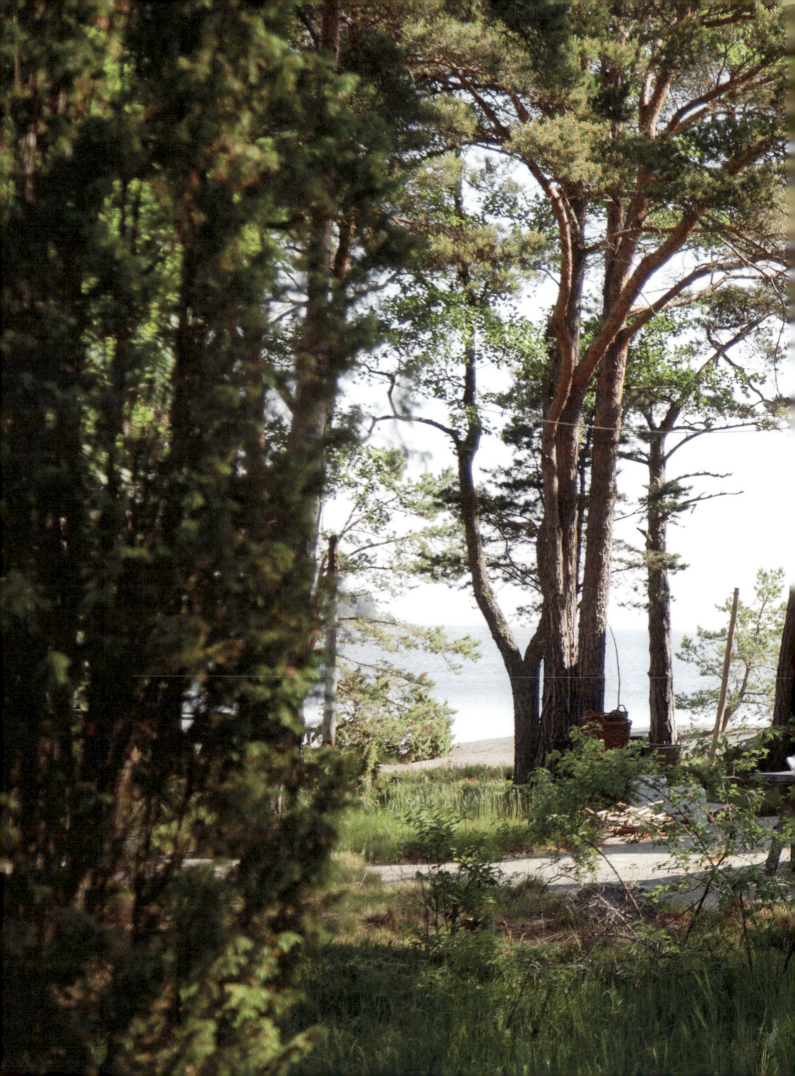

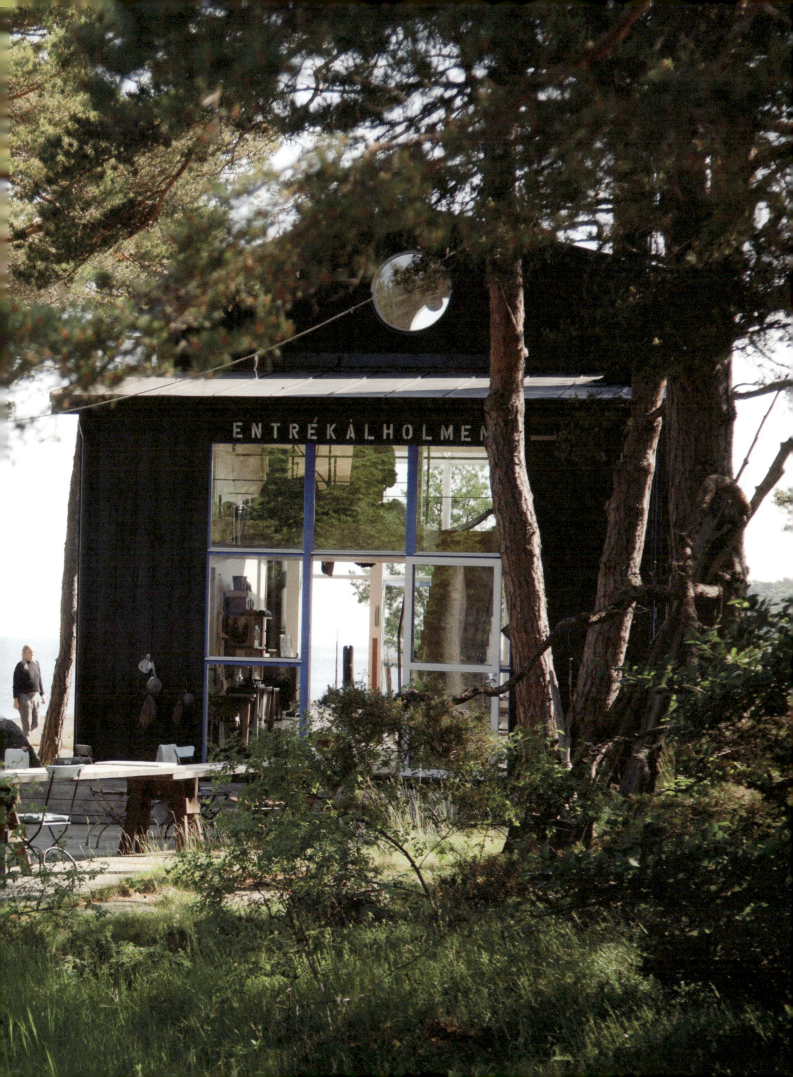

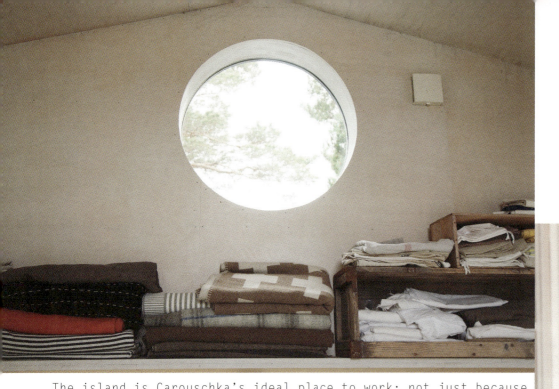

The island is Carouschka's ideal place to work; not just because it inspires her, but most of all because it's a place of inner peace and retreat. Here, away from the world, there is no luxury, no hassle and no distractions. "I live and work in Stockholm from September to April. I enjoy my busy social life there. But when summer is coming and the days grow longer, I always long for isolation. That's when I leave for my island and spend three months there. Visitors are welcome - I have built a guest house next to my studio - but I don't get many of them, apart from my son and grandchild. That is exactly how I want it. I want to spend my summers here forever: bathed in light, right here on the water."

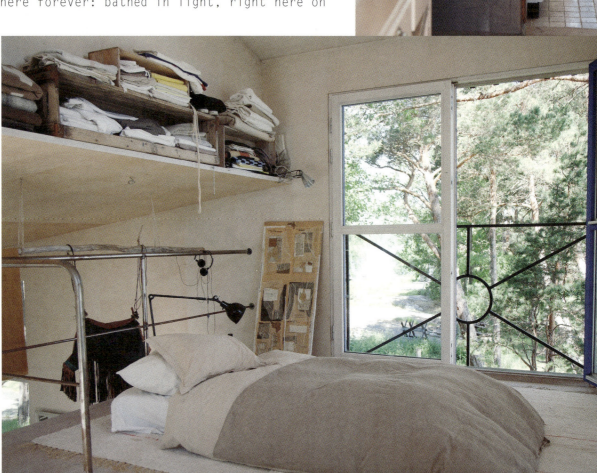

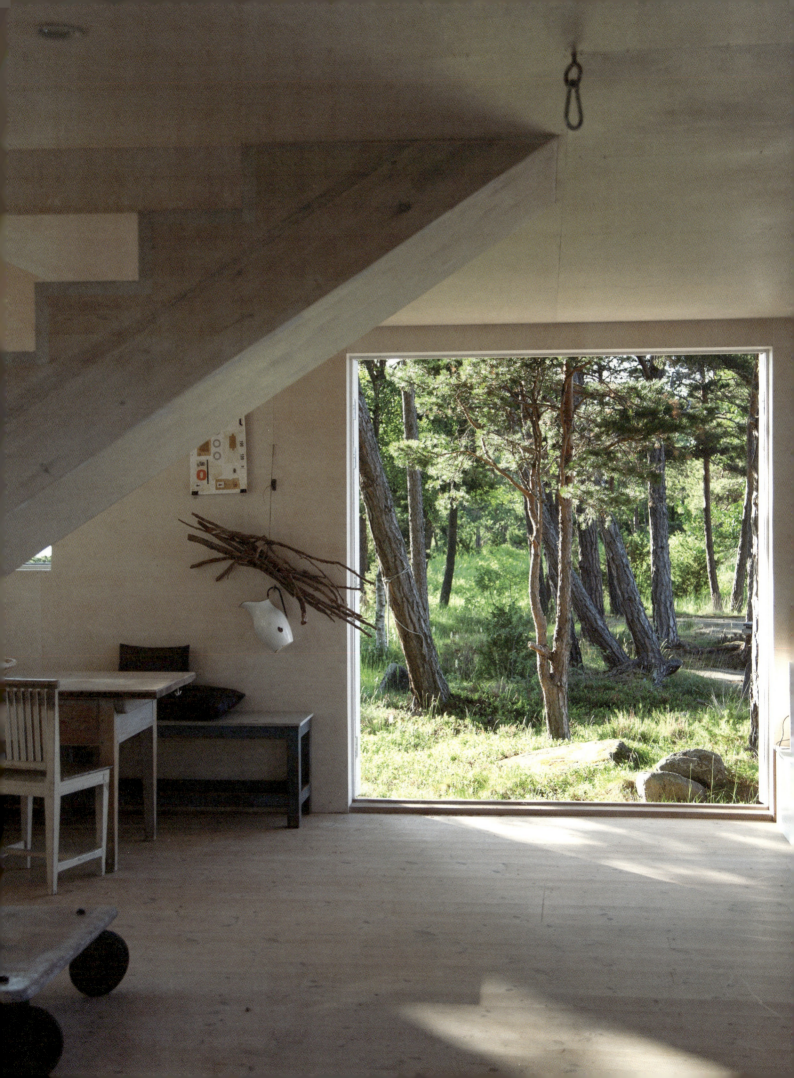

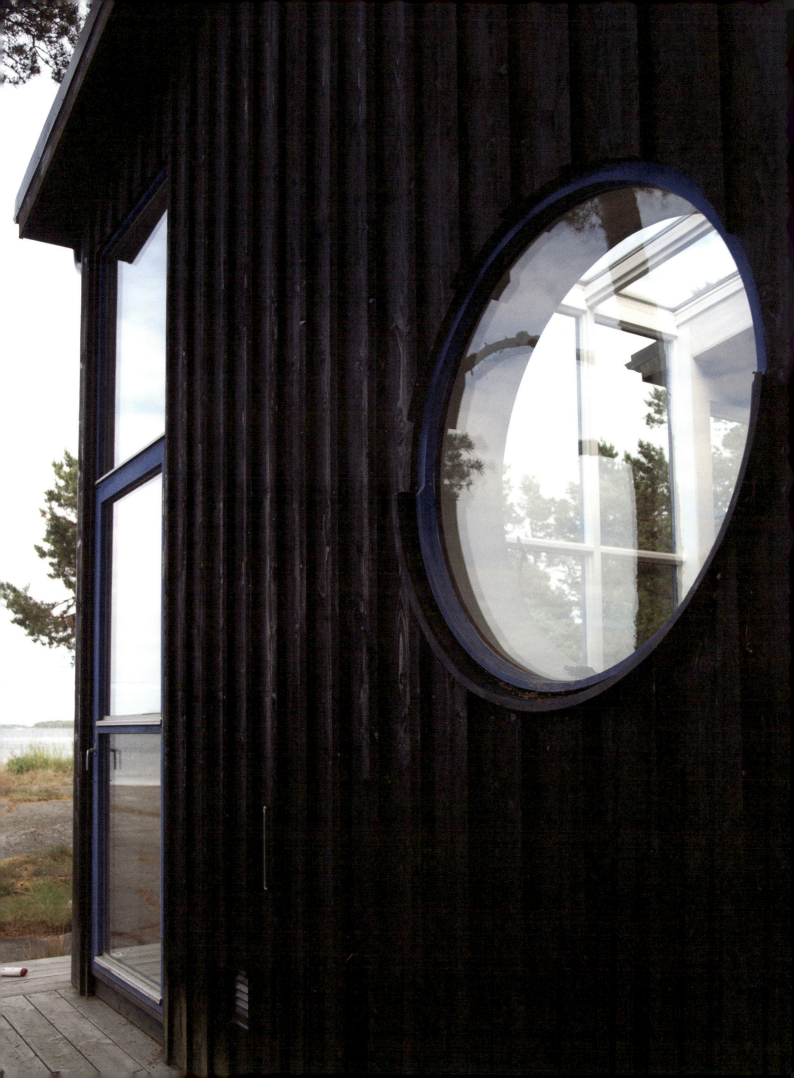

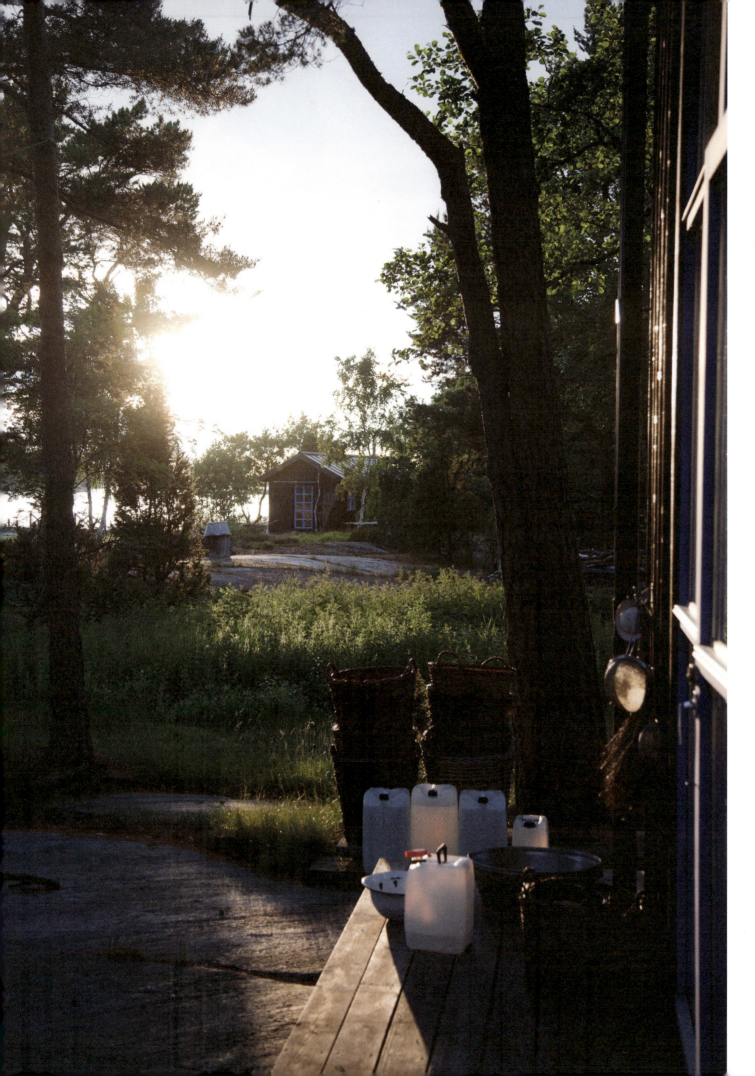

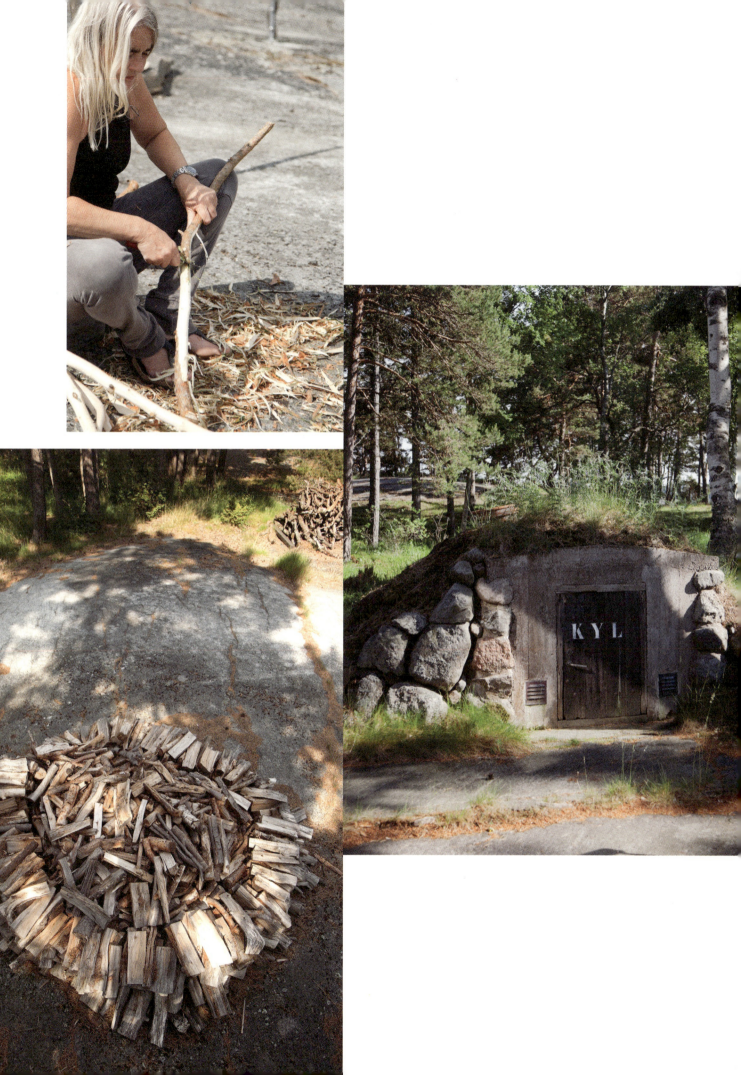

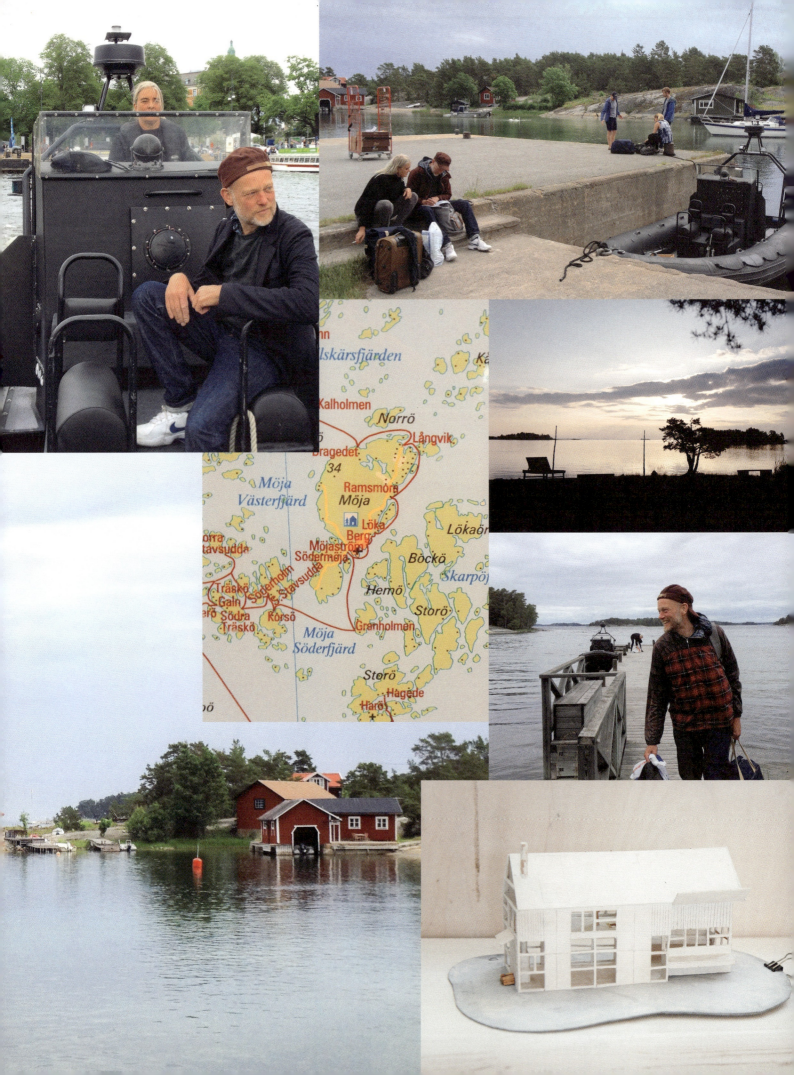

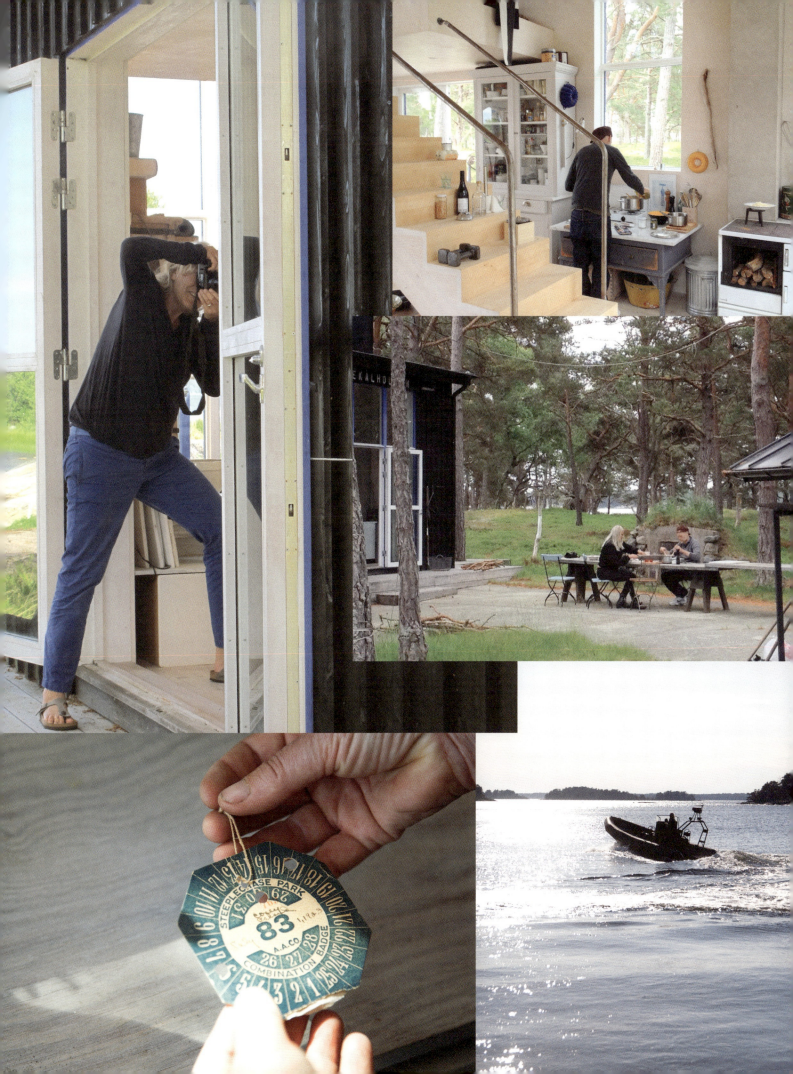

PORTUGAL

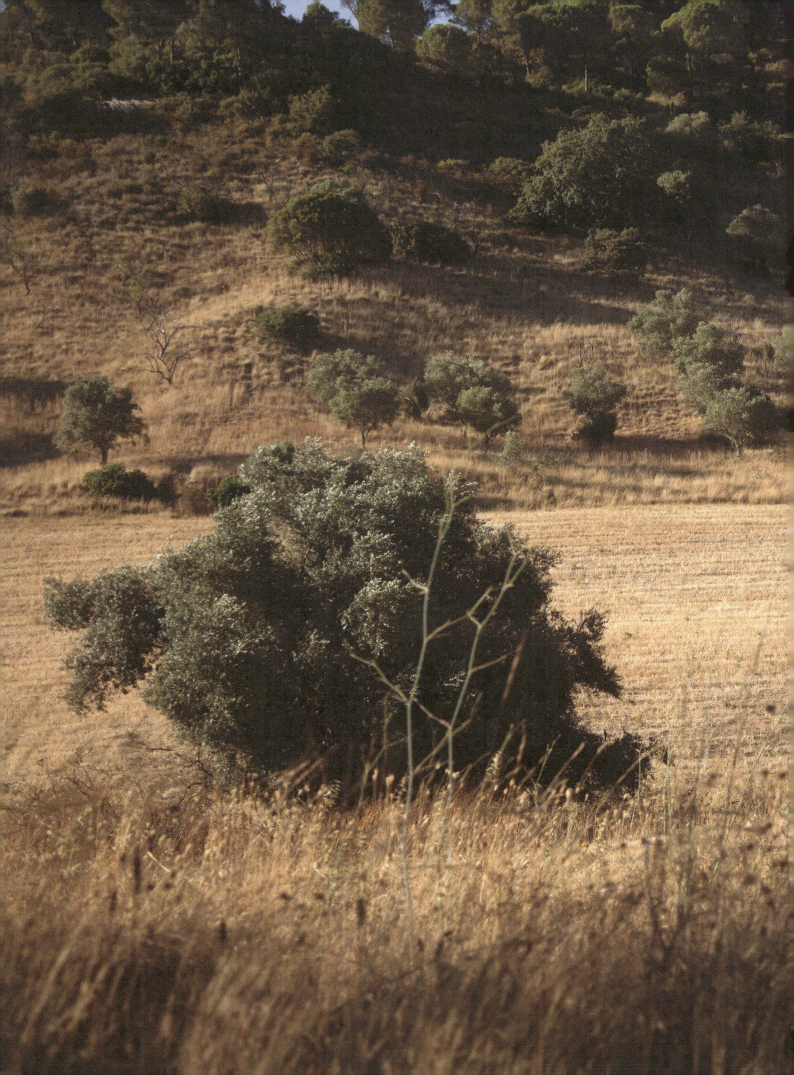

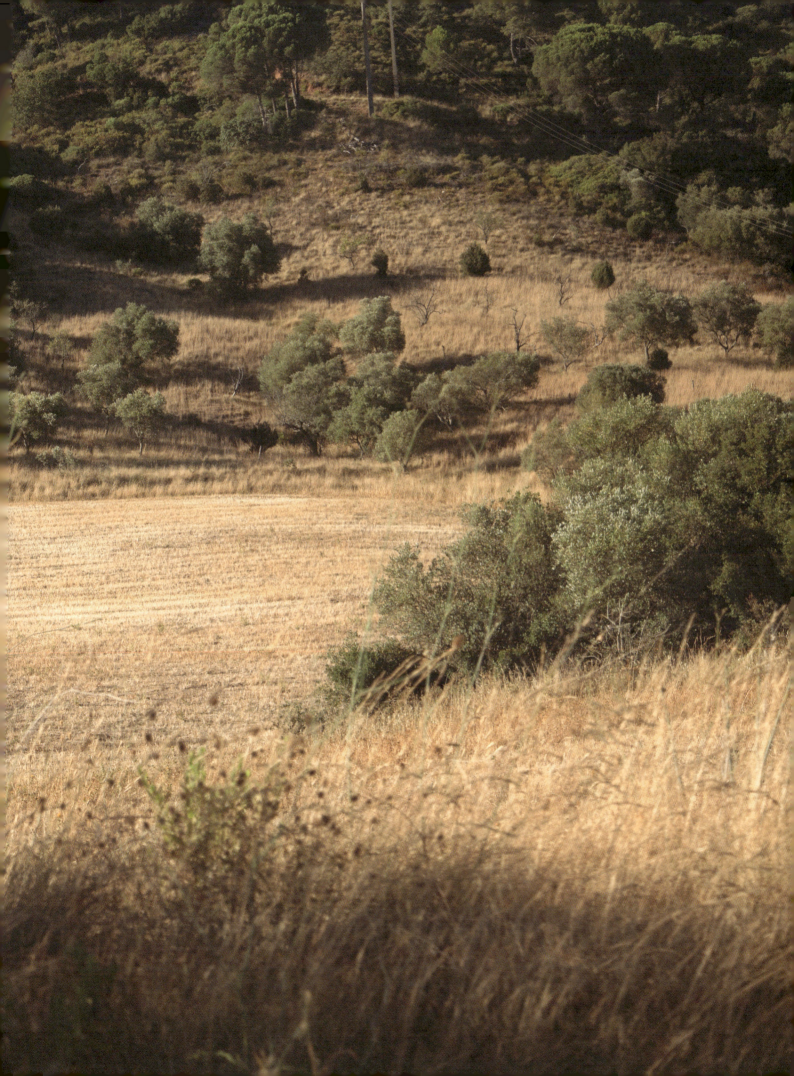

WHERE?

Palmela is located on the Portuguese Setúbal peninsula beside the Atlantic Ocean, a thirty-minute drive from Lisbon.

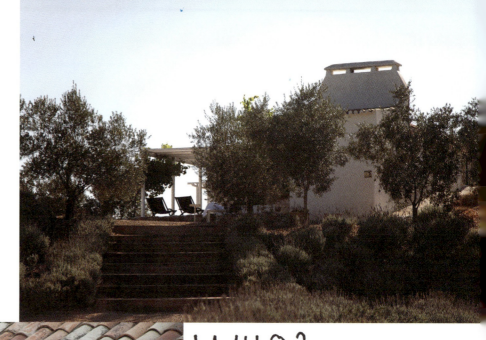

WHO?

Interior designer Mónica Penaguiao is the woman behind interior design store Poeira, which has outlets in Rio de Janeiro, São Paulo, Lisbon and Maputo. Although she was born in Portugal, she spends most of her time in Brazil and currently lives in Rio de Janeiro with her husband Carlos Martins and their sons João (16) and Antonio (15).

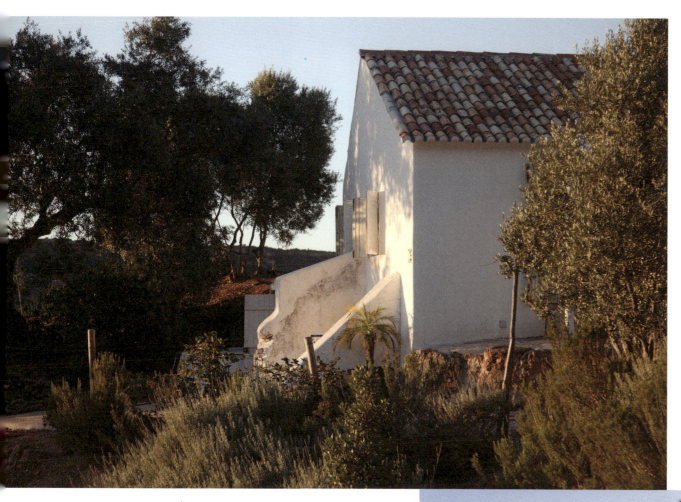
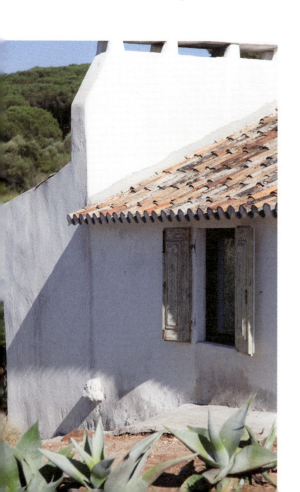
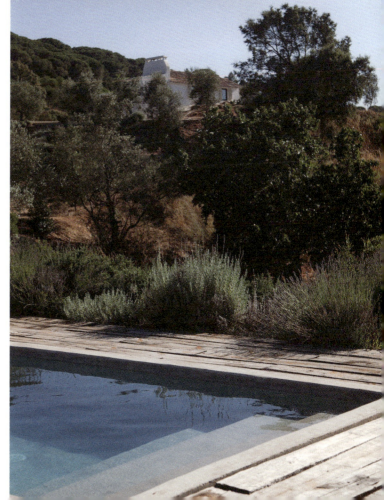

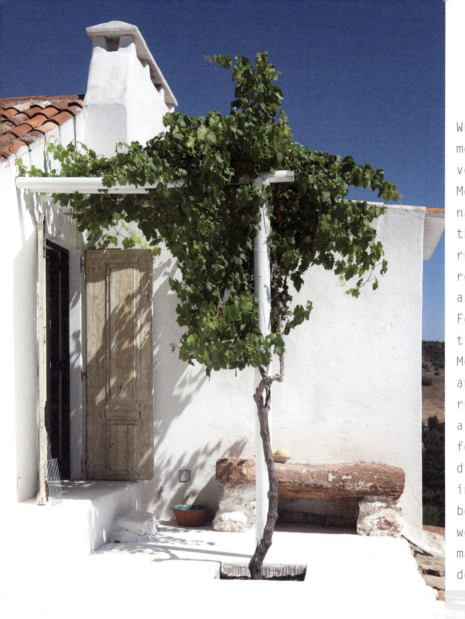

Whenever you visit, you will always meet the lady of the house. "I feel a very strong connection to this house," Monica explains. "There was originally a 200-year-old country manor on the estate, but it was practically a ruin – we had to have almost everything rebuilt. In doing this I wanted to stay as close to the original as possible. For example, we only used old, authentic building materials." The style Monica uses when decorating is light and airy; a warm and colourful mix of rustic and designer elements, industrial objects and luxurious fabrics. Comfort is her number one priority: "I'm difficult when it comes to furnishings like beds and sofas: they have to be perfectly comfortable. I also like working with colours. It is not easy to make it work for a home, but when it's done right, I love it."

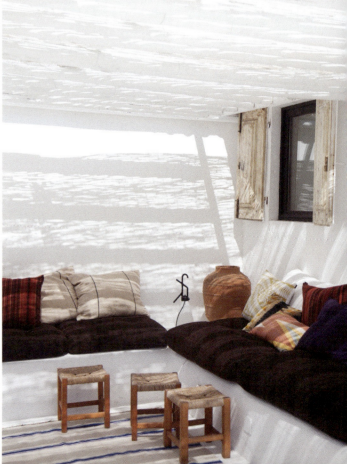

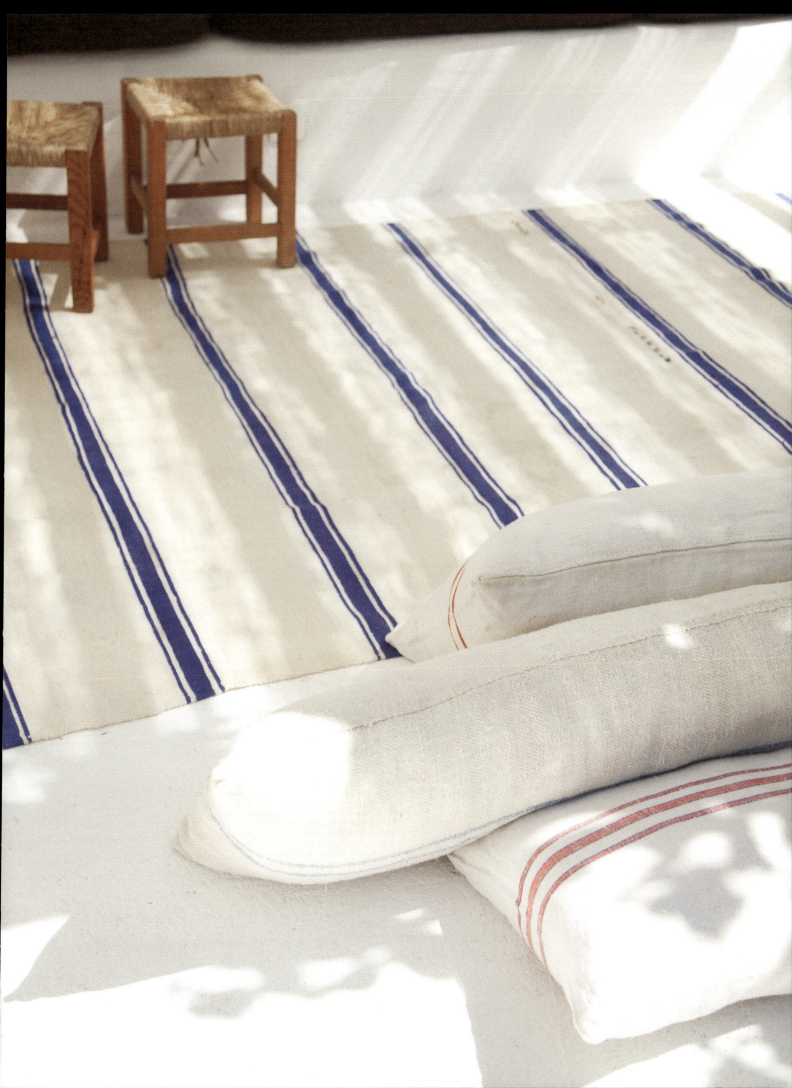

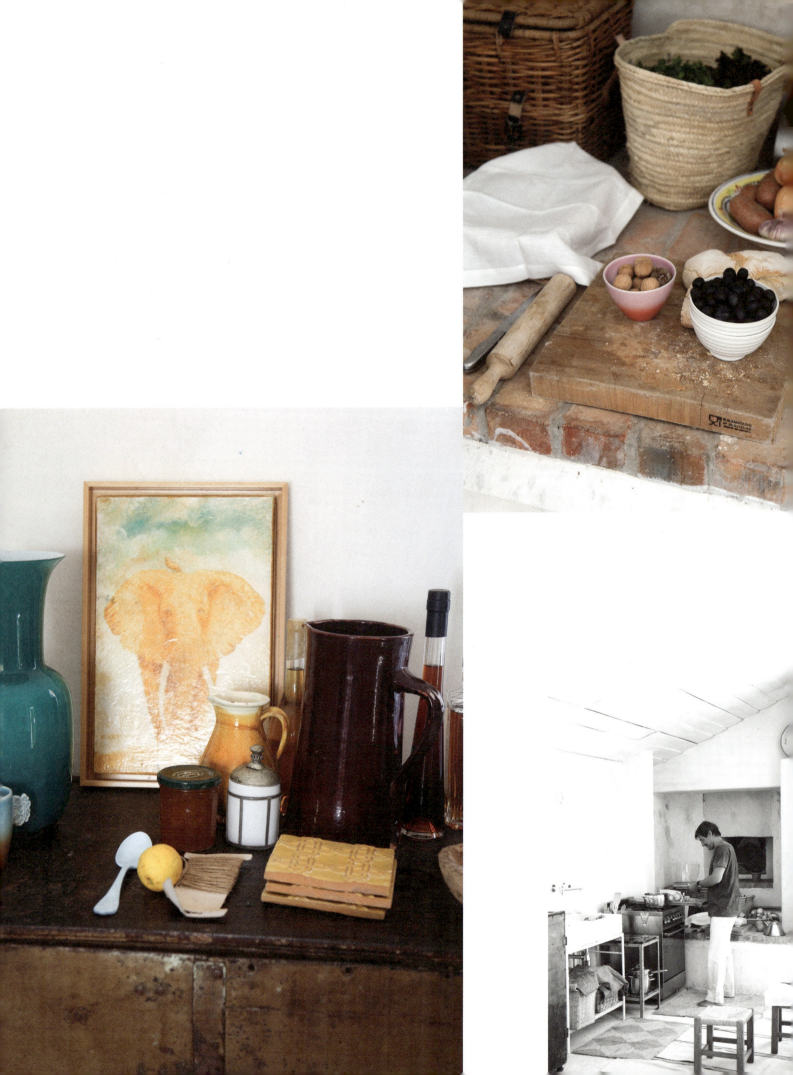

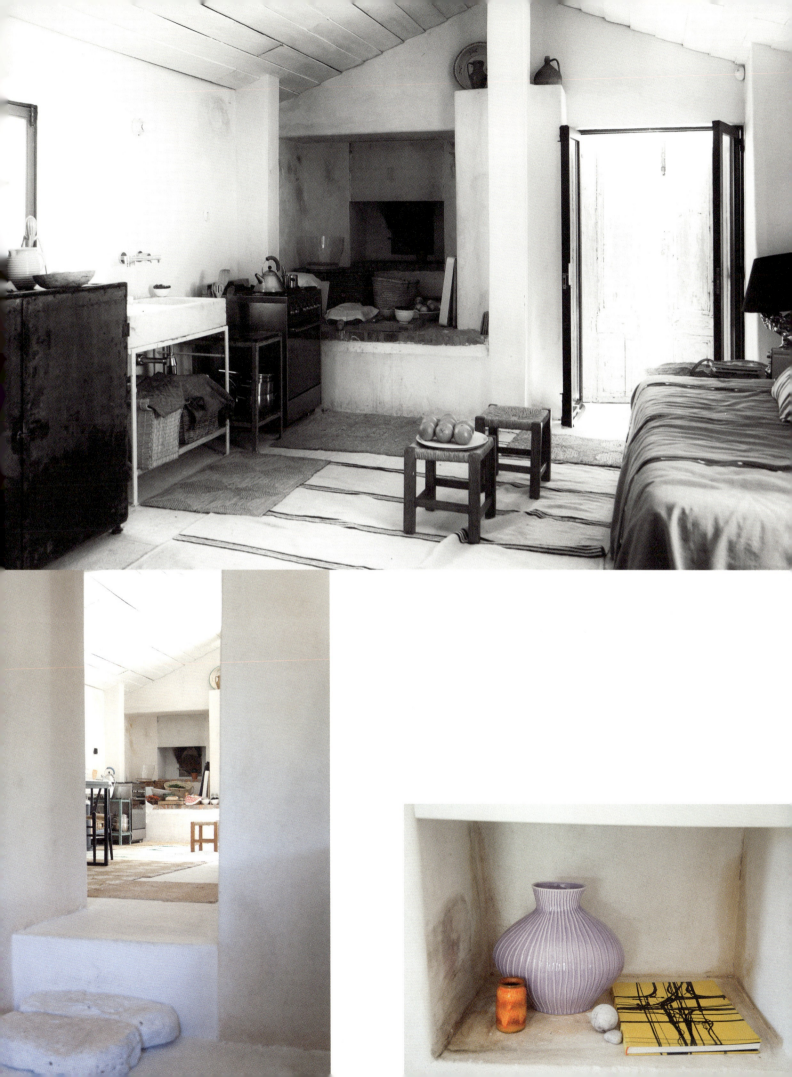

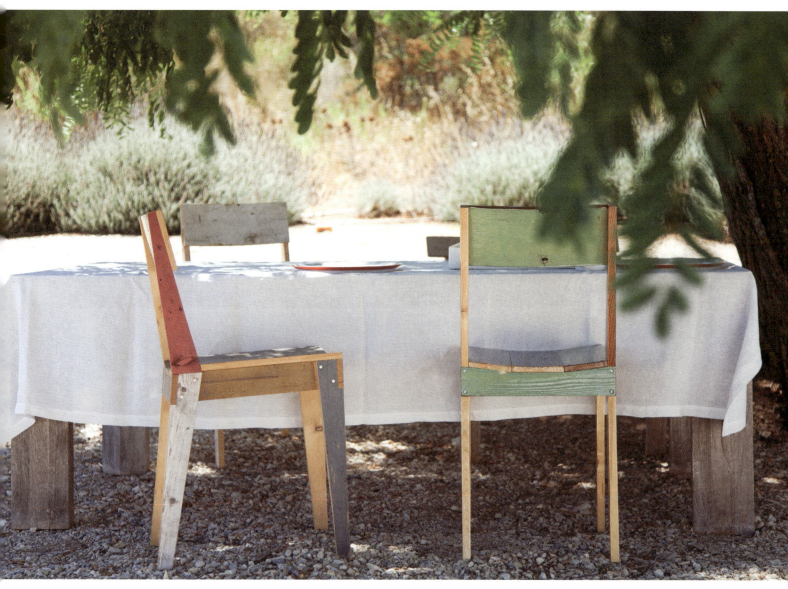

Monica is obviously very enthusiastic about the house: "It's not too big, which makes it very cosy, it's very ecologically friendly and it has a swimming pool. The best thing about it is actually the outside: that's where I spend most of my time, being with friends and family, having meals under the trees or enjoying the long evenings with only the light from a few candles." It's all about living the good life, but also keeping it simple. The countryside is wonderful: "The house is surrounded by really old cork trees, and I also like to go for walks along the country roads. The sea is nearby and the village is even closer: there's an old castle and a market where I go to buy food. Occasionally I might stumble across a nice decorative object - I like incorporating things I find during my travels into my interior design. That way, interior decorating is always an ongoing project. I like change in a home; that is something I need. That is the kind of person I am - always keeping things moving."

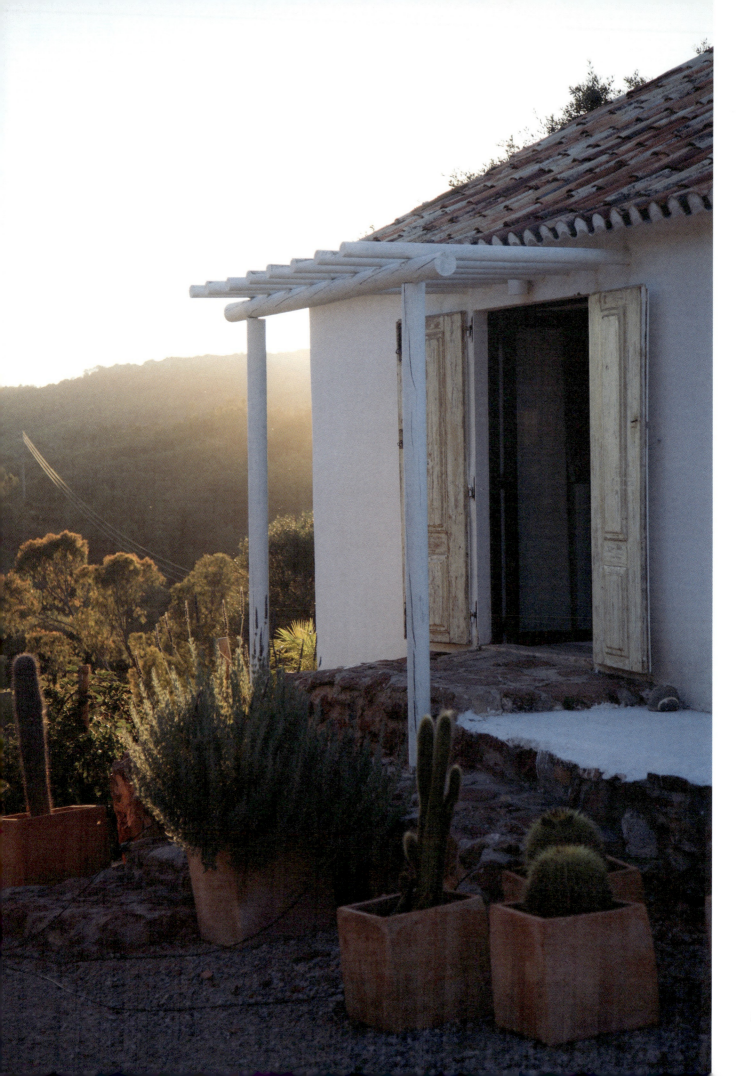

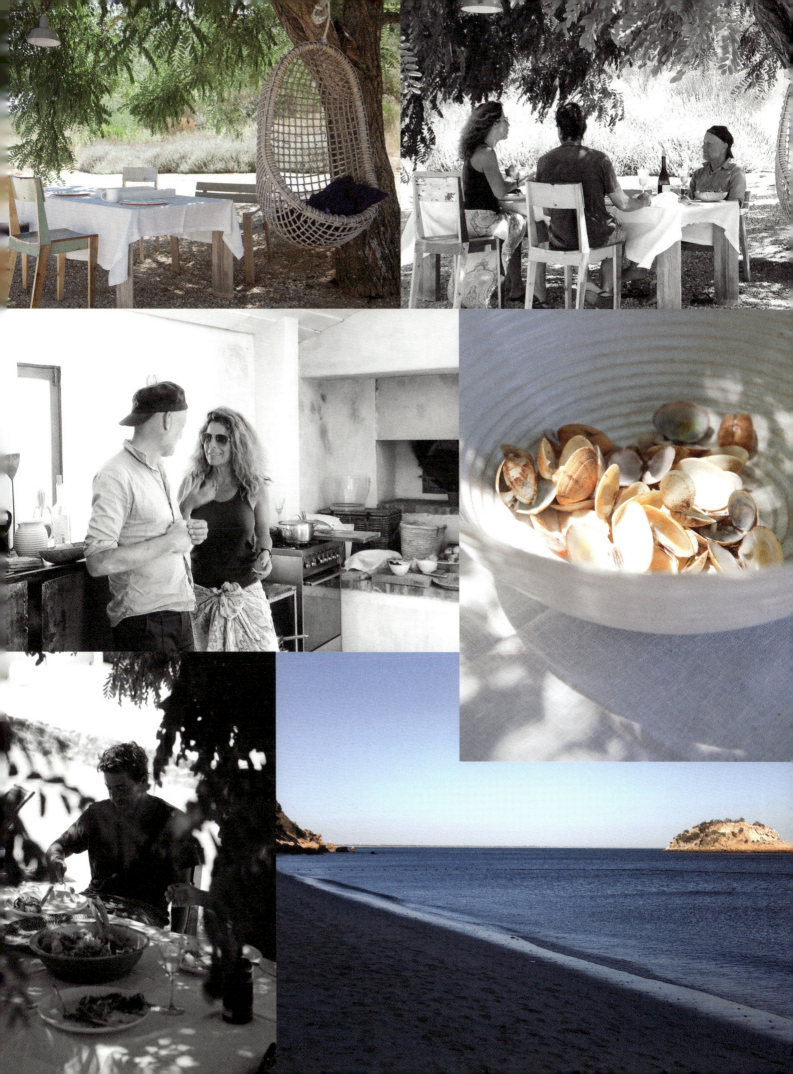

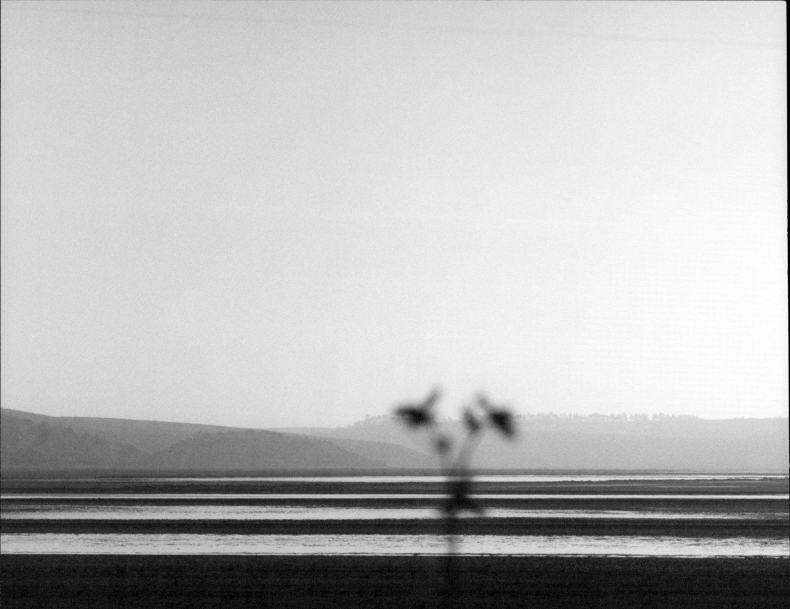

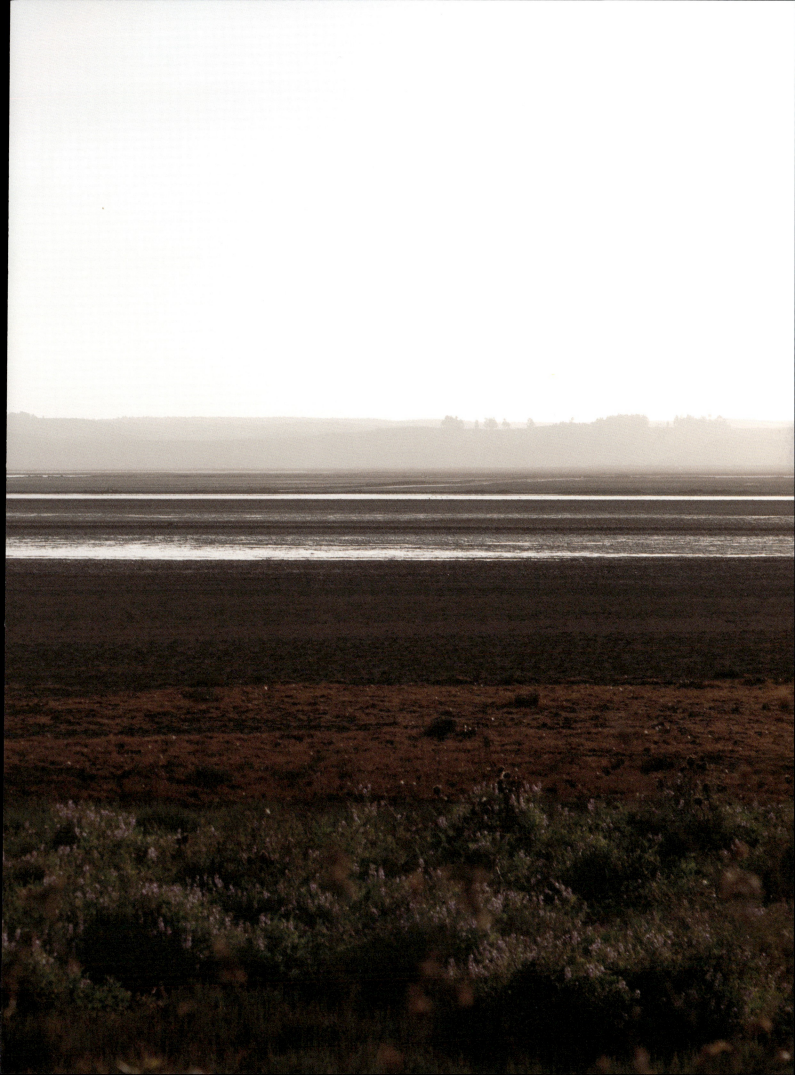

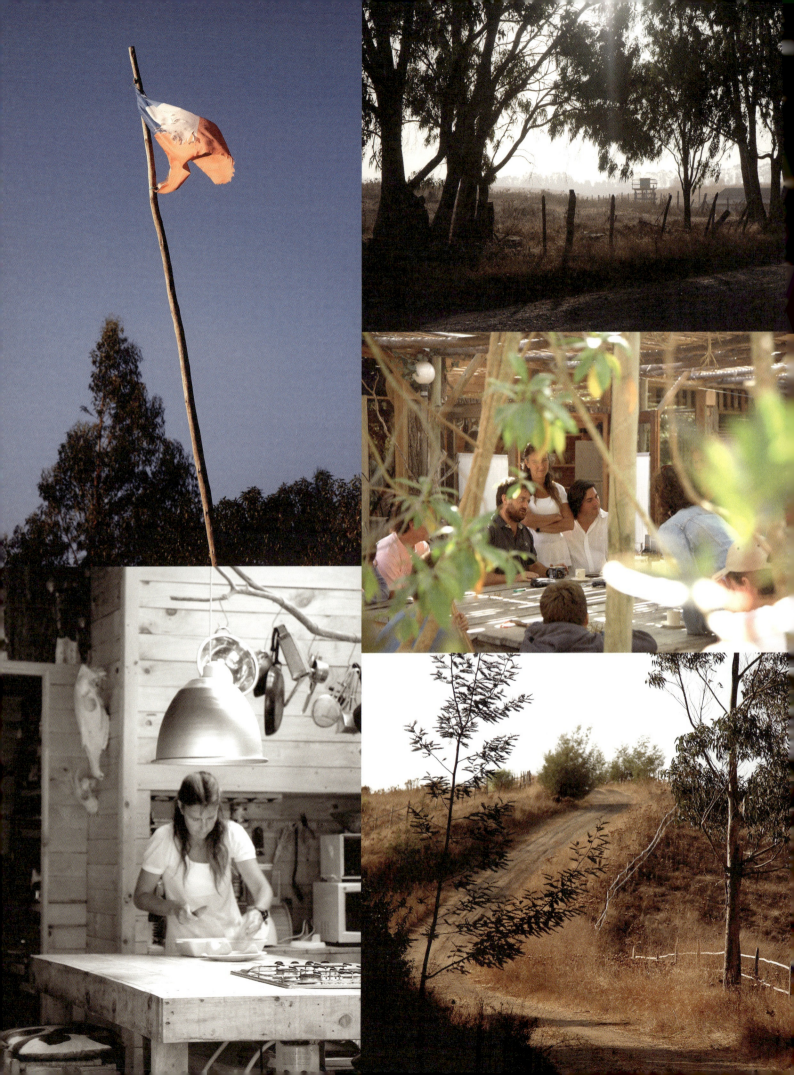

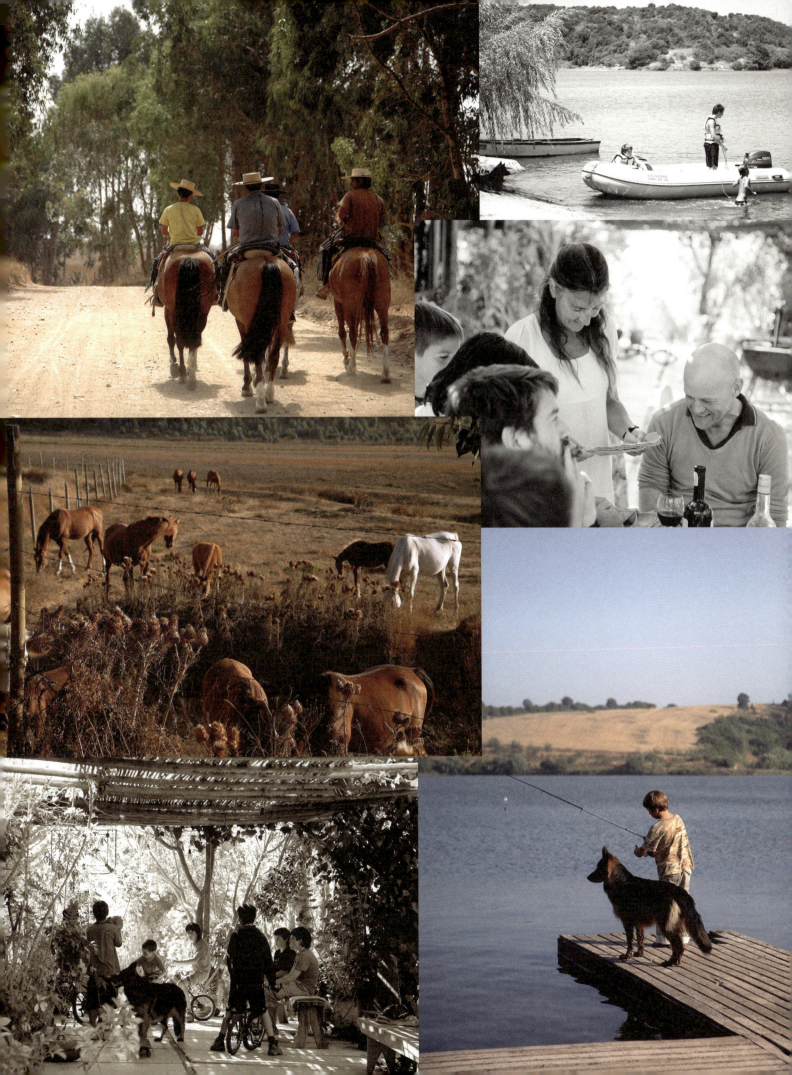

WHERE?

El Yali, a nature reserve located on the coast south of Valparaiso in Chile.

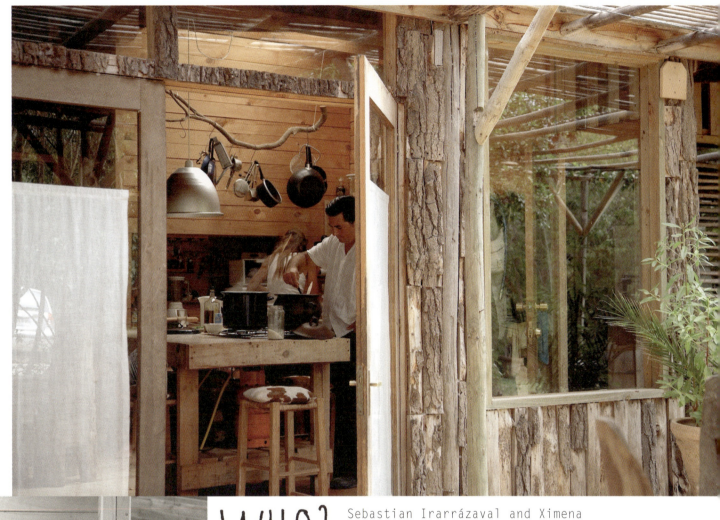

WHO?

Sebastian Irarrázaval and Ximena García-Huidobro are both well respected architects who have designed some of South America's most futuristic buildings. They have four sons and one daughter, plus a cat and a dog.

Sebastian and Ximena's weekend home is built on a substantial area of land that has been in Ximena's family for a long time. Their property in the El Yali nature reserve is situated in the middle of a varied wetland area which boasts rivers, lakes, salt pans, estuaries and dunes, not to mention the richest bird life in Chile. This remote, rural retreat is just a two-hour drive from the Chilean capital Santiago, where Sebastian and Ximena live and work, but when you arrive there it feels like an entirely different world. The couple and their children drive to El Yali whenever they get the chance, to escape from their hectic lives and the bustle of the city. Their weekend home is all about relaxing and enjoying life: meals prepared with care and enjoyed at leisure; sitting outdoors in the peace of the evening with friends and family.

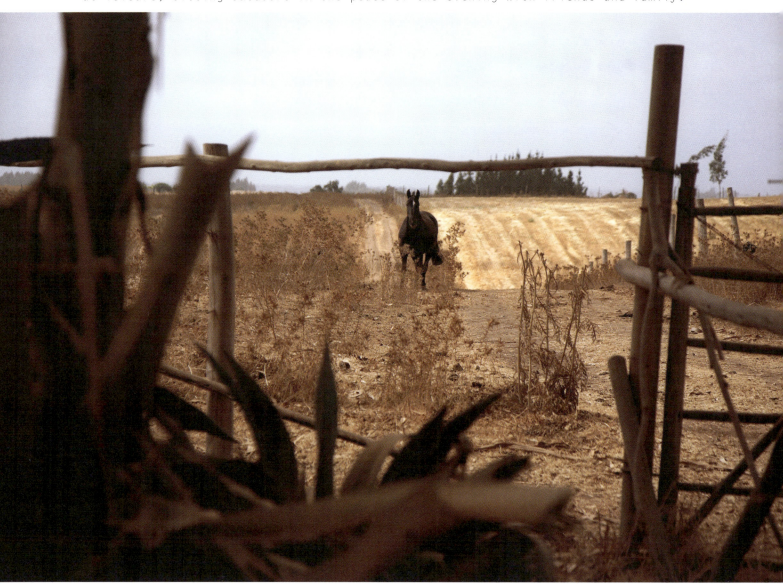

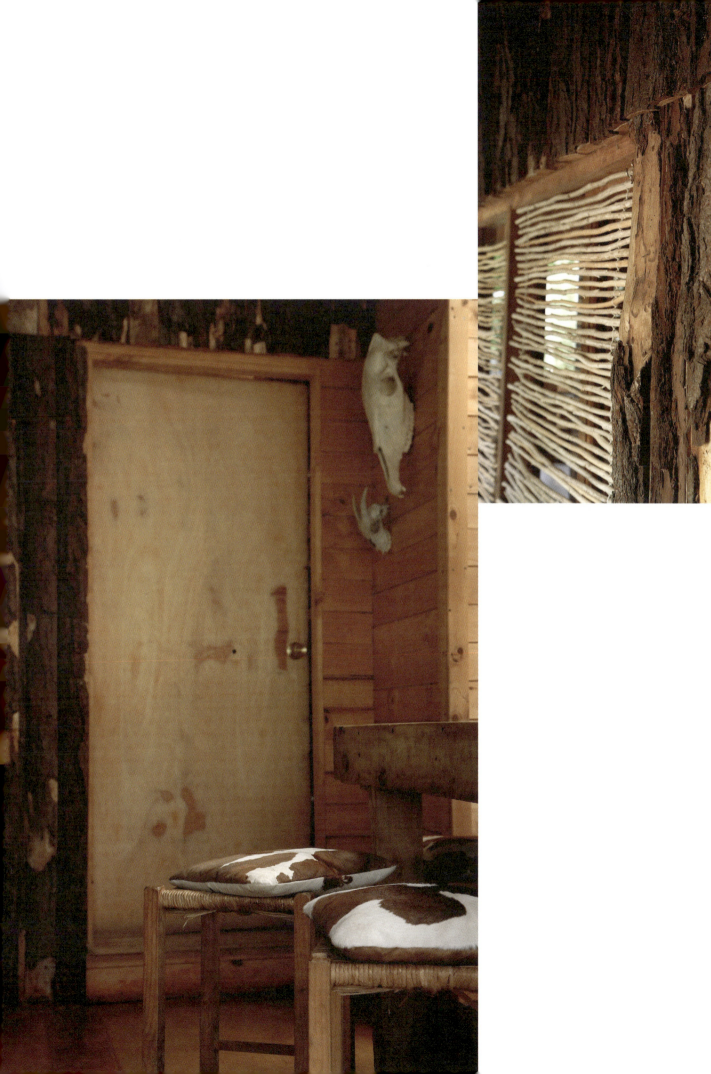

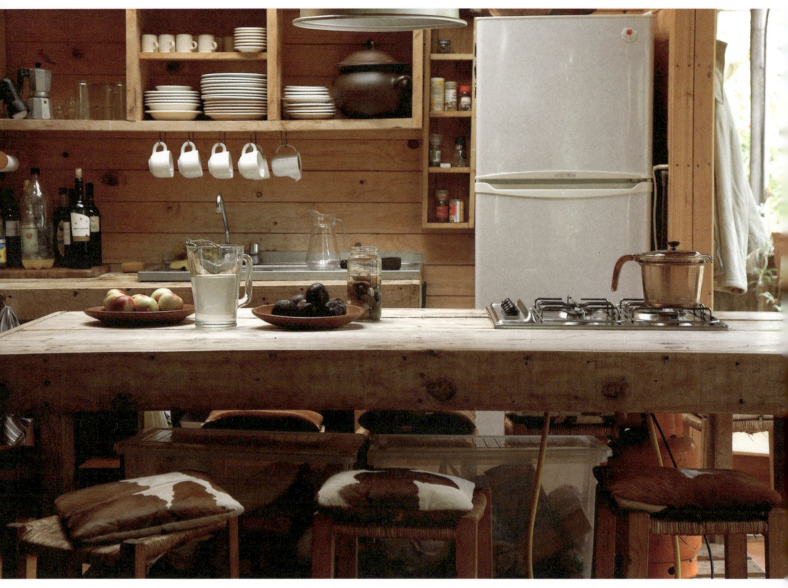

Their sanctuary is a modest wooden structure at the end of a dirt track. "This is quite different from the places we design ourselves," Sebastian admits. "By the time we found it, the building was almost complete, so it's been more of an interior renovation project for us." It is certainly obvious from the interior design that the residents are architects – every detail has been thought of to make the most of the space and the setting. One striking feature is the way the indoor and outdoor worlds intertwine: not only is the house surrounded by nature, but nature has literally been brought into the house. For example, the blinds are made of twigs strung together, there are pebbles on the windowsills, and in the large kitchen, which is the focal point of the house, teacups hang from tree branches. Texture is important too, with slubbed throws in natural tones and rough linen adding to the organic mood. "We wanted everything to be simple and relaxing," says Sebastian. "That's why we chose natural colours and materials that mirror exactly what's happening outside."

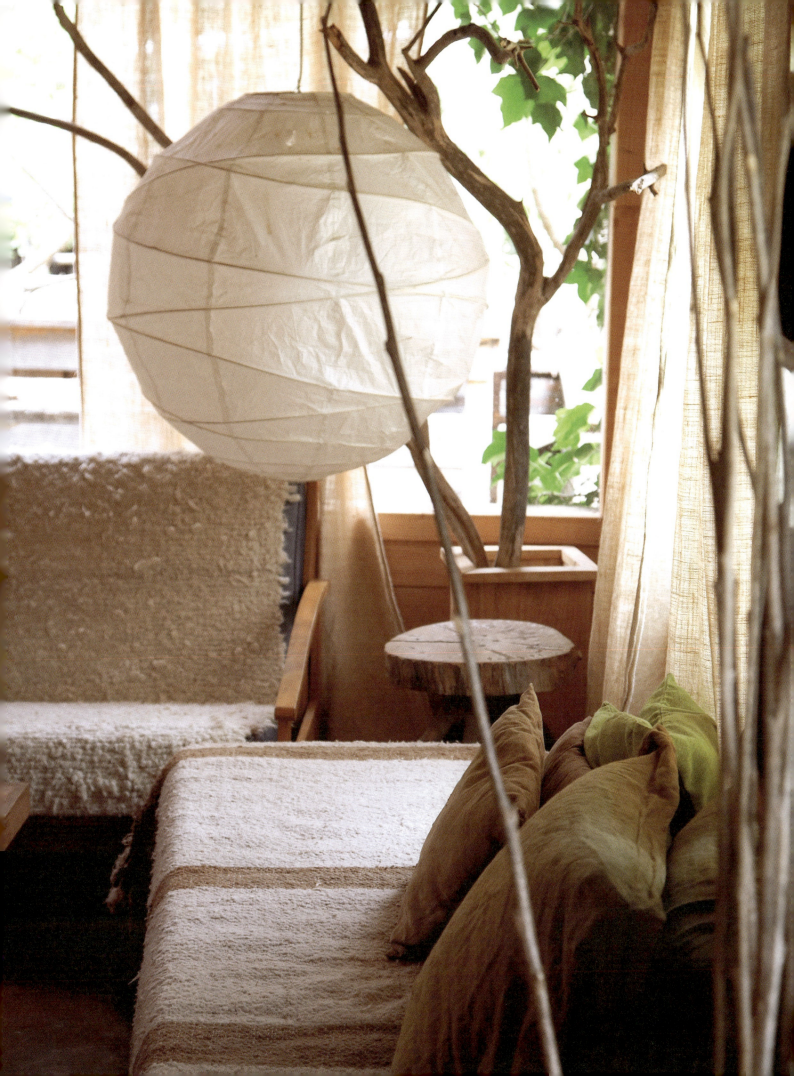

226

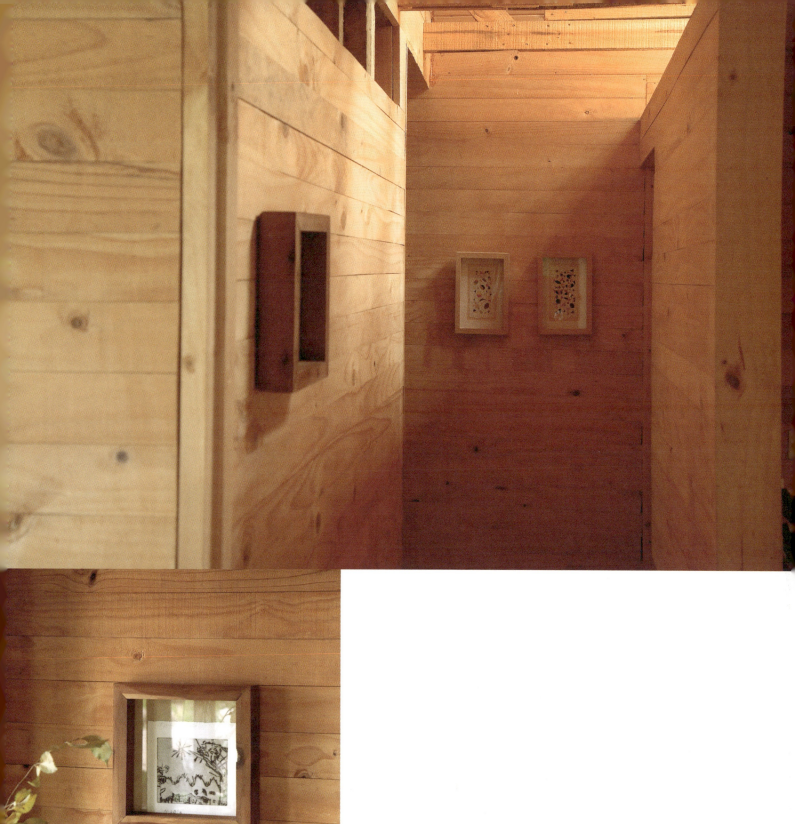

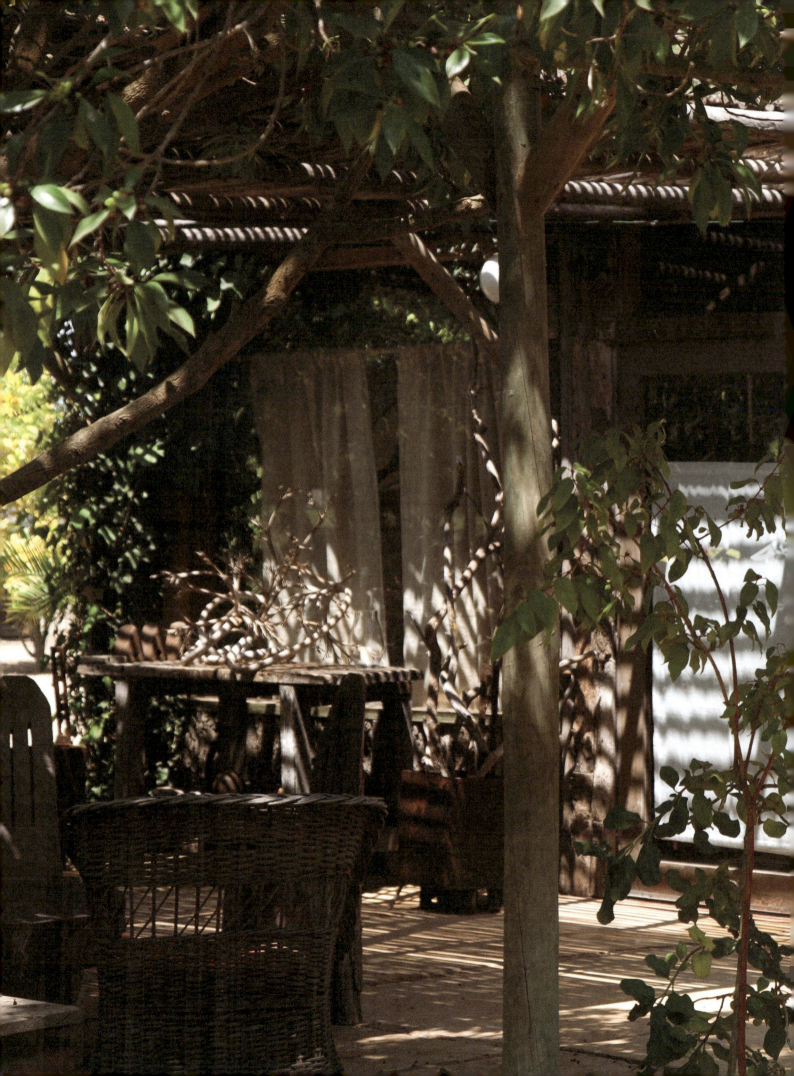

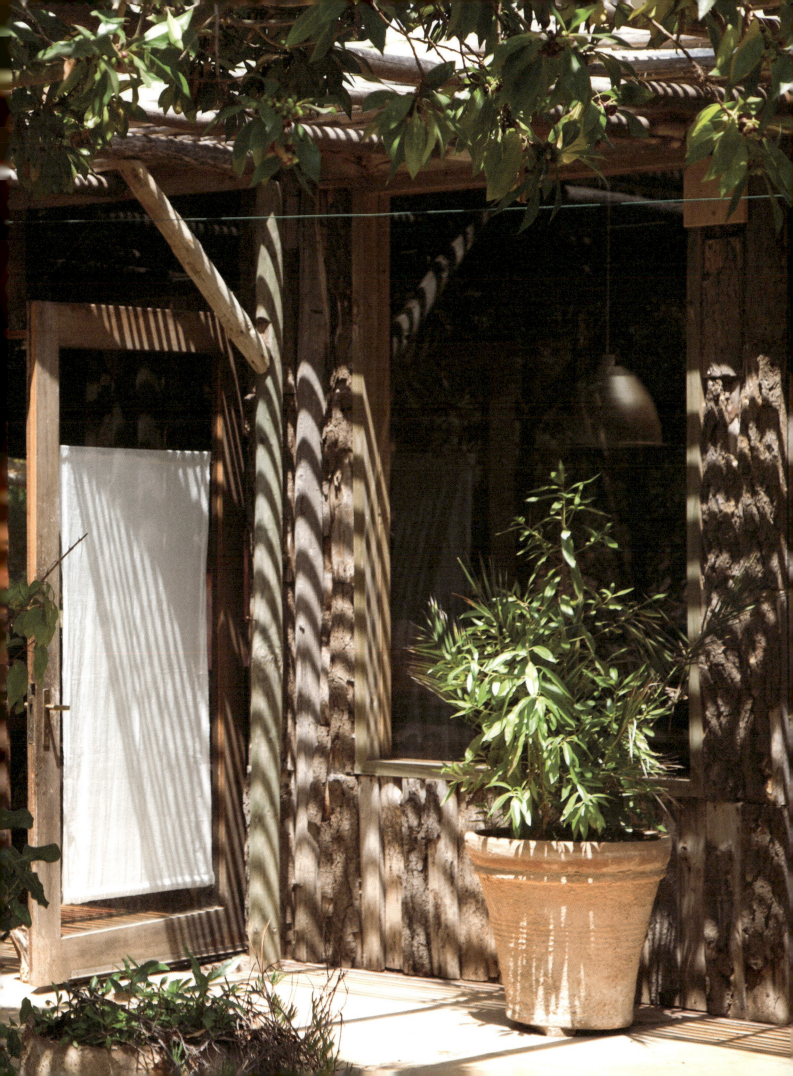

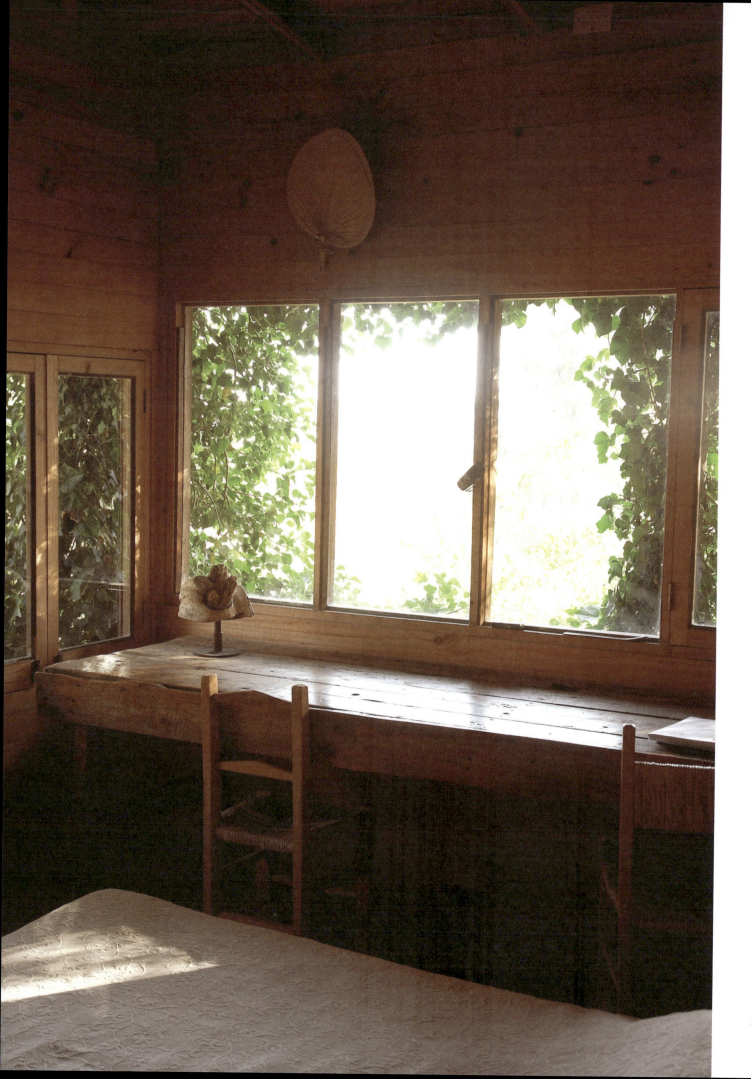

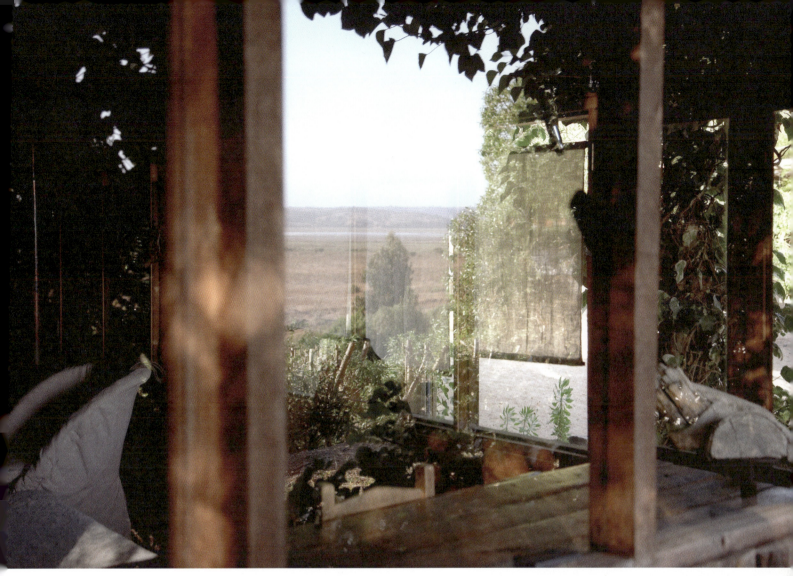

JAPAN

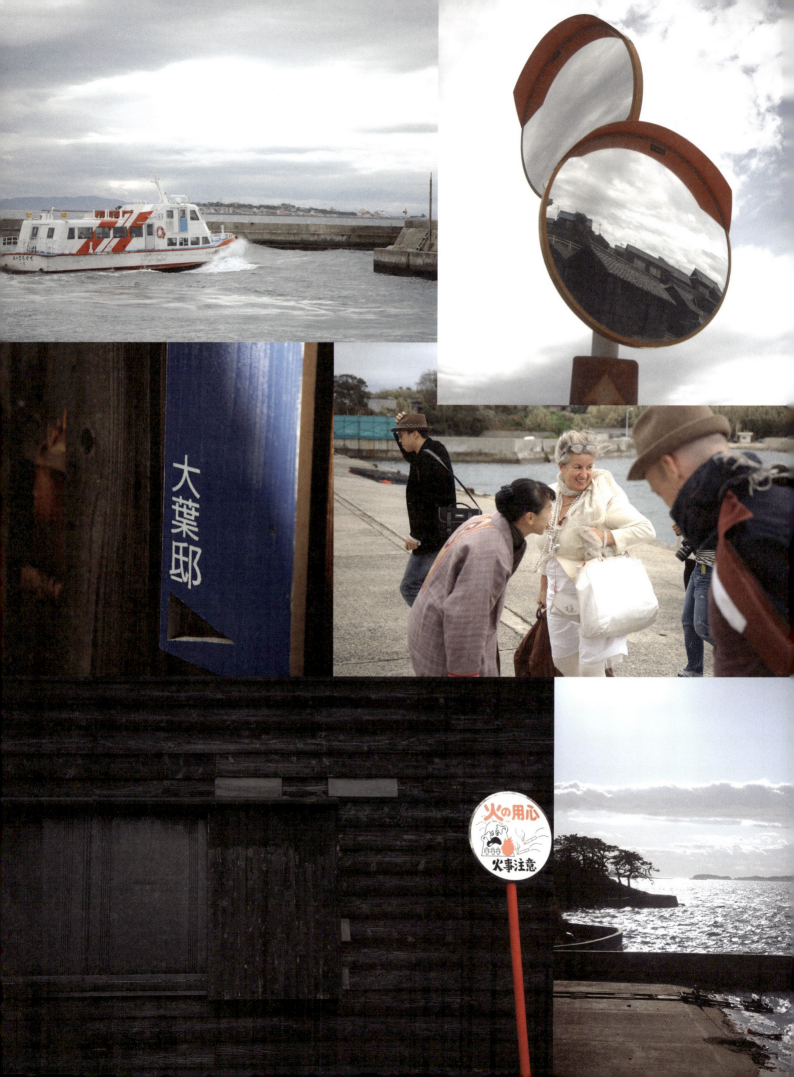

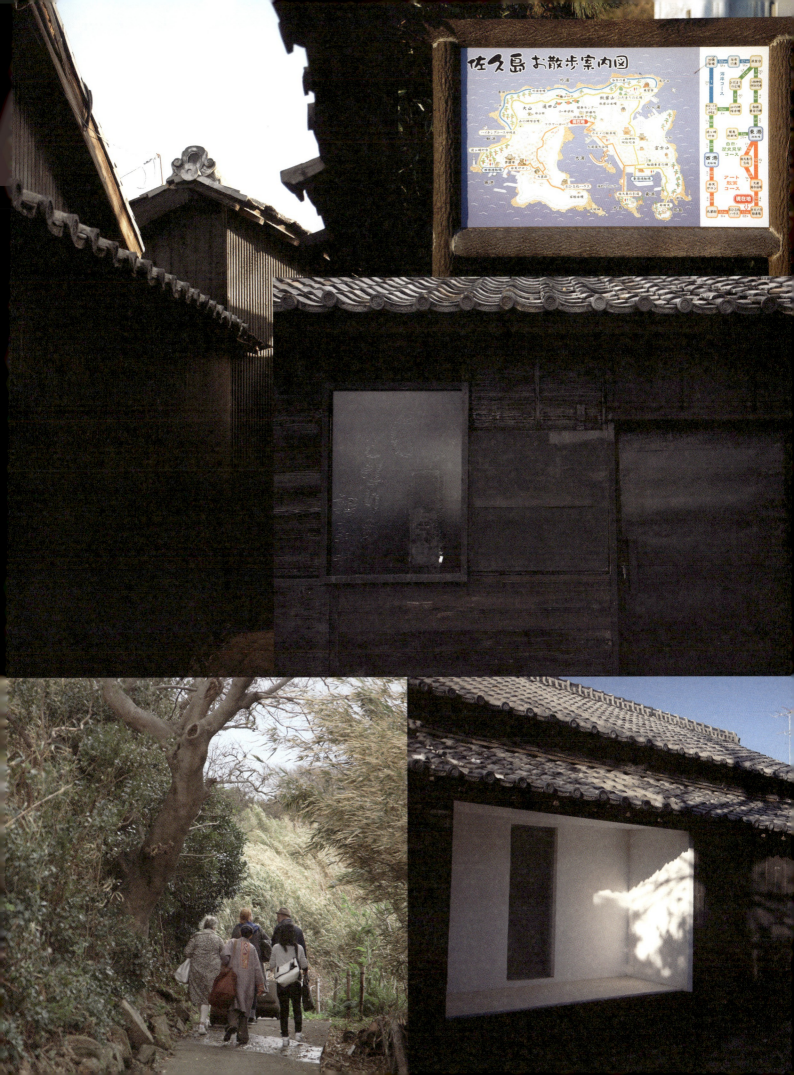

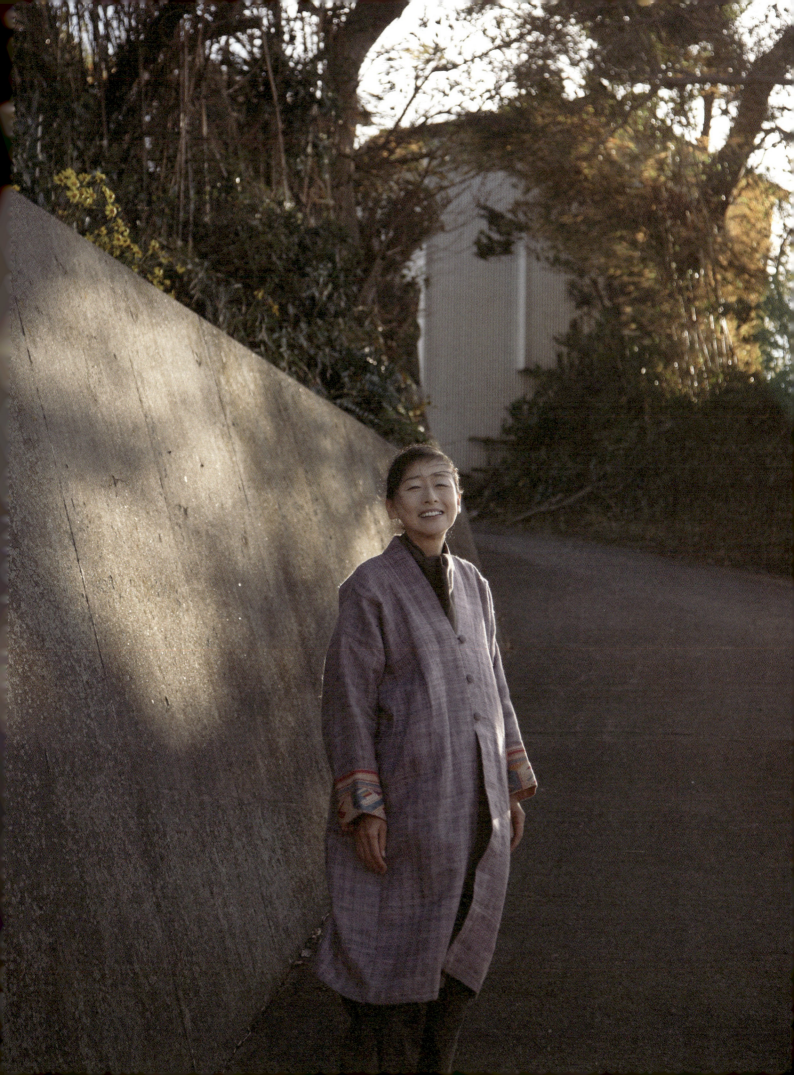

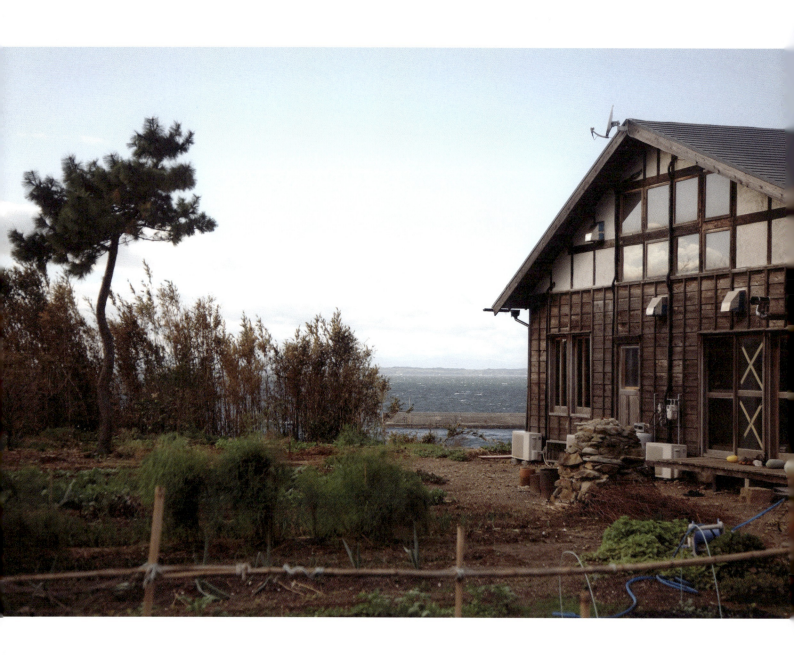

WHERE?

Saku Island (also known as Sakushima), a small island off the coast of the city Nagoya, in the Japanese Aichi prefecture. The island (with a population of less than 300) has a circumference of 11.5 kilometres but its most distant points are just 2 kilometres apart.

"One of our friends is an artist who had worked on a project on Saku Island. She told us about the island and the small authentic living-room restaurant Maaki that she had visited. The restaurant is run by a Japanese couple, Masaki and Hiroko Mizutani. Dining there had been a wonderful experience, she said. Our friend Marlein Overakker, a food stylist and chef, had set her heart on going there, so of course we went along. It's such a unique place; you can't begin to imagine what it's like until you've actually been there."

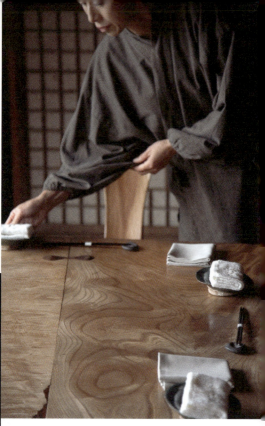

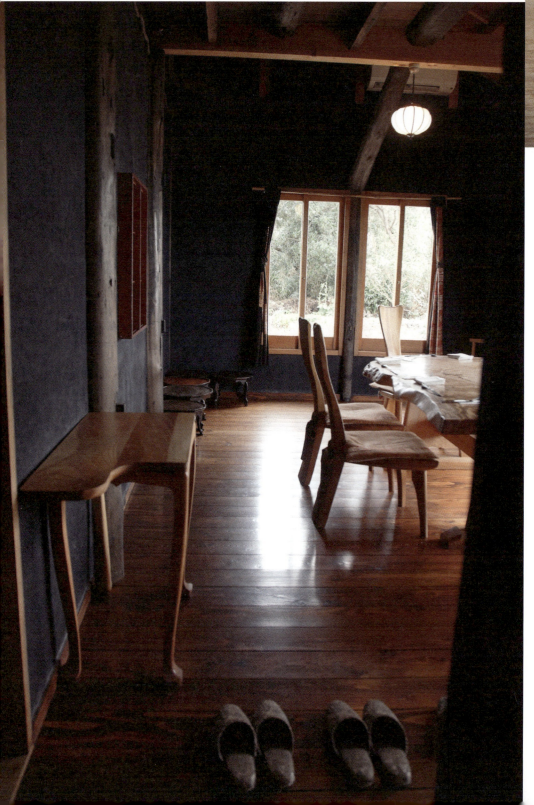

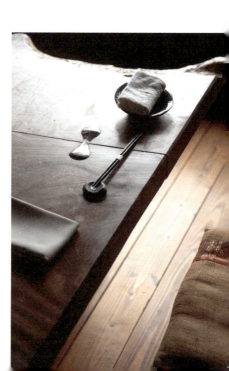

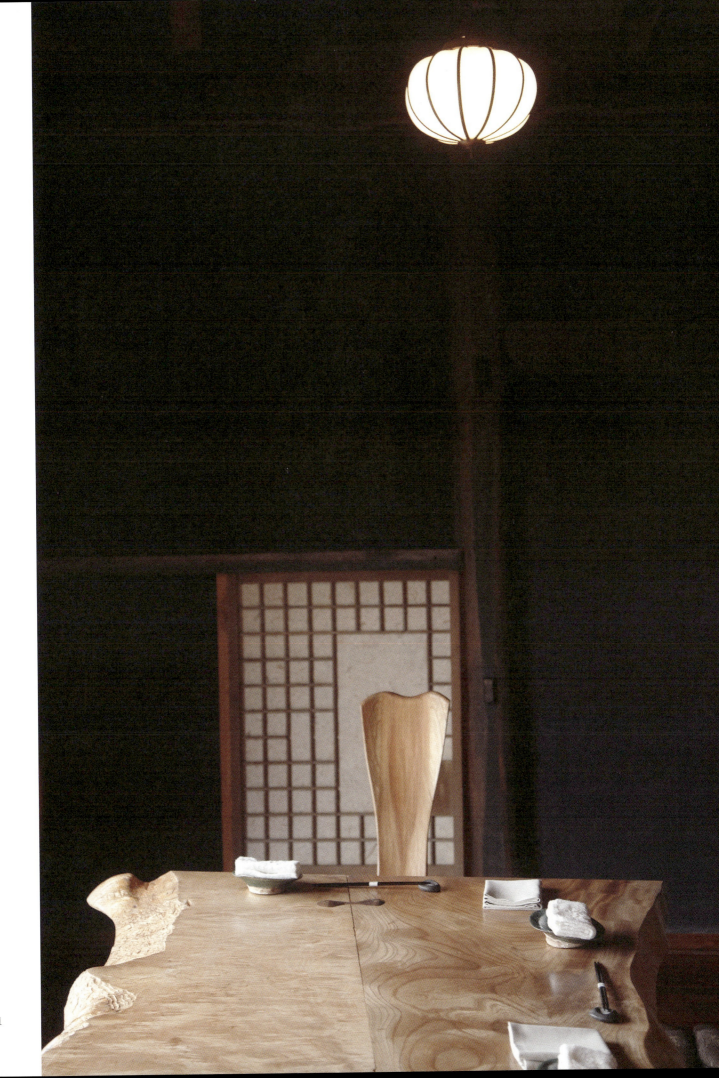

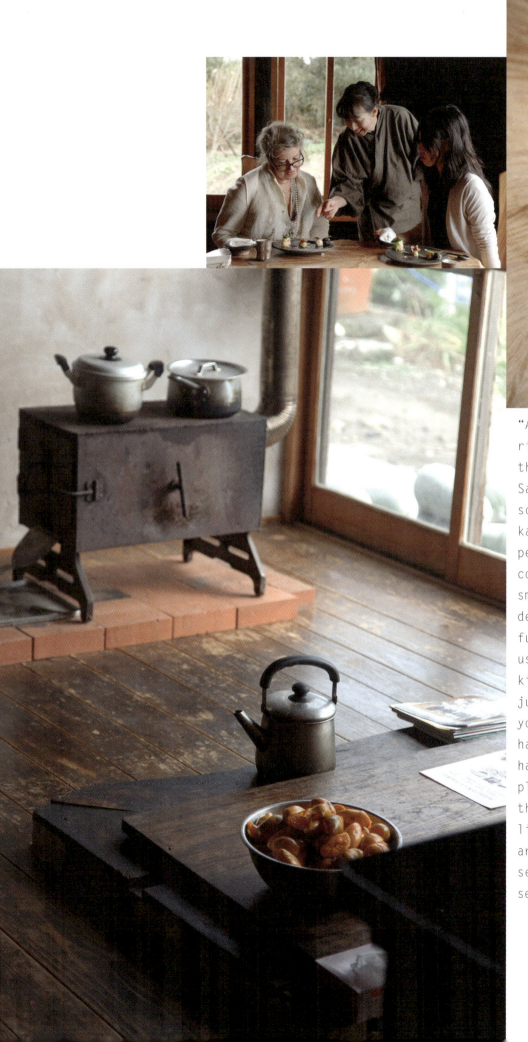
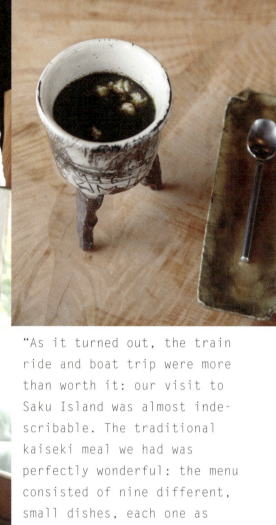

"As it turned out, the train ride and boat trip were more than worth it: our visit to Saku Island was almost indescribable. The traditional kaiseki meal we had was perfectly wonderful: the menu consisted of nine different, small dishes, each one as delicious as it was beautiful. Everything was prepared using produce from their kitchen garden and the sea just down the road – from your seat at the table, you had a view of the ocean that had provided the fish on your plate. The view is part of the whole experience, just like the earthenware plates and cups which are carefully selected to match the food and season."

"Our hosts welcomed us and waited on us with meticulous care. In the ritual surrounding our meal, every tiny detail was important. The surroundings, the way the table was set, the serene atmosphere, the delicious food: it was simply perfection."

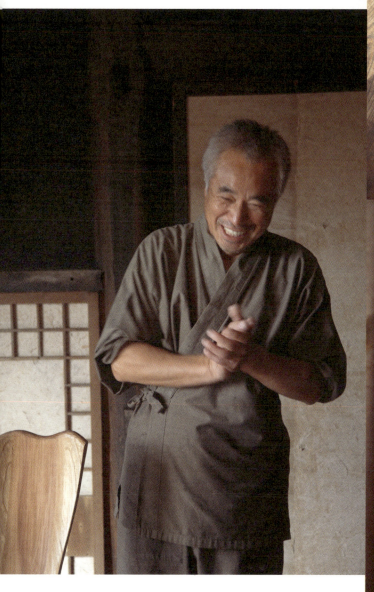

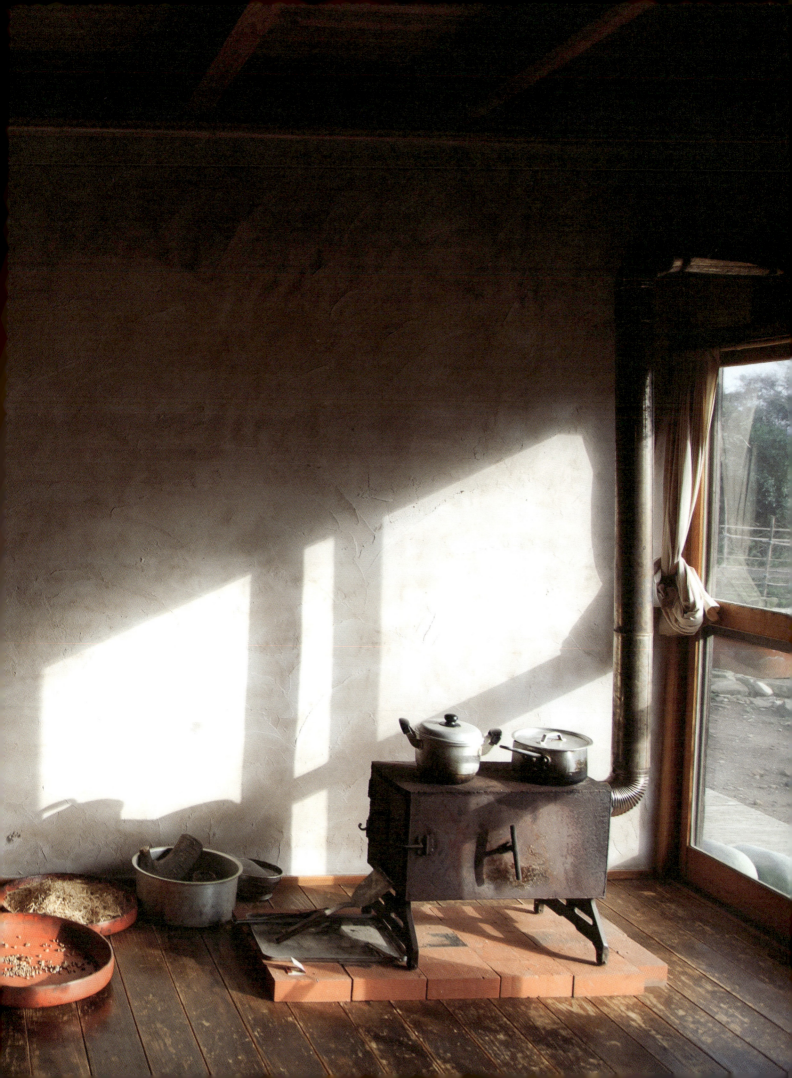

CURAÇAO

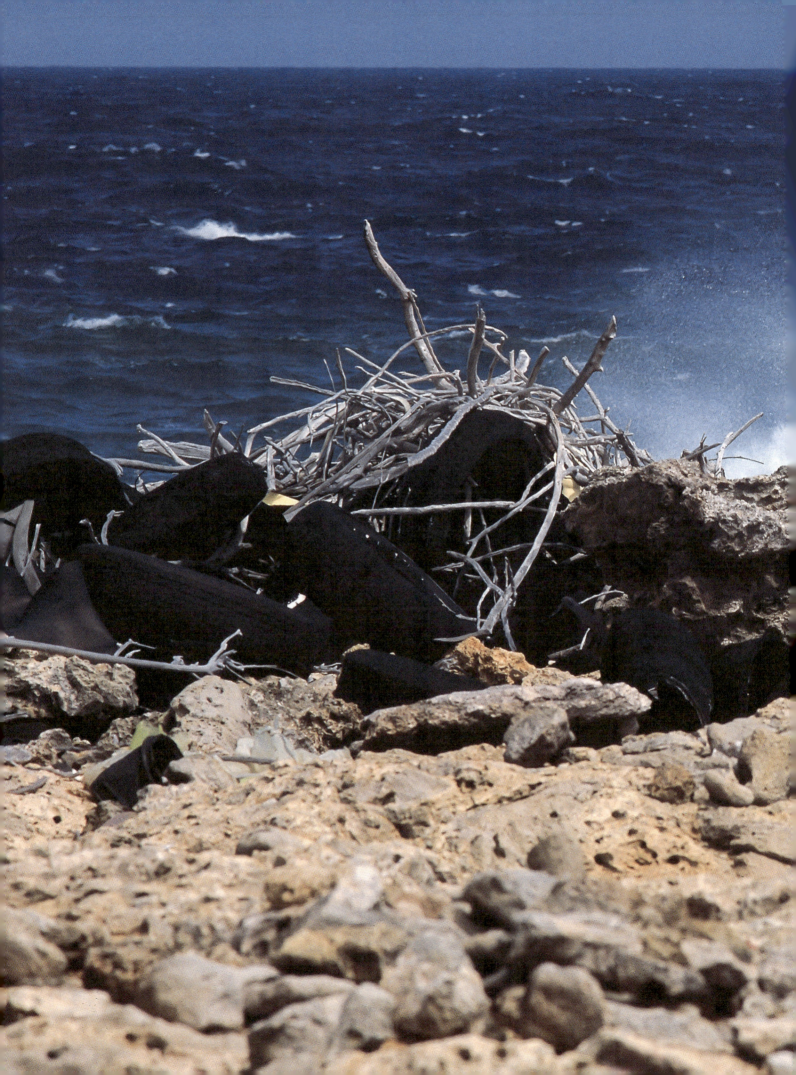

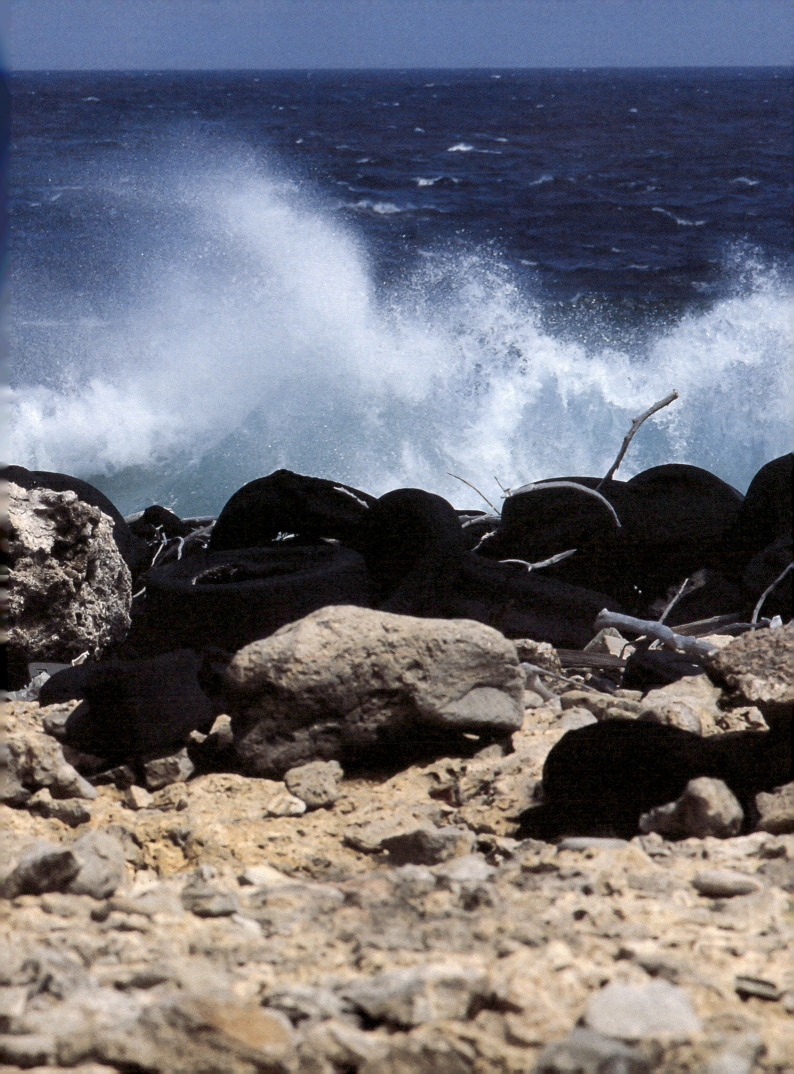

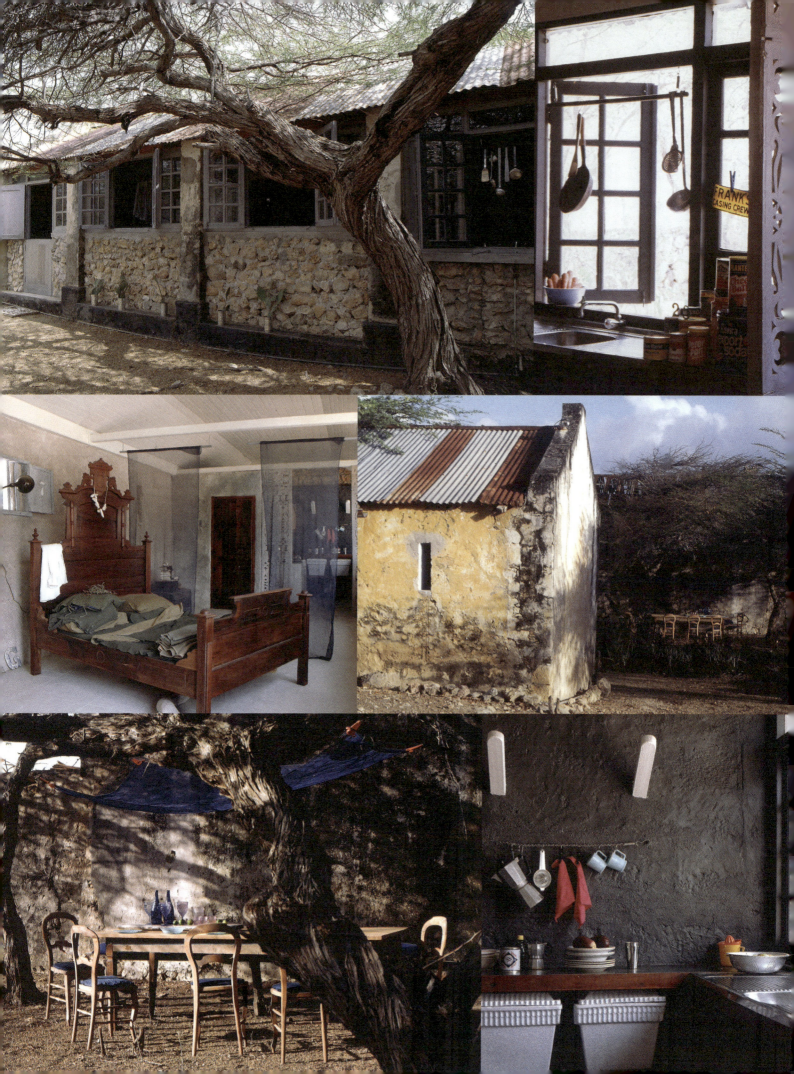

WHERE?

In Curaçao, an island in the southern Caribbean Sea, located off the Venezuelan coast and one of the six islands that make up the former Netherlands (or Dutch) Antilles. Frank and Mirjam also scoured the coastline at the so-called *houtjesbaai* (wood bay) and *plasticbaai* (plastic bay) in the northern part of the island, not far from Willemstad. It takes less than an hour to cross the island and reach the quieter bays on the southern side.

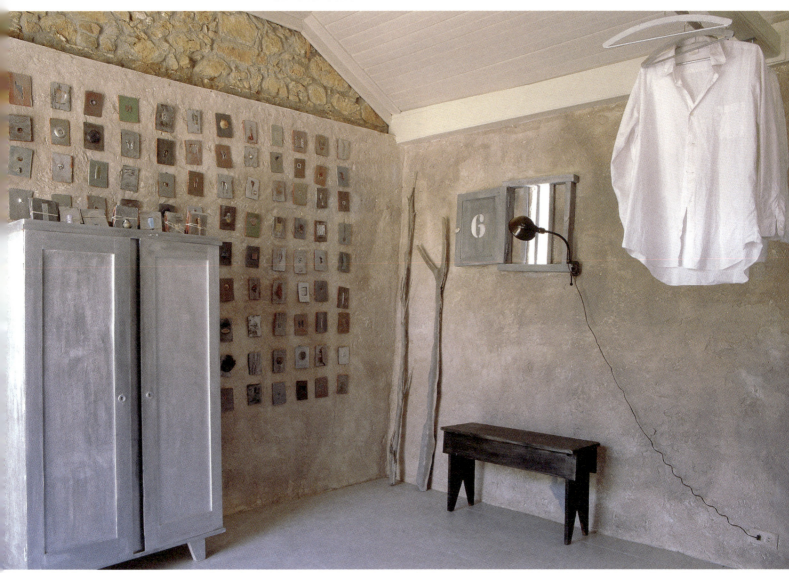

The trip to Curaçao was Frank and Mirjam's first journey together, 18 years ago. For Frank it meant revisiting the surroundings of his youth: "I grew up in Curaçao, and wanted to go back there for a while. I wasn't quite sure what I would do there, and that was exactly the way I wanted it: I just wanted to be there and do something – make something, go shopping, cook, eat, sleep, work on a project, talk to people – anything, just to see the place differently, not as a tourist." This is the way Mirjam and Frank prefer to work: they travel to a destination that interests or intrigues them without a plan and without too much information. They stay with people who they meet through mutual contacts, or lodge in houses or huts which they temporarily make 'their own' using nothing but some fabrics and a few collected items.

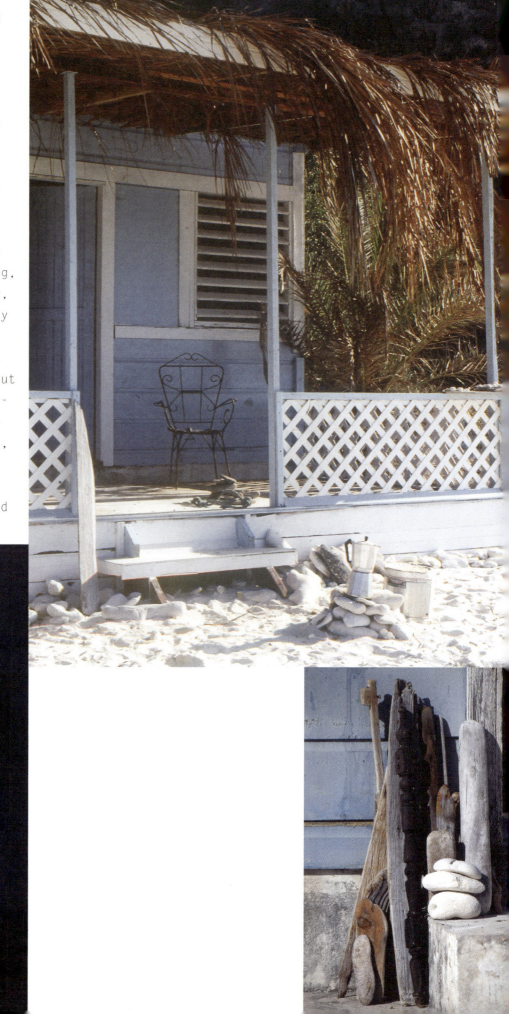

Curaçao was no different. Frank rented a small stone house at a plantation estate close to the northern coast of the island where, because of the northeast trade winds, the sea is wild and where tons of all kinds of 'sea treasures' wash ashore: it's a real beachcombers paradise. The house had been abandoned for a quite a while and it was a challenging project to make it nice and livable again in a short time, with rather minimal interventions. Another project was a beach hut he found in a quiet bay. He started fixing it up using objects that he and Mirjam found during the day on the island's several beaches. The rough northern coast yielded the most treasures - they strung coral beads together to make a bead curtain, transformed driftwood into a new seat for an old iron chair, created still lives of sea urchins on blue windowsills faded by exposure to wind and sand... They combed the beach, cooked, ate, worked on their house, and gazed at the rough seas, their lives moving with the rhythm of the island. All the while Mirjam was taking photos: "Our Curaçao project was a gamble, like most of our later projects have been - we rarely know in advance what we will discover, and most of the time we also don't know whether any magazine will be interested in publishing our spreads. Still, we cherish that uncertainty, because it also means freedom. We are free to go wherever we want, free to spend a short time in a place or stay there for longer, free to be guided by chance encounters - the light, the objects we find, whatever. Wherever we stay, we are free to create a world of our own."

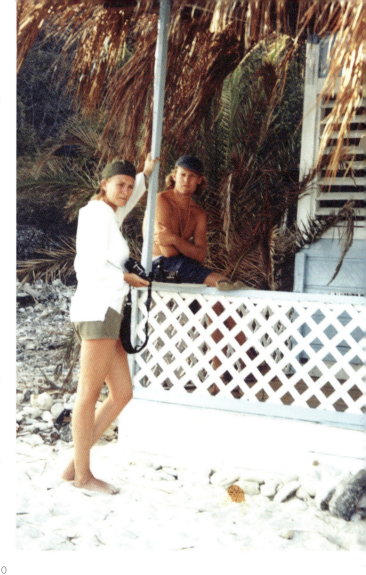

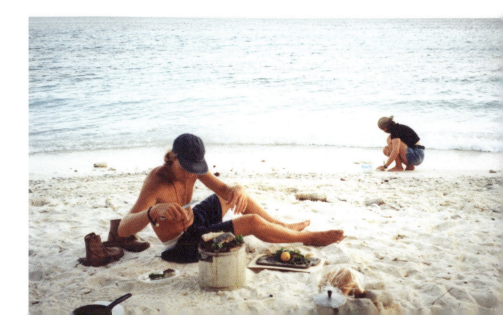

AT THE OCEAN
Inspiring coastal houses and refuges

Photography
Mirjam Bleeker

Production
Frank Visser

Graphic design
Madeleine Wermenbol

Texts
Hadewijch Ceulemans

Translation
Miles Translations

D/2014/12.005/7
ISBN 978 94 6058 1236
NUR 454

© 2014, Luster (Antwerp), Mirjam Bleeker & Frank Visser
First reprint, March 2015
www.lusterweb.com
info@lusterweb.com

All rights reserved.
No part of this publication may be reproduced, stored in a retrieval system, or transmitted, in any form or by any means, without the prior written consent of the publisher.
An exception is made for short excerpts which may be cited for the sole purpose of reviews.

ABOUT THE MAKERS

The Dutch stylist and designer Frank Visser works under the name of IJM on thought-provoking projects which are regularly published in international design magazines.
Mirjam Bleeker is a freelance photographer. She travels the world, often together with Frank, in search of the most beautiful and extraordinary locations and people. Her work appears in numerous international travel and interior-design magazines.

THANK YOU

To all the residents whose homes we have included in this book, for welcoming us in their magical seaside sanctuaries. Everywhere we went, we received a warm welcome. We often stayed with our hosts for an extended period of time; some encounters even turned into lifelong friendships. To all of you: thank you. Not only have you given us the opportunity to create this book, but you have expanded our horizons.

Mirjam and Frank